EGON SCHIELE

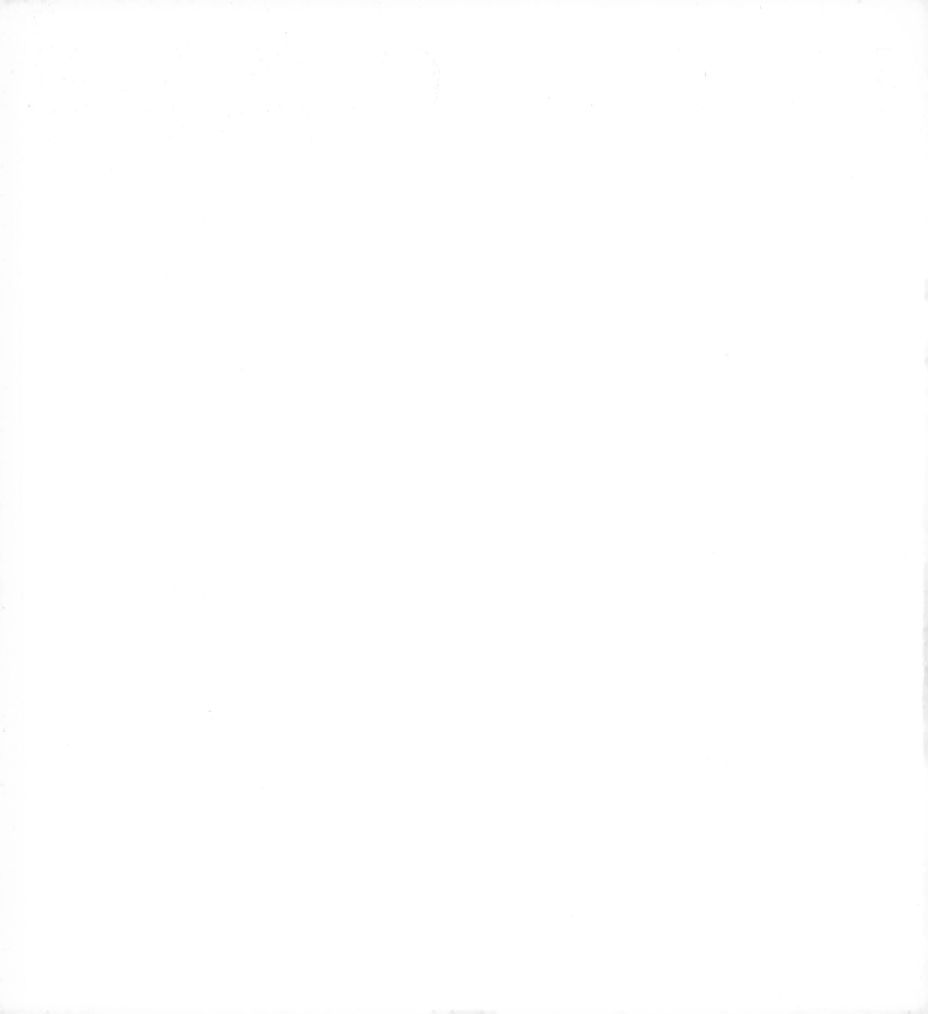

EGON SCHIELE

ERWIN MITSCH

Φ

Translated from the German by W. Keith Haughan

Phaidon Press Limited
2 Kensington Square
London W8 5EZ

First published in English 1975
Second edition 1988
Third edition 1993 (paperback)
Reprinted 1994

Originally published in German as *Egon Schiele 1890-1918*
© 1974, 1987 by Residenz Verlag, Salzburg and Vienna

Originally published in English as *The Art of Egon Schiele*
Translation © 1975, 1988 by Phaidon Press Limited

ISBN 0 7148 2862 9

A CIP catalogue record for this book is available from
the British Library

Printed in Singapore

CONTENTS

BIOGRAPHY

1890 Born June 12 at Tulln on the Danube, the third child of Adolf Schiele, a railway official, and his wife Marie, née Soukup.

1894 Birth of his sister Gertrude (Gerta), who later frequently served him as a model. In 1914, she was to marry Schiele's friend, the painter Anton.Peschka. His two elder sisters were Elvira, born in 1883, died in 1893, and Melanie, born in 1886.

1902 After attending the primary school at Tulln and a class at the secondary school at Krems, Schiele becomes a pupil at the secondary school in Klosterneuburg.

1905 His father dies during the night from December 31, 1904, to January 1, 1905. Schiele's uncle and godfather, Leopold Czihaczek, is appointed his guardian.

1906 Schiele's drawing-master, Ludwig Karl Strauch, the Klosterneuburg painter Max Kahrer, and the Augustinian canon and art-historian Dr. Wolfgang Pauker recommend artistic training. In the autumn he begins his studies at the Academy of Fine Arts in Vienna, under Professor Christian Griepenkerl (1839–1916).

1907 Schiele moves into his first studio in Vienna II, Kurzbauergasse 6. Personal acquaintance with Gustav Klimt. Journey to Trieste with his sister Gertrude.

1908 First participation in a public exhibition in the Kaisersaal at the convent of Klosterneuburg (May–June). He is represented by ten works.

1909 In April he leaves the Academy. Founds the "New Art Group" ("Neukunstgruppe") with other students. Participates in the "International Art Exhibition", Vienna 1909, with four pictures. In contact with Josef Hoffmann and the "Viennese Workshop" ("Wiener Werkstätte"). In December the "New Art Group" has its first exhibition at the Pisko Gallery in the Schwarzenbergplatz. On this occasion, Schiele meets the writer and art critic of the Workers' Journal (Arbeiter-Zeitung), Arthur Roessler, who introduces him to the collectors Carl Reininghaus and Dr. Oskar Reichel and to the publisher Eduard Kosmack.

1910 As a result of negotiation by Josef Hoffmann, Schiele exhibits a picture in the "International Hunting Exhibition" in Vienna. On the occasion of an exhibition at Klosterneuburg in the autumn of this year, Schiele meets the civil servant and collector Heinrich Benesch.

1911 First collective exhibition at the Miethke Gallery in Vienna (April–May). Sets up a studio at Krumau, his mother's home-town. Lives with the model Wally Neuzil. In August, he moves to Neulengbach. Contact with the Munich art-dealer Hans Goltz. In November, Schiele becomes a member of "Sema", an artists' club in Munich.

1912 Exhibition with the "New Art Group" in Budapest. The Goltz Gallery in Munich puts on show works by Schiele, together with some by artists of "Der Blaue Reiter" group (February 15 till March 15). Exhibition at the Folkwang Museum in Hagen (April–May). Schiele's first lithograph, a nude self-portrait, appears in the "Sema Portfolio". On April 13, he is arrested at Neulengbach, and later transferred to St. Pölten, where he is sentenced to three days' imprisonment for the dissemination of indecent drawings. After 24 days' imprisonment in all, he is released on May 8. Journey to Carinthia and Trieste. Brief use of the studio of his friend, the painter Erwin Dom Osen. Takes part in the exhibition in the "Hagenbund" (July) and meets the restaurant owner and collector Franz Hauer. Journey to Munich, Lindau, Bregenz and Zurich. In the exhibition of the "Sonderbund" in Cologne, Schiele shows three works. In October, he moves into a studio in Vienna XIII, Hietzinger Hauptstrasse 101, where he remains for some years. At the turn of the year, he stays at Györ (Raab), as the guest of the family of the industrialist August Lederer.

1913 Schiele becomes a member of the "Association of Austrian Artists" and exhibits with them in Budapest (March). Collective exhibition at the Goltz Gallery, Munich, and in other German cities. Journeys to the Wachau, Krumau, Munich, Villach, and other places. In July, is the guest of Arthur Roessler at Altmünster on Lake Traun. In August, at Sattendorf, on Lake Ossiach. He works for the Berlin periodical "Die Aktion".

1914 In the "C R. Competition—Works of Painting" at the Pisko Gallery Schiele shows his picture "Encounter", but the prizes go to Anton Faistauer and Albert Paris Gütersloh. He exhibits also outside German-speaking countries: in Rome, Brussels and Paris. He learns the techniques of graphic art and makes six etchings. The photographer Anton Josef Trčka takes a number of expressive portrait-studies of Schiele. On December 31, a collective exhibition of Schiele's work opens at the Arnot Gallery in Vienna (ending on January 31, 1915).

1915 Exhibition of his works at the Kunsthaus in Zurich. On June 17, marriage to Edith Harms; on June 21, called up for military service in Prague. After a period of training at Neuhaus in Bohemia,

he is employed in and around Vienna on office duties and escort duties with Russian prisoners of war.

1916 Exhibits in the "Viennese Art Exhibition" in the Berlin Secession, among others. From March 8 till September 30, Schiele keeps a war diary. At the beginning of May, he is transferred to the prisoner-of-war camp for officers at Mühling, near Wieselburg, and works in the catering office. He is given a studio and the opportunity to pursue his artistic career.

1917 Schiele is posted to the "Royal Stores Office for the Employees of the Army in the Field", which is headed by First Lieutenant Dr. Hans Rosé; the latter commissions him to record in drawings the head office in Vienna and the affiliated depots throughout the monarchy. To this end, Schiele undertakes journeys to the Tyrol with his superior, Karl Grünwald (June–July). At the end of September, Schiele is assigned to the Army Museum in Vienna. Takes part in the war exhibition in the Kaisergarten (the "Prater"), and also in exhibitions of Austrian art in Amsterdam, Stockholm and Copenhagen. The plan to found a work-team "Kunsthalle" remains unrealized. He works on the Viennese periodical "The Beginning" ("Der Anbruch").

1918 On February 6, Gustav Klimt dies. At the 49th exhibition of the Viennese Secession in March of this year, the main room is placed at Schiele's disposal. The exhibition, for which he also designed the poster, is a great artistic and material success. The "Society for Graphic Art" wants to publish a lithograph by Schiele in this year's portfolio, but the two he submitted ("Portrait of Paris von Gütersloh" and "Recumbent Nude Girl") are found unsuitable and are rejected. On July 5, Schiele moves into a second new studio in Vienna XIII, at Wattmanngasse 6. His wife Edith, who is expecting a child, dies on October 28 from Spanish influenza. Three days later, on October 31, Schiele himself falls victim to the epidemic.

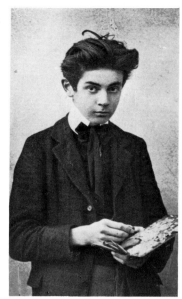

Egon Schiele with palette, 1906

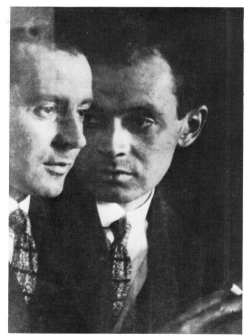

Egon Schiele, Double Portrait (double exposure)

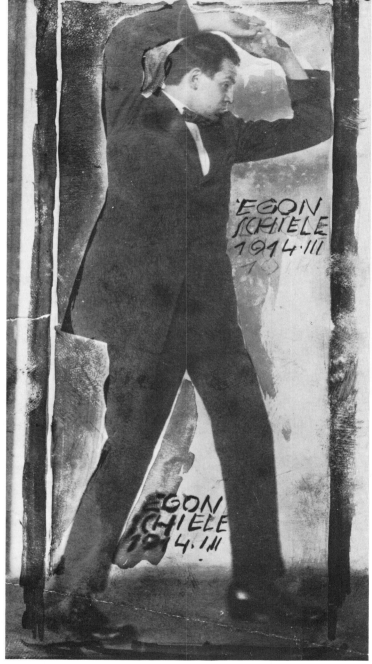

Egon Schiele full-length with raised arms, 1914

10

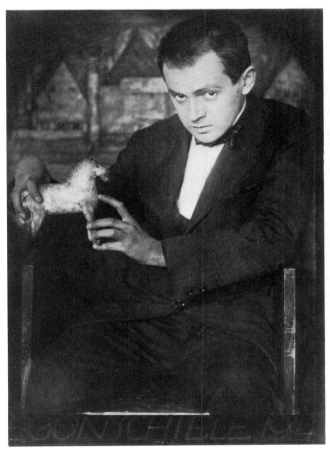

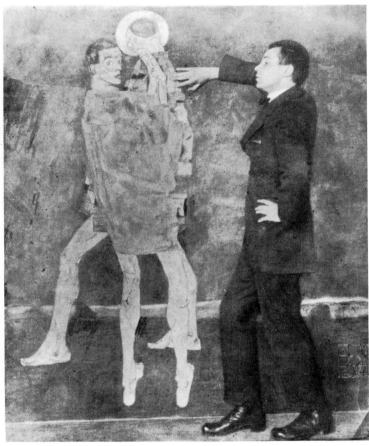

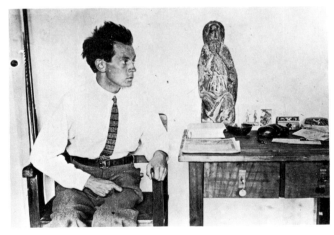

Egon Schiele with toy horse, 1914
The horse appears in several of the painter's works
In the background, the painting "Row of Houses"

Egon Schiele in front of his painting "Encounter", 1914
Signed and dated in the plate by the photographer Anton Josef
Trčka: Ant Jos 1914

Egon Schiele in his studio in Hietzing, 1915

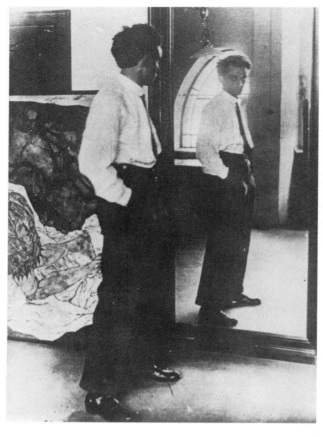
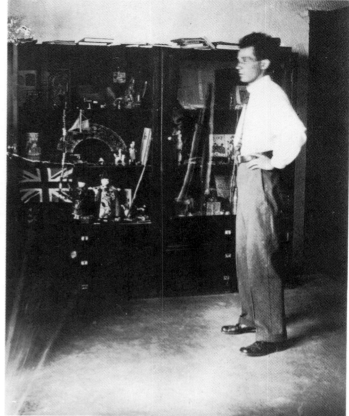
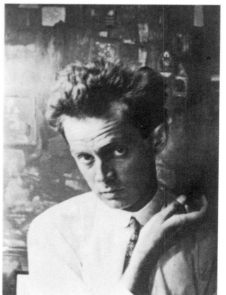

Egon Schiele standing before the mirror, 1915
In the background, his painting "Death and Girl"
(cf. pl. 59)

Egon Schiele with his collection, 1915
The cupboard contains toys and works of folk-art, and
also a copy of the almanach "Der Blaue Reiter"

Egon Schiele in front of his painting "Woodland Prayer", 1915

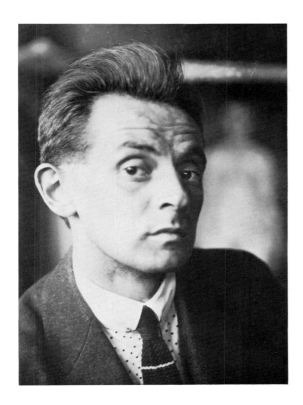

Egon Schiele, 1918

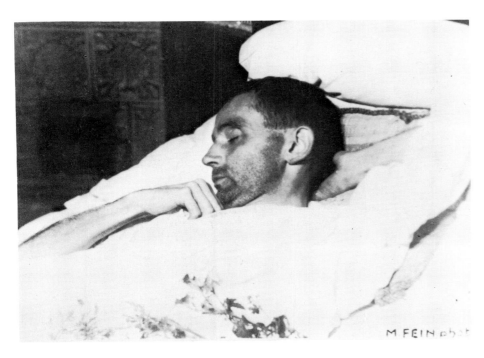

Egon Schiele on his deathbed

13

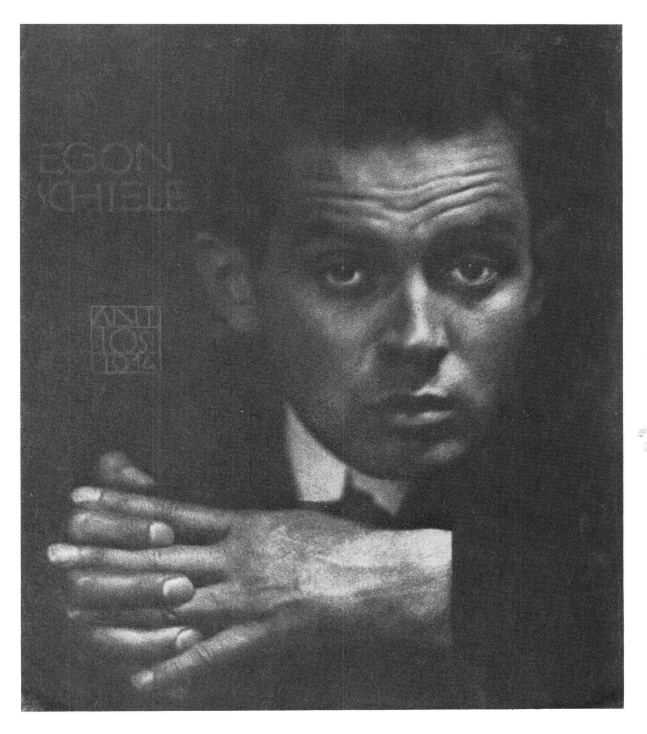

Egon Schiele, 1914
Signed and dated in the plate by the photographer Anton Josef Trčka: Ant Jos 1914

INTRODUCTION

In the preface to the catalogue of the 1912 Exhibition in Cologne, which was one of the great, important events in the history of expressionism, it is stated that the exhibition "is intended to offer a general view of the newest movement in painting, which has succeeded atmospheric naturalism and the impressionist rendering of motion, and which strives after a simplification and intensification in the mode of expression, after new rhythms and new uses of colour and a decorative or monumental configuration—a general view of that movement which has been described as expressionism. The younger artists of almost all civilized countries of Europe have become part of this movement . . . While this international exhibition of works by living artists attempts to give a cross-section of the expressionist movement, a retrospective section will highlight the historical foundations on which this very controversial style of our time is based: the work of Vincent van Gogh, Paul Cézanne, Paul Gauguin . . . And let everyone who has experienced for himself the burning passion in the bold brushstrokes of Van Gogh and the brilliant luminosity in his areas of colour, the dreamlike stillness and unique poetry of colour in the work of Cézanne, the fairy-tale peace of Gauguin, let him then visit, in the Wallraf-Richartz Museum, the Old Masters of this city, and he will be astonished to discover how old are the ancestors which the modern movement recalls, how many bonds link the most recent painting with this flowering of medieval art".[1]

Some essential characteristics and principles of expressionist art are indicated in these few sentences, though no attempt is made to explain or define them comprehensively. The choice of artists and works to be exhibited was not always completely happy, and there were definite omissions as well as sure appreciation. Thus the importance of the Norwegian Edvard Munch was fully understood, and a room was devoted to his works. They were the great attraction, for Munch had already become a classic, the leader of a new generation.[2] On the other hand, one looks in vain, among the forerunners of expressionism, for the name of Toulouse-Lautrec, who had died in 1901 and whose work, as we know today, was of decisive influence. Of the Austrian artists contributing to the exhibition, those given the most space were Oskar Kokoschka, with six paintings, and Egon Schiele with three.[3] Gustav Klimt, the dominant figure in Viennese art around 1900, whose work engendered both enthusiasm and opposition at the time, was not represented. His work reveals considerable tendencies of an expressionist nature, particularly around 1909–10, and the tragic seriousness in the paintings "Old Woman" and "Mother and Children" has often called forth a comparison with the art of Schiele.[4] These paintings do constitute exceptions, however, and Klimt's work was even then considered the consummation of an epoch which was already passing away.

The new generation of artists was shaped by a new intellectual climate. The call for inherent truth and simplicity in art was becoming increasingly distinct and compelling. As early as 1895, Tolstoy had complained, in his essay "What is Art?", that art had become a lie of aesthetes and was serving only as entertainment.[5] Tolstoy was not alone. The aesthetes' paradise gardens, sheltered from reality and cultivated, as it were,

in a hothouse, were clearly beginning to wither and decay. Beauty as a refuge and a moral code subordinate to it were an obviously insecure basis for coping with a life fraught with problems and fears. As the catastrophe of the First World War loomed more threateningly, the illusions dissolved the more. In Vienna, the capital of a monarchy heading for its downfall, and later described by Karl Kraus as a "research station for the end of the world", these developments had particular significance. The atmosphere of insecurity and menace sharpened the perception of the symptoms of the ills of our existence, and it was surely not by chance that psychoanalysis had its beginnings in this city. The revolt against the rationalistic, positivist outlook of the middle-class and its moral code was extremely violent. In Robert Musil's first novel, "The Confusion of the Pupil Törless", which appeared in the progressive "Wiener Verlag" in 1906, there is the remarkable sentence about those "aesthetically intellectual souls who find reassurance in the observance of the laws and perhaps also, in part, of public morality, because they are thus raised above having to think about anything crude, anything that is far removed from the finer spiritual happenings . . ."[6] The dark powers of the soul, lying beyond the threshold of consciousness and not comprehended, but only divined, were given absolute precedence over factual knowledge and rational discernment. A positivist psychology, believing in its ability to explain everything, was met with the deepest mistrust. Reason and willpower, and a system of values based on them, were overshadowed by the discoveries of the uncontrollable subconscious instincts in man. However, a strong emphasis on the spiritual, visionary side opened the way towards the realms of the metaphysical and religious, even though interpreted in a very subjective way.[7] In his book, "Expressionism", published in 1916, Hermann Bahr has given an impressive portrait of that age: "Never was there a time shaken by so much terror, such a fear of death. Never was the world so deathly silent. Never was man so small. Never had he been so alarmed. Never was joy so far away and liberty so dead. Now necessity cries out: Man cries after his soul, and the whole age becomes a single cry of need. Art, too, cries with it, into the depths of darkness; it cries for help, it cries after the spiritual: that is expressionism."[8] The cry became a metaphor for the distressed state of human existence. Once the belief in a divine world-order had been shaken, men began to experience a profound feeling of being abandoned, coupled with that fateful, unbounded subjectivity that relies almost exclusively on the primary authority of the ego. The consciousness of being helpless, homeless, provoked a state of fear, one of the most important basic experiences of the expressionist generation. Fear is indissolubly tied up with the question of the meaning of life, which also represents the central concern of psychoanalysis.

The problems were not new, but in the first decade of this century they took on an unexpected urgency. In the visual arts, the definite recoil from the excessive refinement of the "Jugendstil" (art nouveau) led to a particular regard for originality and to a primitivism, which seemed desirable because it led back to original sources. The significance ascribed to folk art, to the child's world of experience, or to the results of ethnography, spoke in clear terms. The basic attitude, proletarian and frequently comprising critical involvement in social matters, turned for preference to social outsiders of all kinds and colours. Expressionism is centred radically on man, and dedicated to the idea of humanism. The realization that the stylistic methods used in the past were inadequate for tackling the new tasks and aims inevitably brought about a revolution in artistic form too. "Necessity creates form", Kandinsky had postulated in the almanach "Der Blaue Reiter", which was practically a manifesto of expressionism. He thereby clearly defined the

relation between content and form.[9] The spiritual intention has absolute precedence over an optically exact rendering of nature, which provides the artist only with the raw material for the representation of his own visions.

Oskar Kokoschka, who was then working in Vienna, was a pioneer in these methods. His 1910 exhibition at Cassirer's in Berlin became a landmark in expressionist art.[10] But the illustrations he had made in 1907 for his poem "The Dreaming Boys", evocative of the fairy tale and the folk-song, already show the germs of his future development. Some drawings in Indian ink made shortly afterwards point even more clearly in this direction. In "Woman and Child Riding on a Doe", the whirling motifs, thorn-like spikes and line patterns reminiscent of barbed wire intrude a disquieting, threatening element into the idyllic theme. They culminate in the deep-wounding strokes used in the illustrations for his drama, "Murder, Hope of Women".[11] In these works, a novel expressionist style asserts itself, fundamentally different from Klimt's sensitive style of drawing, which scanned the subject and transcribed it impressionistically. It could reach to deep-lying, common areas of experience, and yet at the same time embodies the artist's highly personal desire for expression. Kokoschka's art of portraiture was revolutionary and particularly important for the expressionist imagery of man. The portrait of Father Hirsch, created under the strong influence of the Van Gogh exhibition of 1906 at the Miethke Gallery in Vienna, in which 45 of the master's works were displayed, attempts to penetrate the outward appearance, through to the depths of the human psyche.[12] It stands at the beginning of a series of unsparingly analytical pictures, which were decisive in establishing Kokoschka's early fame. This laying bare of the inner structure with the painter's brush has been compared to surgical operations with a scalpel. Similar comments have been made with regard to the writings of Arthur Schnitzler, and this was not surprising in an age which pursued the discovery of the soul with an almost scientific detachment. Gustave Flaubert, the greatest psychologist among nineteenth-century authors, had been portrayed in a doctor's coat in a caricature.[13] In the context of Austrian art, however, the picture is particularly revealing. With this "getting under the skin" in the truest sense of the word, which stripped man of his skin, laid bare layers of muscles and nerves and attempted, with the aid of "clinical evidence", to attain to a synonymous expression for spiritual states, the realistic approach so deeply rooted in Austrian art asserts itself. Kandinsky went another way: that of abstraction. But how far the conceptions of their aims were alike is clear from Kandinsky's statement that artistic abstraction is tied up with man's apparently new capacity to break through the skin of nature and to make contact with its essence and content.[14]

These introductory observations touch only upon some aspects of expressionism and naturally simplify the problems. However, they point to some important ideas underlying the art of Egon Schiele and should prove a useful background for the following interpretation.

Egon Schiele was born on June 12, 1890, at Tulln on the Danube, a little town near Vienna. From his mother's side, he had Bohemian blood in his veins, whilst the ancestors of his father, who himself was born in Vienna, had had their home in Protestant North Germany. The self-revealing and uncompromising nature of Schiele's art and the intensity of its statements may have had some roots in this background.[15] In the autumn of 1902, Schiele became a pupil at the secondary school in Klosterneuburg. Ludwig Karl

Strauch, drawing-master at this institution from 1905, Max Kahrer, a Klosterneuburg painter, and Dr. Wolfgang Pauker, an Augustinian canon and art-historian, became aware of his talent and recommended artistic training. In September 1906, Schiele passed the entrance examination for the Academy of Fine Arts in Vienna. He joined the painting-class of Christian Griepenkerl, a conservative artist rooted in the tradition of historicism, who had been a professor at the Academy ever since 1874. Growing tensions between teacher and student finally led to Schiele's leaving the Academy of his own free will in April 1909. With like-minded colleagues, he founded the "New Art Group", which came to public notice for the first time in the winter of 1909–10, with an exhibition at the gallery of the art dealer Pisko in the Schwarzenbergplatz. By that time, Schiele was no longer an unknown. In the big "International Art Exhibition, Vienna 1909", he had been represented by four paintings and was already being discussed by critics with much abuse and slander. A meeting with the art critic and writer, Arthur Roessler, on the occasion of the exhibition at Pisko's, was to be important for his future. Roessler became a strong champion of Schiele's art, to which he dedicated himself with both word and deed throughout his life.

These biographical notes cover the period in which the early work of the artist was developing. Schiele already belonged to a generation whose impressions were formed from the beginning by "modern" art. Historicism had been defeated on the decisive fronts. Frequent exhibitions promoted international contacts and an exchange of new artistic ideas and advances. In 1905, the Viennese Secession, founded in 1897, had had its first deep breach, caused by the withdrawal of Klimt and his group.[16] The reason for this lay in commercial and artistic disagreements, but it was also obvious that membership was no longer felt to be so necessary as in the great days of unanimous struggling towards the accomplishment of common artistic ideals. What they had fought for had become common property and had been accomplished on the broadest basis. Schiele's questing and groping beginnings took place in the rich spectrum of post-impressionist stylistic trends. One of the earliest proofs of his artistic ability is a small picture of a courtyard at Klosterneu-

Fig. 4 burg, painted on cardboard. It is dated 6. IX. 06 and was therefore executed immediately before Schiele entered the Academy. The colours are partly applied with a brush and a spraying-mesh, a technique at that time particularly favoured by dilettante artists, who translated the pointillist idiom into a method suitable for craftsmen. The view depicted was chosen with regard to a strong, unified pictorial composition. This youthful work must certainly not be overvalued, but the distinct feeling for balance and tectonic values that is announced in it was to remain an important characteristic of Schiele's later work. Stylistically related is a painting of the following year, "Path along the Kierling Brook", which also has a subject from

Fig. 6 Klosterneuburg. The steep perspective leading into the depth and the graphically detailed beating of the waves against the stakes on the sloping bank are completely in the taste of Secession art. These characteristics

Fig. 7 are more matured and even more marked in a very similar composition, "Sailing Ships in Trieste Harbour", whose charm lies above all in the graphic mastery of the complicated arrangement and criss-crossing of masts and rigging, mirrored in the waves as very calligraphically conceived ornamental bands. The picture was painted in 1907, on Schiele's first visit to Trieste, and initiates a series of studies of ships made 1907–8. But he was to turn to this theme again in 1912, when he made splendid drawings and water-colours of

Plate 34 ships and fishing-boats in Trieste, and also of a paddle-steamer lying at anchor at the quay on Lake Constance.[17]

20

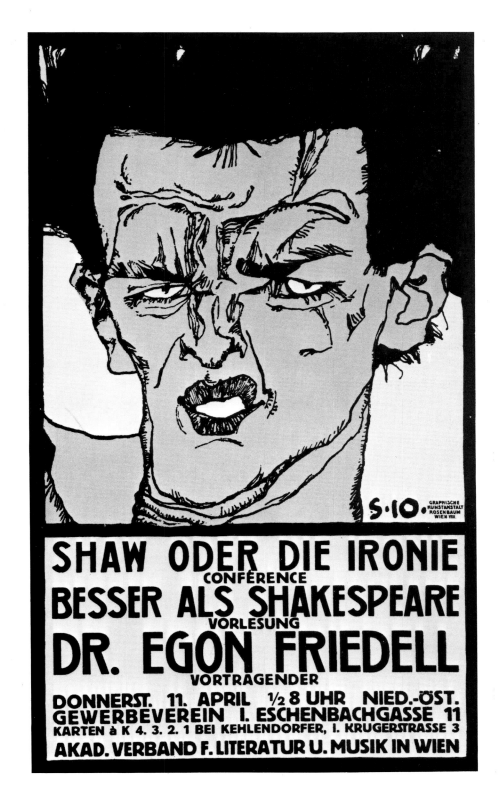

POSTER FOR THE LECTURE
"SHAW ODER DIE IRONIE" (Shaw
or the Ironic) GIVEN BY DR. EGON
FRIEDELL 1912
Printed by Graphische Kunstanstalt
Rosenbaum, Vienna
Based on Schiele's self-portrait of 1910
(pl. 13)

The other important component of Schiele's art—powerful, pathetic explosions of feeling, often discharged in dynamic, excited brush-strokes—is lacking in these works, but it is also found as early as 1907, in
Fig. 5 tentative form, in a series of landscapes. In the "Autumn Landscape", there is little peace, harmony or solidity to be felt: the whole surface of the picture conveys a sense of movement and unrest through the violence of the brush-strokes.[18] In 1910, this dynamism, now developed into a colourful maturity, was to assert itself strongly and could be held in check only as a result of his knowledge of pictures by Secession artists.

Parallel with the landscapes goes Schiele's preoccupation with the human figure, a subject in which his art was able to express itself particularly strongly and convincingly. The study of a male nude dated
Fig. 2 20. XI. 06 may have been drawn at the Academy. The atmosphere of the life-class is vividly conveyed by
Fig. 1 a photograph taken at about the same time, where Schiele can be seen among his fellow-students, in front of the living model. Whilst the latter leans on a stick, the figure in the drawing is leaning on a scythe, and this may be interpreted as a concession to the contemporary requirement for meaningful content. The strong contrast between light and shade seems to recall indirectly the effect of artificial lighting. The broad sweep of the shadows, executed with the brush in Indian ink, separates light and dark areas one from another, and at the same time emphasizes the anatomy of the body. The flat areas and ornamental tendencies of "Jugendstil" art are strongly in evidence. Many comparable and closely-related examples of such treatment are to be found in "Ver sacrum", the periodical published by the Secession artists.[19]

Fig. 3 A study of a nude young man with a child in his arms, made two years later, conveys an entirely different impression. Regarded stylistically, the date of 1908 may, in the first instance, give surprise, yet this particular drawing proves how far Schiele had advanced as a student at the Academy, how much his power as a draughtsman had increased. The figure is captured in space with the greatest subtlety and the light is rendered in the finest gradations. Whilst the man's back, which is turned towards the area of shadow, is drawn with powerful, suggestive lines, the child's head and arm are immersed in a dusky half-light and, in this allusive rendering, are only divined rather than perceived.[20] Schiele did not continue on this track. In 1908, the very year which offered so many artistic possibilities, he began more and more to search for a style of his own. The two versions of his "Water Sprites" are examples of this development. At the same time they are important documents in Schiele's dialogue with the art of Gustav Klimt.

Fig. 8 The first version, dated 1907, is connected in its composition with Klimt's painting of "Water Snakes",
Fig. 9 which was begun in 1904 and re-worked in 1907. Schiele took over the basic idea of horizontal figures gliding along between glittering lights, but for the rich luxuriance of ornamentation and the harmonious lines of enchanting sensuality he substituted an almost wooden, arid sobriety. Even if one takes into consideration Klimt's quite inimitable mastery and perfection—the fruit of a long development—the difference can finally be explained only by a fundamentally different intention. The three girls' bodies are formed without noteworthy individual differences, and are almost identical in silhouette. Between the two figures lying one over the other, there are additional regular correspondences. Their arms are bent at the same angle as well as symmetrically related to each other like reflections in a mirror, and it is of little formal significance that the upper arm of either girl corresponds to the lower arm of the other. The criteria of parallelism and eurhythmics, so characteristic of the ornamental nature of the "Jugendstil",

and which mark the compactness and ordering towards a centre, determine the composition. The heads, with their luxuriant, flowing hair, are brought together into a strip which lies exactly at the centre of the picture and opposes a static, vertical weight to the horizontal flow of the lines.

These features, which were entirely characteristic of the "Jugendstil", were transcended in the second version of "Water Sprites", dating from 1908. Despite the retention of the most important figures, the effect has been radically altered. The formal interplay of the two figures has been dissolved and their original, static function changed into a dynamic one. The upper figure is not only set back, but is assimilated to the one on the far right by means of the arm bent back at a right angle, and is brought into continuous contact with her. The result of this new constellation is a greater intensity of the movement towards the right. This is further accelerated by the tapering, wedge-shaped area of the background, which draws the figures into an eddy. The newly added ornamentation of horizontal stripes and arrow-like zig-zag lines also accents this sense of direction.[21]

The changes in the outlines of the figures prove to be just as significant as those in the composition. The sequence of predominantly concave components meeting at their sharp points produces an entirely new feeling of strong tension, which, however, is completely at the expense of the figures' organic structure and plasticity. They look as thin as leaves, like cut-outs, against a background that has also lost all spatial depth.[22] The lights, previously floating in space and mysteriously blinking, are now forced into a circumscribed area, as if caught in a net. The sensuously swelling, life-giving line of Klimt has been turned into its opposite, and implies the idea of death and transitoriness. The picture is therefore nearer in effect to Klimt's "Procession of the Dead" of 1903, with its emaciated, skeletal forms.[23] But whereas the form there had an iconographical function, in Schiele's work it has become an element that shapes his style and permeates all the themes and objects.

A sense of measure and formal discipline is also conveyed by the "Standing Woman in a Long Cloak" of the same year. The colouring, reduced to monochrome tones, is reminiscent of Rodin; the fine curling lines of the hair recall "Water Sprites II", and are still found in works by Schiele dating from 1910.[24] The pattern of the dress, with vertical rows of dots and short, closely-spaced horizontal strokes, which themselves often end in thicker dots, is of particular delicacy. A row of schematic, oblique lines indicates the rounding of the body in an abstract fashion. This ascetic nobility, achieved with the greatest economy of means, is of a different order from that of Klimt and can be considered the very personal expression of the young Schiele's art. This impression is confirmed in looking at the paintings which Schiele exhibited in the 1909 "International Art Exhibition" at Vienna. In the exhibition catalogue, four of his works are listed, without any further information: "Young Girl"; "Portrait of the Painter G. (sic!) Massmann"; "Portrait of the Painter Peschka" and "Tide of Youth". The last-named picture is lost.[25] Hans Massmann and Anton Peschka, who was later to become Schiele's brother-in-law, were fellow-students at the Academy and members of the "New Art Group". The composition of the two portraits is similar: the sitters are shown in strict profile, sitting in an armchair, against a patterned background parallel to the picture surface.[26] This type of portrait was taken over from Klimt, and harks back further, to Whistler.[27] It concentrates on a detail view, and is found once again in the crayon drawing of the composer Löwenstein, also dated 1909. The painting of the "Young Girl" has been identified as a likeness of Schiele's younger

Plate 1

Plate 2

Fig. 12

Plate 3

Fig. 13

sister, Gerta.[28] It has undergone some changes by overpainting and restoration, particularly in the background, but the figure itself has remained relatively unchanged. The dark silhouette shape, bounded by a curvilinear, undulating white, is very close to the portrait of Massmann and shows a high degree of simplification, tending towards abstraction. The buttons on the coat are rendered as light-coloured, circular blanks, whilst the agitated, three-dimensional pattern of the scarf is rendered like rings, with which the hands seem to juggle. In the same year, Schiele created a second portrait of his sister, which is even more strongly related, with its bizarre angular contours, to the style of 1908.[29] The picture was very carefully prepared in a crayon drawing, but it differs from this in one important point, hitherto overlooked: Schiele had his model sit squarely on the back of an armchair, and, by means of this vertical gradation of components, he achieved a tower-like composition, which cuts through the whole length of the square-shaped picture. On account of this change, Schiele felt compelled to change the original patterned wrap of the sitter into a dark, homogeneous area, in order to obtain a contrast with the extra depth.[30] The fragmentation of the figure into distinct areas contributes towards clarifying the relation of form and space without striving for illusionistic effects. The unusual relationship between the figure and the shape of the picture intensifies the emptiness of the background and removes the figure, who has her eyes closed, into an imaginary realm beyond the frontiers of experience. The brittleness of the forms recalls the autumnal impermanence of the withering "Chrysanthemums"[31] or of the "Sunflower", whose leaves hang, rigid in decay, on the weak, wilting stems as on strings. The tall, narrow format of this latter picture, not unlike the edging of a tapestry, was popular with "Jugendstil" artists on account of its eccentricity, and was especially favoured for book illustrations.

Schiele's development up to this point rested undoubtedly on the art of Gustav Klimt, with which there are numerous points of contact. On the other hand, an analysis of Schiele's works shows that he looked upon his great model in a very independent manner, which clearly foreshadows his future expressionist direction. For this, moreover, there seems to have been one active influence which has not in the past been sufficiently considered: that is the Viennese School of Applied Art and the impulses emanating from it. Klimt himself was a product of this institution. After a thorough reorganization, Felician Freiherr von Myrbach, a founder-member of the Secession group, was installed as its principal in 1899, and the staff soon included some of the leading artists of the time, among them Josef Hoffmann, Kolo Moser, Alfred Roller, Carl Czeschka and Berthold Löffler. This roll-call already reveals the close connection with the "Viennese Workshop", which was founded in 1903 by Josef Hoffmann, Kolo Moser and the banker Fritz Waerndorfer, and was exercising an increasing influence on Viennese art. Together with the Klimt group, which had broken away from the Secession, it organized in 1908 the first art exhibition, which had set itself the aim of presenting—according to the opening speech of Gustav Klimt, the president of the exhibition committee—a "review of the forces shaping Austrian artistic life, a true account of the present state of culture in our country".[32] The exhibition building, designed by Josef Hoffmann, was built in the Schwarzenbergplatz and was used again in the following year, 1909, for the "International Art Exhibition", before it was pulled down to make way for the new Viennese Concert Hall. In the 1908 art exhibition, works of the young Oskar Kokoschka could be seen for the first time. He had been a student at the School of Applied Art since 1905, and was soon to become the "enfant terrible" of Viennese art. In 1907 he was

Plate 4

Plate 5

24

already working with the "Viennese Workshop", which also brought out his poem and series of lithographs "The Dreaming Boys" as a book in spring 1908. The headpiece of this work—dedicated respectfully to Gustav Klimt—is related to Schiele's picture "Water Sprites II", in the sharpness and hardness of its ornamentation.

By contrast with the Academy, which clung more closely to tradition, the School of Applied Art had become an up-to-date, modern educational institute for budding artists. It is certainly an irony of fate that Schiele was originally to attend this institute, but was recommended for the Academy on account of his great talent.[33] In 1908, however, the time had become ripe for him to leave the Academy, as happened shortly afterwards, in April 1909. Personal acquaintance with Gustav Klimt, who had become his real master even while he was still at the Academy, had certainly contributed to this decision.

The School of Applied Art was not only a rallying-point for the great names who were important in the development of modern art in Austria: its original purpose made it also an important contributor to the development of expressionism. Posters, whose first great master had been Toulouse-Lautrec, require an economical, condensed formal language and an over-emphatic underlining of the message. To succeed in their aim, they have to obtrude themselves on the spectator's attention like a blow, and force him to respond. Indeed, they often became daring.[34] This was also the case with many of the drawings made for half-tone illustrations which enjoyed a wide circulation.[35] The affinity between many of the drawings of Olaf Gulbransson, who was then working for "Simplizissimus", and some drawings Schiele made in 1908–9 is very striking. Both artists used the same suggestive line and exploited the empty areas in the same significant way in producing a visual effect. Caricature had an especially important role in this connection, as its very nature is to accentuate certain aspects by means of deliberate exaggeration. Its function as a point of departure for expressive composition has long been appreciated; one has merely to mention the name of Lyonel Feininger. Its influence was also of importance for Schiele's art. In a self-portrait by Schiele, dated 1909, a comic-caricatural undertone is clearly perceptible in the gestures and attitude, and also in certain costume details.[36] The general appearance of the figure and the bearded face recur, slightly modified, on one of Schiele's sketches for a postcard, showing two men standing on a high pedestal. This group is a variation on one of Oskar Kokoschka's lithographs for "The Dreaming Boys", and has been plausibly interpreted as representing Klimt and Schiele.[37] This homage to Klimt is couched in the artistic idiom of the younger generation, which was well aware of how much it owed to this great master, but nevertheless went its own way. This led from the aestheticism of the "Viennese Workshop" to the forms characteristic of expressionism.

The year 1910 marked a decisive turning-point in Schiele's work and the real breakthrough into expressionism. The twenty-year-old artist was seized by a creative urge of eruptive power, bordering on obsession, and his work was permeated by the force of his personality as never before. The conspicuous features are directness and spontaneity, an uncompromising disregard for himself and a fanatic search for truth, unchecked by any other consideration. This development did not proceed in a straight line and did not entail an abrupt break with the past. Instead it rested on the basis of Secessionist art, which penetrated to the surface again and again, and was able to reassert itself. At times the process can lead backwards, but it can also produce those stylistic tensions which form an essential part of Schiele's

Fig. 10

Fig. 11

expressionism. There is a case to be made for defining his style as an expressionist transformation of Secessionist art.[38] How strongly the traditions of the latter influenced him is obvious from a painting he exhibited in the art pavilion at the "First International Hunting Exhibition" of 1910 in Vienna. Although it has been lost, a photograph of the exhibition room and an extant study for it give a sufficient idea of it:

Fig. 20

a seated nude girl, frontal view, with the right arm extended and bent at the elbow. The extreme length of the arm is the result of formal and aesthetic considerations.[39] The finished picture, unlike the sketch, was of square format. Josef Hoffmann, who arranged the exhibition, was probably responsible for this, for his idea of the "total work of art" required an architectonic fusion of exhibition-room and paintings. It is significant that all the paintings had the same title: "Decorative Panel". The high point of an exhibition design of this kind was the display of Max Klinger's statue of Beethoven in the Viennese Secession in 1902, also arranged by Josef Hoffmann. For it Klimt had created his celebrated Beethoven frieze which, with the exception of the later mosaic decoration for the dining-room of the Palais Stoclet in Brussels, offered him the only opportunity to carry out his ideas for large-scale frescoes. Schiele probably saw the frieze, which was later removed from the Secession, and must at least have known the sketches for it.[40] The thin, elongated figures with their bony limbs produced a strong echo in his works. Klimt himself, when he developed this fresco style, was influenced by the works of the Belgian sculptor George Minne. The kneeling figures in the part of the frieze called "The Longing for Happiness" are very closely related to the famous fountain which Minne created in 1906 for the Folkwang Museum at Hagen. Its elongated figures, reminiscent

Fig. 33

of Gothic sculpture, seem to anticipate Lehmbruck's "Kneeling Woman" of 1913. The model for this fountain dated from as early as 1898, and was exhibited in the Secession in 1900.[41] A model for one of the kneeling youths came into the possession of Carl Moll, the Viennese painter and member of the Klimt group, and occupies a prominent position in his "Self-portrait in the Studio", painted about 1906.[42] On the occasion of the eighth exhibition in the Secession in 1900, there appeared an informative report by Ludwig Hevesi, the art-critic and chronicler of the Viennese Secession: "George Minne carries off the prize for novelty. We see here the circular fountain which made him famous and notorious a few years ago . . . Minne's eye is like those distorting-mirrors in which the human form appears to be long and thin. The five men who kneel on that fountain's edge and stare down into the holy water are like Christian fakirs. No such lean, bony, angular, ascetic figures have been carved since the Middle Ages. These human beings consist mainly of reedy bones and atrophied muscles. Only with such emaciation as this is it possible for a man to embrace himself, like these poor people. Indeed, they can reach everywhere with their hands, even across to their own shoulder-blades . . . And yet they are not caricatures. In these pitiful figures there is a fervour, a spirituality such as has not been portrayed again until our own days . . ."[43] Despite the gentle mockery this is an apt description, and suggests that Schiele must have been fascinated by Minne's art. Minne, probably the purest "Jugendstil" sculptor, is especially close to Schiele in the restraint and lyricism of his feelings, and in the austere, yearningly extended slenderness of his figures. If Minne's sculptural forms receive linear accents from strictly contained, ornamental contours, the broad outlines of Schiele's drawings in turn convey material volume and spatial relationships. Later on we shall have to deal again with the relation between the art of sculpture and Schiele's drawing style. Here we only

Fig. 31

refer briefly to a drawing done the following year, 1911, a nude study of a young girl, whose flowing,

undulating contours are tensely accented at the knees, hip-bones and shoulders. The drawing suggests the budding of the young, ripening body, "the poetry of undeveloped limbs, the elasticity of innocent flesh", as Maier Graefe expressed it so vividly in "Pan", speaking of the work of Minne. In 1910, indeed, Schiele still used more strongly expressive accents. They prove that he pursued his own intentions and assimilated artistic stimuli in a completely free and independent manner. In a study of a female nude, he used one Fig. 21 of Minne's favourite motifs, that of the arms crossed on the breast; but the expression of absorbed contemplation has given way to a chilling withdrawal, an isolation. The colours are exaggerated expressively and congeal like patches of blood; the right arm appears to be an amputated stump. It is not clear whether Schiele concealed the hand by bending it sharply (as in the later painting), or has intentionally omitted it. This kind of cutting short has something so final about it that the imagination of the spectator is not allowed to supply what is not shown. Whilst the face is fully shaped by means of precise delineation and bold foreshortening, the body itself appears remarkably flat and insubstantial. Crossed by abstract lines, it looks as if it were composed of a number of strips. Its contours hardly undulate at all, but are drawn as parallels; the arms are laid one across the other like ribbons. The drawing served as a study for a painting, now lost, which belonged to a series of four large nude studies in square format.[44] The most mature and interesting of them represents a seated male nude. As so often, Schiele omitted everything extraneous and allowed Plate 6 the human body to speak for itself through its attitude and posture. Hence the figure is not shown resting on a seat, but seems to be floating quite autonomously in an abstract space. An extremely oddly-drawn contour, which emphasizes the shape of different areas, contrasts with the highly plastic articulation of separate parts of the body. The ribs arch out plastically from the chest, the hip-bones stand out like cornices and one has the impression of being able to take hold of the corded muscles in the legs, which are almost abnormally tensed. The strong, beam-like right arm laid in front of the face yields quite surprisingly to the weight of the bent head, and the nose is deeply buried in it. (An arm crossing the face is a frequently recurring motif in Schiele's work; it appears in the nude for the 1910 "Hunting Exhibition" and is still to be found in his late period.[45]) The jagged form of the raised left arm, with its peculiar metamorphosis into a plant-shape, is to be compared, as a shape, with the withering leaves of the sunflowers. (A similar deformation can also be seen in the wrists in the portrait of Poldi Lodzinsky.) The organic unity of the Fig. 19 body is destroyed through these contrasts and it is split up into discrepant and conflicting parts. They become reflections and visible expressions of inner spiritual forces and reactions. How important the language of the body had become, as a medium for conveying expression, can also be seen in a few portrait studies of Schiele's friend, the painter Dom Osen. When placed together, these drawings form a series Figs. 15–17 which basically offers variations on the same visual theme. But at the same time they convey the impression of a temporal sequence, of a movement split up into separate phases.

The genetic root of this method goes back to the Impressionists. An unbiassed, completely unacademic way of looking at subjects led, in the art of Edgar Degas, to a deeper knowledge of the structure and movement of the human body. Rodin is said to have sketched hundreds of particular positions of the body from a moving model—a practice which Gustav Klimt, too, is reported to have adopted.[46] The distance between the immediacy achieved by this method and the finished, "meaningful" work became greater and greater. Rodin, inspired by Gothic art and Michelangelo, aimed at profound significance and emphatic

effect, and thus he was a forerunner of expressionism.[47] His masterpiece, "The Burghers of Calais", attains its concentration, its expressive character and its psychological tension by means of an exactly conceived form, which excludes everything that is fortuitous. Even though, at the artist's wish, the group was placed amongst the living on the pavement of the Place d'Armes, it still retains its unshakable monumental character. It was these static and monumental qualities that "Jugendstil" art was striving after around 1900. In Schiele's portrait studies of Dom Osen, the organic rhythm of movement is suddenly disturbed and interrupted: the poses have become stiffened and frozen, reminiscent of the emphatic language of gestures in pantomime and dance, which played such important roles in expressionism. The relationship with the theatre is also confirmed by the inscription "Mime van Osen", which appears on one of the drawings. But the impression of mechanical motion also conjures up the idea of marionettes and puppets,

Plate 13 which are operated from the outside. A self-portrait that must date from late in the year goes even more decisively beyond the Dom Osen drawings. Mime and theatrical gesture have been exaggerated to abnormal tensions which are no longer subject to the will and cannot be controlled by it. Ferdinand Hodler understood, as did only few artists at the beginning of our century, how to saturate his forms with elementary power. With Schiele, this movement halts and congeals as if in a spasm. The greyish green shades of paint, mixed with "syndetikon" glue and put on with broad brush strokes, and speckled—particularly noticeably in the region of the heart—with brilliant red patches, give the skin a hardened, crust-like appearance. It encloses the body like a suit of armour, behind which life appears to be beating and knocking against its curb. The body as a strait-jacket and prison for the soul and mind is a common theme of the expressionists. Delivered over helplessly to mental anguish, it utters an uncontrolled scream.[48] The expressive head is

Fig. 25 reminiscent of the water-colour of the "Mischievous Woman", a psychological study which is pushed to the bounds of caricature, and which reveals its derivation from the art of Toulouse-Lautrec.[49] Apart from these studies of expression, Schiele now turned also to the true portrait, which attempts to catch the essence and uniqueness of a personality and throw light on its most hidden depths. Oskar Kokoschka had done pioneer-work in this field. His art influenced Max Oppenheimer, a Viennese painter who is, unjustly, almost forgotten today, and who portrayed people famous in Viennese cultural life as early as 1909; among these were the composer Schönberg, the pioneer of twelve-tone music, and the writers Arthur Schnitzler and Peter Altenberg.[50] Schiele and Oppenheimer were friends, shared the same studio, and painted portraits of each other. A likeness of Schiele executed by Oppenheimer in 1910–11, formerly in the Arthur Roessler collection, has a special claim on our interest, because it presents Schiele as he was seen by another artist.[51] A drawing in the Albertina shows Oppenheimer with his arm stretched out, but incomplete,

Fig. 14 possibly in the act of wielding the brush. The pale colour of the face, rendered as a bright yellow, and the agitated silhouette show—by comparison with the "Portrait of Gertrude Schiele I" of 1909—the step made towards expressionism.

In 1910, Schiele devoted himself largely to portraiture. The suggestion that he paint life-size portraits of well-known Viennese personalities came from the great architect Otto Wagner. This project foundered,

Fig. 27 and even the portrait of Wagner remained unfinished. Independently of these, however, Schiele painted several important portraits, of which those of the art-critic Arthur Roessler and the publisher Eduard

Plate 11 Kosmack may be singled out. In the "Portrait of Roessler" a compositional relation to the great nude

28

pictures of the first half of the year can still be discerned. As in the painting of a "Kneeling Male Nude", one leg is sharply bent aside and the head is turned in the opposite direction.[52] Further contrasts are provided by the hands, which are arranged in parallels with the fingers spread out. This system of contrary motion leads the spectator's glance uneasily back and forth, though in strictly determined paths. The principles of abstract zig-zag ornaments seem here to have been applied to the human form. The large aureole enclosing the figure has an independent formal value as in works by Klimt. In the "Portrait of Eduard Kosmack", such considerations of form are pushed into the background. What strikes the spectator Plate 12 first of all is the hypnotic power of the eyes, which blaze forth from a body already threatened by decay. This impression is strengthened by the magically luminous halo surrounding the silhouette of the head. The pressure of space weighs down on the figure, and the few vertical brush-strokes in the background strike a harsh note. The figure is withdrawn into itself and dried up like its attribute, the sunflower beside it. One is tempted to assume that the picture was influenced by Munch's "Puberty",[53] but it should be borne in mind that Schiele's preparatory study is almost completely devoid of these expressive qualities: Fig. 24 the overpowering spatial effect, the concave sweep of the form and the concentration bordering on rigidity are still lacking. Our glance remains focussed on the pupils. Comparing the study with the picture, one is tempted to speak of a natural attitude and a lack of tension. The observation that the legs are not pressed tightly together, but are separated by a narrow space, is of some importance in judging the relationship to Munch.[54] Related to this picture is another portrait study of Kosmack, probably dated 1911 by Schiele Fig. 23 at a later date. Here the sitter is resting his left hand on his knee, whose rounded shape is plastically rendered by the curved spread of the fingers—a way, characteristic of Schiele's art, of suggesting corporeal and spatial volumes. This accounts also for the fact that one shoulder is pushed so far forward, but it should be noted in passing that this latter motif, which occurs frequently in Schiele's works, is also to be found in Oppenheimer's 1909 portrait of Schönberg, "as if he were bidding defiance to the world".[55]

The many studies relating to these two portraits make it clear that Schiele was an untiring draughtsman of life. He was always seeking new ways of revealing its secrets. An incorruptible eye and the ability to adapt optical impressions immediately to a two-dimensional surface, and to invest them with tectonic strength and compositional firmness, are here combined in a masterly way. The "Three Street Urchins" Plate 10 are captured on paper with the immediacy of a photographic snapshot. The different ways of using the pencil result in a graphic variety, ranging from a deep blackness applied with the point to a broader, duller, more painterly effect. The relatively ample thickness of line defining the subjects creates harmony between contours and interior detail, and produces spatial effects and painterly values of an impressionistic character. The spontaneous way in which Schiele has captured the nature and temperament of these lads and their proletarian, coarse, work-worn grown-ups' hands, is consummate. His children belong to no "paradise" created by adult nostalgia and sentimentality. They are considered seriously and fully as human beings, and not infrequently are already marked by life's hardships, its temptations and its vices.

The rich painterly style employed here, which sometimes dispenses with contours and suggests space and masses simply by a very bold use of colour,[56] gave way, at the end of 1910, to a more economical use of line. "Schiele Drawing a Nude Study in front of a Mirror" is an early example of the drawing style he Plate 15 used in the following year. The composition is of a transparent clarity, although the subject is more

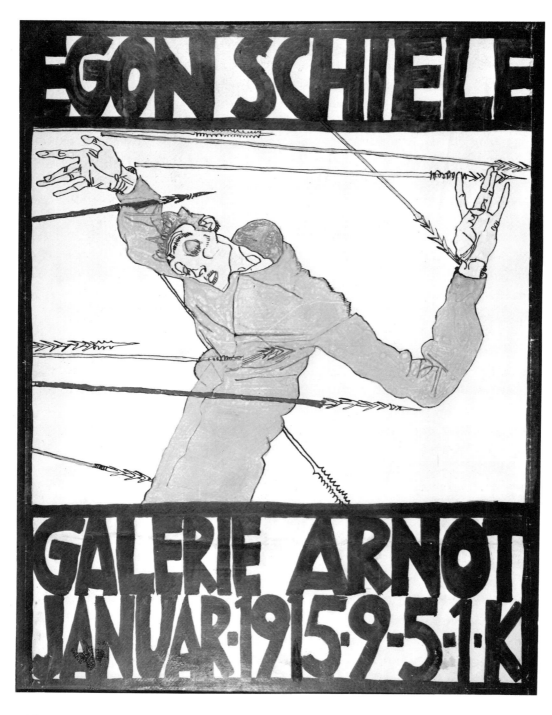

POSTER FOR THE EXHIBITION IN THE ARNOT GALLERY 1914–15
Indian ink and gouache. 67 × 50 cm
Historisches Museum der Stadt Wien, Vienna

complicated than the group of three street urchins: Schiele shows himself drawing a female nude from the back, and at the same time seeing a front view of himself and the model in the mirror.[57] This use of the mirror has the "mannerist" effect of compressing the space, yet the dynamism resulting from the diminution in the size of each successive figure is largely counteracted by their strong link with the plane surface. The plane of the drawing-paper and the surface of the mirror appear to us to coincide optically, and the clarity and precision are greater in the reflected image. The diagonal lines lead the glance automatically to the artist's eyes, in which all the attention of the searching draughtsman is concentrated. Their contrast with the duskily veiled eyes of the model hints very discreetly at the contrast between the sexes. A breath of worldly elegance and notoriety of the "femme fatale" is discernible. It is not unlikely that the model was the dancer Moa, whom Schiele drew several times in 1911. This is suggested by the similarity to a Plate 16 drawing, also in the Albertina, which is entitled "Moa".

Among the important elements in Schiele's work of 1910 were a newly-achieved direct relation to nature and a deeper knowledge of the great pioneers of modern painting which goes far beyond the "Jugendstil". In his reactions to these primary sources, Schiele developed his own expressionist idiom, which is by no means limited to the rendering of emotion. Much more characteristic is a very close link with the art of symbolism, which, filtered through his own experience, marked Schiele's work decisively.[58] The self-portrait with the hand touching the cheek seems to conform to the iconographic tradition of the "Man Fig. 28 of Sorrows", which goes far back into the Middle Ages. The profanation of religious themes and scenes is a frequent phenomenon in expressionism. In the humanist art of the sixteenth century, Dürer chose a similar gesture for his famous self-portrait drawing now in Erlangen, on which he later based his painting of "Christ as Man of Sorrows", in Karlsruhe.[59] Schiele's portrait is unusual in that the hand pulls the cheek down, and thus splits the face into two unequal parts.

The monologue of the self-portraits continued throughout 1911. There was now a new accent on weariness and melancholy, resignation and submission, which also pervade the picture characteristically entitled "Lyricist". The pathos of revolt has faded into weariness and submission; the cry of affliction is followed Fig. 35 by an exhausted collapse. The body is forced into the narrow shape of the picture, the position of the head, which is strongly inclined to one side, seems enforced by the top edge of the canvas. The frame has become a prison from which there is no escape. The bared parts of the body are rendered as abstract zones, which traverse the picture diagonally, but are placed, like the hands, at right angles to each other. In another self-portrait from this period, Schiele's figure appears like an erect pole, with the centre of the body again Fig. 34 bared as an abstract rectangular zone. It surrenders itself to the spectator without making the least offer of resistance. The eyes are opened wide in fear and terror, as if awaiting the death-blow. Three years later, Schiele depicted himself on an exhibition-poster as St Sebastian, pierced by arrows.[60] Of particular importance for Schiele's involvement with symbolism is the "Self-portrait with a Black Vase". The vase, Plate 23 whose sculptured wall consists of three overlapping faces, came from the artist's studio and is still extant. In the picture, it is assimilated to Schiele's own portrait by a heightening of the forehead and is thus given a direct relationship with it.[61] The artist's head, turned sharply to the front and most intensely alive, has a shadowy Janus-face seen in profile. Gauguin had also used the unusual oblong shape for his "Self-portrait with Yellow Christ", painted around 1890.[62] Here, beside his own likeness, he painted a container shaped

31

like a human head; this was his tobacco-jar with his self-portrait, now kept in the Louvre. It is presumably the same jar about which Gauguin wrote, in a letter to Madeleine Bernard: ". . . It represents something like: the head of Gauguin the savage." The painted self-portrait and the jar do not have so close a formal connection as in Schiele's picture. Nevertheless, we are justified in wondering whether these repeated and extremely unusual correspondences between the two works occurred by chance or show that Schiele knew the work by Gauguin.[63] Gauguin's feeling for plastic, tactile qualities, which are harmonized with balanced, rhythmically organized planes, has clear echoes in Schiele's picture.

Plate 14 Symbolism is as strongly marked in other paintings of this period as in the self-portraits. At the very end of 1910, Schiele took up a theme, in his painting of the "Dead Mother", which had been of importance for other artists of recent times, for instance Klinger and Munch. It derives its moving realism from the idea of the great forces of life and death, growth and decay. Schiele's composition is of a fascinating density and compactness.[64] The two obliques of the mother's head and hand, parallel to each other, enclose a round shape approximating to a circle. In it the child is placed at a right angle to the mother. Its form, enclosed by wavy lines and standing out box-like, is hard to define objectively.[65] It certainly brings to mind the thought of life unborn, still sheltered in the mother's womb. The child radiates an inexplicable brightness, shines out like a star in the darkness of the night. The effect of the picture derives entirely from the contrast between life and death. The used-up, withered body of the mother, sallow and bony, is contrasted with the new life of the child, just developing itself. Its body is still unformed. The hands are marvellously rendered: their framework of bones is still undeveloped, and the amorphous fingers are, as it were, hung on the palms—a shape repeated in a portrait of a boy drawn in 1911.[66] This important picture also exercised a strong influence, in conception and composition, on later works by Schiele: the "Birth of Genius" of 1911[67]

Plate 37 and a gouache drawing of 1913 which has been identified with a "Holy Family" mentioned in Schiele's lists of his works.

Plate 27 In the picture of a "Pregnant Woman and Death", painted in 1911, the idea of birth and death is again taken up and given a new formulation. In contrast with Klimt's "Hope", it is not envious, malevolent ghosts which here threaten the pregnant mother, but Fate, approaching in the noble form of Death personified.[68] The solemnity and awe-inspiring meeting of these two life-forces convey the atmosphere of a holy rite. The monk-like head of Death is disembodied to a skeleton by the garment laid over its shoulders. Powerful lines, like the leading in Gothic windows, divide the picture into geometric areas. The "cloisonné" style of Gauguin and the Pont Aven School is transformed by the expressionist generation into a mystical Gothicism, and the colours are strengthened and given a glowing luminosity. The brightest light is concentrated in the pregnant body of the woman, which shines like the sun in mediaeval representations of the Visitation. Light must here be understood metaphysically, not as illumination, just as the colours are not intended to describe objects, but to stimulate feeling and emotion. The artist himself has given an interpretation of his symbolist ideas in a letter of September 1912: "The picture must radiate light, the bodies have their own light which they consume to live: they burn, they are not lit from outside."[69] These words are also a key to the understanding of the "Dead Mother". The same mystical Gothic light is to be found in a picture entitled "Madonna", in which these metaphysical tendencies are most strongly in evidence.[70] This style manifests itself especially impressively in Schiele's water-colours, which reached

a culmination in 1911. In the drawing of the artist's mother, sleep does not mean peace and relaxation, Plate 26 nor wandering into the subconscious regions of the dream, but a deathlike withdrawal that approaches the bounds of eternity. Many works of this period are characterized by the search for unshakable rules, which are not subject to hazardous chance and are able to express something like "absolute truths". In the lively portrait of two little girls, they consist in the contrast between types and temperaments, which are Plate 21 rendered with an incomparable power of characterization; in the water-colour of "The Brother", in the Plate 25 compact combination of a strict full-face and a profile view, and the symmetrically frame-like disposition of the arms.

If nature, in the true romantic manner, had often been the vehicle for the artist's feelings and moods in 1910, he now used it more and more to convey his most intimate thoughts and private visions. The picture "Dead City", a variation of a water-colour dating from 1910, shows a view of Krumau, seen from Plate 19 the Schlossberg. The group of houses is enclosed on three sides by a deep-blue background symbolizing the Moldau, and they seem, in their isolation, to be floating in an indeterminate, abstract space—a "still life" emerging like a vision from the darkness. The moonlike light gives to the colours a fluorescent splendour and illuminates the pale, ivory housefronts in a ghostly way. The "Autumn Trees" of 1911 have been Fig. 32 connected (with reference to the 1912 painting of "Calvary") with the three crosses on Golgotha. Such a comparison was suggested by the pyramidal arrangement of the trees and the almost identical formation of their sparsely-leaved tops. Schiele had already depicted the crucifixion of Christ in the traditional iconography in 1907. Important suggestions for that early work may have come from a picture by the Munich "Jugendstil" painter Franz Stuck, which shows not only similarities in the composition and in the form of Christ, but also has the motif of the darkened sun.[71] Whether this interpretation of the "Autumn Landscape" is justified can hardly be conclusively decided. Parallelism—an endeavour to achieve an impression of unity by means of repetition—and also the subordination of individual forms to one type and a concern for a rhythmic cadence in the composition—all these were in any case already qualities characteristic of the "Jugendstil", and they continued to play an important part also in Schiele's work. There is hardly any doubt, however, that the numerous landscapes with trees dating from this period also have an anthropomorphic character, and symbolize human destiny. It can also be symbolized by inanimate objects which are owned by a man and accompany him through life: Van Gogh painted an old pair of shoes or a simple chair to suggest human misery and destitution. We have already, in the introduction, briefly indicated the importance of the 1906 Van Gogh exhibition in the Miethke Gallery in Vienna for the development of Austrian expressionism. But it was the 1909 "International Art Exhibition" which was of decisive importance for Schiele's knowledge of Van Gogh's art. It must have been a revelation to the nineteen-year-old, who had just begun to discover his artistic individuality. In Room 14 of the exhibition, there were eleven of Van Gogh's paintings on show, among them the "Bedroom in Arles" of 1888, which was later to come into the possession of the Viennese collector Carl Reininghaus and is today in the Chicago Art Institute.[72] Schiele certainly had this picture in mind when, in autumn 1911, he painted his room Plate 22 at Neulengbach, where he had moved from Krumau shortly before. As well as obvious parallels between the two interiors, there are also marked differences, which underline the individual approach of each artist. Schiele's picture lacks the steep perspective leading deeply inwards and the dynamic qualities of expression

connected with this. It is significant that the corners of the room are largely omitted and the floor is rendered as an area of flat colour. In place of dynamic lines which emphasize direction, there is a juxtaposition of well-ordered areas. This gives the simple room a harmony, typical of the style of the Secession, which also finds expression in such details as the decorative pattern of the bedcover and cushions. The black-painted bed, with its front board standing on the floor, reminds one, despite its shabbiness, of the furniture made by the "Viennese Workshop". Among the objects in the room that attract attention, there are, apart from a few painting utensils, a picture on the wall, obviously by Schiele himself, and some brightly coloured plates with folk-art designs. The Secession's achievement lay between the art of Van Gogh and that of Schiele.

Plate 7 In this context, Schiele's gouache, "A Field of Flowers", dating from 1910, is also instructive. The technique of this painting approaches that of Van Gogh, but while the latter uses the brush boldly and impulsively like a reed-pen, here a more ornamental result is achieved by restraint and deliberation.[73]

The first months of 1912 were an especially fruitful period in Schiele's life. In addition to a considerable number of landscapes and portraits, he created several figure compositions, which continued the symbolist

Plate 29 tendencies already referred to. Among the most important paintings of this kind are the "Hermits" and "Cardinal and Nun". The "Hermits" can be identified as Klimt and Schiele, and the painting takes up an idea he had already used in the post-card sketch. But now he was no longer thinking of a monument, and the static effect is replaced by a transitory moment. That was the really new pictorial motif, and proved to be indicative of the future: it is that which Schiele, on being reproached that the stance of the figures was not clear, justified in a letter to Carl Reininghaus. In it, Schiele speaks of the bodies of men of sensibility, "... figures like a cloud of dust resembling this earth and seeking to grow, but forced to collapse impotently".[74] Seldom has the human body been visualized so exclusively as a materialization of spiritual forces as in this picture. It is not their own inner stability that holds the figures upright, but a spatial support beyond their limits which stays and upholds them. Abstract lines at their left serve as supports and complete the construction of the composition to form a pyramid.[75]

Schiele had made intensive experiments with pyramidal composition since 1911. It also provides the formal

Plate 30 basis for the painting "Cardinal and Nun", which can be considered as an expressionist paraphrase of Klimt's famous "Kiss".[76] Klimt's picture dates from 1907–8 and was painted entirely in his decorative style, with its rich, golden touches. The "firmament" of his golden background, which seems to disclose unending areas of space, is replaced, in Schiele's picture, by the impenetrable darkness of night, and the festive, variegated glow has given way to a chord of red and black, the colours of love, ecstasy and death. An oasis of blissful happiness is invaded by the uncontrolled forces of blind passion and excitement, which bind the figures together fatefully. Munch had already interpreted the relations between the sexes as "urges" in his "Dance of Life" (1899–1900). Schiele now gave this interpretation a robust popular element, and over-accentuated the articulation of movements and gestures, which are doll-like and almost wooden. A grotesquely daring undertone emerges, too, in the masquerade costume and in the expressive exaggeration of naked legs and feet. The short, shirt-like garment ending above the knees—which had already appeared on a kneeling figure in Rudolf Kalvach's poster for the 1908 "Art Exhibition"[77]—was later often used by Schiele.

The tragic time of Schiele's imprisonment[78] began on April 13, 1912, when he was arrested on a charge

34

of attempting to abduct a minor, a young girl in Neulengbach. On April 30, he was transferred to the prison of the district court at St. Pölten. Although the charge turned out to be unfounded, he was sentenced to three days imprisonment for disseminating indecent drawings and endangering public morality. After an imprisonment lasting twenty-four days, he was released on May 8. Whilst on remand in Neulengbach, he produced several drawings with water-colours, some of them self-portraits that belong with the most moving documents of his life. They are all exactly dated to the day, and have memorable, strongly suggestive titles. "To Confine the Artist Is a Crime, It Means Murdering Unborn Life", he wrote on the earliest Fig. 37 self-portrait, made on April 23, which shows him condemned to inactivity, lying on a plank-bed. A year earlier, Schiele had painted a picture, closely related to the "Dead Mother", with the title "The Birth of Genius", and it does not seem too far-fetched to suggest an analogy between the life unfolding in the mother's womb and the ripening idea of the artist which strives to be realized.[79] The inscriptions on the other three self-portraits—"I Love Contrasts", "Prisoner", "I Will Gladly Endure for the Sake of Art and My Loved Ones!"—are also full of expressionist pathos and we can feel, bearing in mind his recent Fig. 39 work, that they come from the depths of the artist's personality.

Seven other drawings, made before these self-portraits, treat the prison cell in the style of a still life, but differ noticeably from each other in their approach. To begin with, Schiele explored and recorded his new surroundings, and tried to find his bearings. The inscriptions on the drawings accompanying this process are couched in symbolistic language. On one of an orange on a bedcover: "The one orange was the only light"; on a view into the prison corridor, with brooms: "I feel not punished, but purified!"; on one of the prison door: "The door to the open air!". In this last drawing twigs in spring leaf with birds perched on them are visible through the bars. The mood is here related to that of a drawing of 1912, "Young Trees in Spring", which gives expression to hope and anxiety in its gentle fragility.[80] The next four drawings record only the chairs in his cell and his small possessions—a jug, stockings, handkerchiefs.[81] One of them, which depicts two chairs and the stove in the prison-cell, bears an inscription of profound intuition and timeless validity: "Art cannot be modern, art is timeless". More difficult to interpret is the inscription "Organic Movement of the Chair and Jug". The two objects are brought into a complicated spatial Fig. 38 relationship, the artist hesitantly feels his way, by using guidelines, into the depths of space.[82] By contrast with the static qualities of the "Jugendstil", expressionism has predominantly dynamic stylistic tendencies, which naturally assign an important role to the phenomenon of motion. The significance that can be given to this may be illustrated by a passage from one of Schiele's letters, dated August 25, 1913, to the Viennese collector Franz Hauer: ". . . At present, I am mainly observing the physical motion of mountains, water, trees and flowers. One is everywhere reminded of similar movements in the human body, of similar impulses of joy and suffering in plants . . ."[83] Schiele's painting of 1912 which has become known under the title of "Autumn Tree in Movement" is also filled with motion. The tree-trunk, bent in mighty curves, Plate 33 and with its richly-twigged branches stretched out wide, sets the whole picture in vibrating restlessness. In the years 1911–13, Schiele had, after a long interval, turned once more to the intensive creation of landscapes with trees, a theme that appealed strongly to his symbolist leanings. Over some of them shines the last glimmer of autumn; others are already gripped in the stiffness of winter frost. For the most part, they are young saplings still in need of support, which are exposed to the cold and the raw air of the climate, Plate 32

and raise their tops from the bare earth into a gloomy sky. Our tree bears about it the undeniable traces of a struggle with merciless storms. Bent and bruised, with its trunk dressed with lime and its twisted branches, it offers defiance to all threats. It is as if the characteristic which we have observed in Schiele's self-portraits emerged renewed in his pictures of trees. The title of the painting was not given it by Schiele. On the reverse, it is inscribed "Tree in Winter" in another hand, and it may be identical with a painting already exhibited in the "Hagenbund" spring exhibition of 1912, which is entered in the catalogue under the title "Trees in Winter".[84] In expression and style, it represents the development of a picture dated 1911, and was therefore probably painted in the spring of 1912.[85] As in no other work by Schiele on this subject, the whole composition is subordinated to the theme of the tree, and dominated by it. The indication of the earth is limited to two narrow strips, the fine web of lines that are the branches spreads itself over the whole surface, and is cut off on three sides by the edges of the canvas. The picturesque richly-modulated background of the cloudy winter sky forms a tight-meshed web of colour which reminds us of Cézanne. These peculiarities lead the picture to the bounds of abstraction, and invite comparison with Mondrian's pictures of trees painted between 1909 and 1912, which demonstrate the step-by-step transition from the representation of a natural impression to the autonomy of abstraction.[86] Schiele's art is a long way from Mondrian's severe compositional logic and single-mindedness, and retains a strong sensuous element, even in borderline cases such as this picture. Nevertheless it is clear that considerations of form and problems of composition were beginning to press more and more strongly to the fore. It is to these that our discussion of Schiele's middle period will have to pay particular attention.

Fig. 46 A self-portrait of 1913 formulates his new aims in an almost programmatic way. He represented himself as a crouching nude in a squatting position, kneeling with his left leg and propping himself up with the right leg. The head and torso lean far forward, both arms are bent at a right angle. This position of the

Fig. 43 body is a variation on a self-portrait of 1912, which in turn has a closely-related forerunner in another

Fig. 42 drawing of a squatting figure. With its arms pressed closely to the body, it was probably Schiele's first

Fig. 44 variation on Rodin's "Femme accroupie" of 1882, which was to inspire him again more than once in the following years. The fluid forms, suggestive of clay and earth, in these last-mentioned self-portraits underwent a radical transformation in the geometrically abstract self-portrait of 1913. A peculiar functionalism has asserted itself here, the joints look like hinges which enable the body to be opened and closed like a piece of machinery. The ribbon-like elongation and loose intertwining of the limbs hark back to works of 1910 (Dom Osen), but translate their relative flatness into the three-dimensional. A perspective which plunges boldly into the depth eliminates the extremely foreshortened trunk of the body. This approach had been

Fig. 45 anticipated in a drawing portraying young Erich Lederer, made in the last days of 1912, when Schiele had spent the days over Christmas and the New Year as a guest of Lederer's family at Györ. The near-elliptic shapes of the head and the shoulders intersect one another like the cosmic orbits of the planets. This notion was a familiar one in art at the beginning of our century,[87] and was to be even more concretely

Plate 62 expressed in some of Schiele's drawings of his sister-in-law and her nephew in 1915. The geometrization of the human form is accompanied by a change in the style of drawing. The gentle, harmoniously flowing line was abandoned in the course of 1912. We can observe this hardening and an abrupt breaking of the

Plate 35 continuity of line in a self-portrait dating from the end of this year.[88] The deliberate precision of the line

36

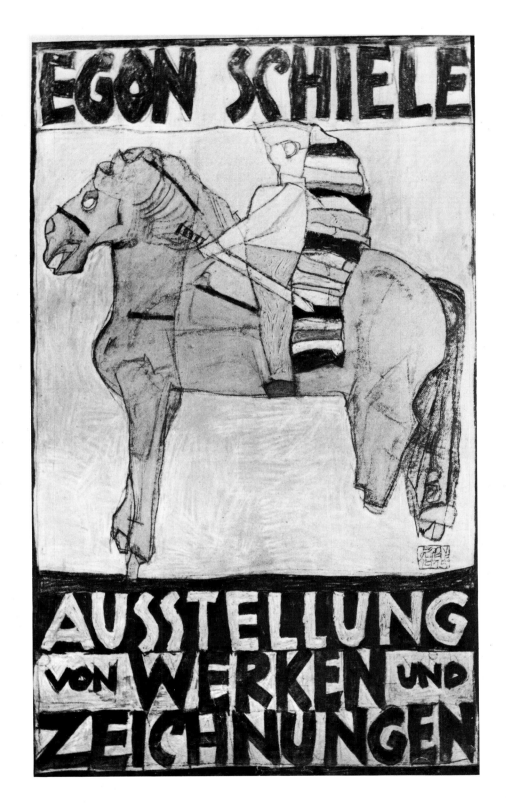

POSTER 1915
Black and white chalks, gouache.
97.5 × 60 cm
Signed and dated: Egon Schiele 1915
Private collection, Vienna

has grown, but so has its recalcitrance. Enriched by small cross-strokes and spirals, it frees itself from the
Fig. 39 flat surface and attains spatial energy. A comparison between a self-portrait made during his imprisonment
Fig. 40 and a study with a very similar composition for the "Holy Family" of 1913 shows the effect of this change.
Plate 39 In one of Schiele's most expressive self-portraits, this striving for space shows itself in a chaotic system of
strokes shooting off in all directions. A powerfully-drawn curve loads the enormous burden of the scalp
onto the much-wrinkled, prominent forehead above the raised brows. The tension of forces opposed to
each other, which can be observed so often in Schiele's work, is here employed masterfully to intensify
the psychological expression. In a sketch closely related to this drawing, the head was still upheld by the
Fig. 48 powerful support of the neck: now it is deeply bowed, and a co-ordinate system of abstract auxiliary lines
is needed to sustain it in some measure. They meet beneath the ear, at one of the most sensitive, vulnerable
parts of the head, which is fixed and made motionless by them. The eyes, which are turned on the observer,
reflect fear and helplessness, and are like those of a trapped animal.

Plate 40 Among Schiele's most remarkable and original figure compositions of 1913 is the great "Double Portrait".
It represents Heinrich Benesch, one of the earliest and most faithful collectors of Schiele's work, and his
son Otto, who later on, as an art-historian and director of the Albertina in Vienna, championed Schiele's
art wholeheartedly and contributed decisively to his international recognition. It is due to him that the
Albertina has its comprehensive collection of drawings and water-colours by the artist.[89] The painting,
which was already shown in the great Schiele exhibition at the Goltz Gallery in Munich in June 1913,
Fig. 49 was preceded by several preparatory drawings. A study for the head of Heinrich Benesch shows the already
familiar nervous style of drawing, but displays at the same time the plastic stability resulting from the
formal combination of the graphic elements. Three studies for the hands of Otto Benesch were combined
in a harmoniously balanced composition of great artistic originality.[90] Schiele inscribed this drawing with
the words "Folded Hands". This kind of title was used by him particularly frequently from 1911 to 1913,
and gives us, as a piece of interpretative evidence, an additional insight into his mind. The double portrait
of Heinrich and Otto Benesch is a masterpiece of powerful psychological characterization. The father is
seen from behind, but he looks out from the picture with a sharp turn of his head. His arm, raised like
a barrier, provides the formal link between the two figures. This important motif, apparently adopted
only in the final painting, lends the composition the firm structure of a piece of architecture. There is
Fig. 50 a comparable parallel in Schiele's self-portrait as a monk, which has survived only as a fragment.[91]
The clear tectonic structure, with an emphasis on the horizontal and vertical axes, naturally left its mark
on the townscapes of this time. The town of Stein on the Danube was the subject of four paintings in 1913.
Two of them are in small format and give views of the town in opposite directions: one from the bank
of the Danube, looking towards the terraced vineyards behind the town, the other from these downwards
in the direction of the river. They were already finished in March, and served as models for two larger
paintings, which were executed in the studio around the middle of the year.[92] Painted partly from memory
and partly based on sketches that were to hand, they often deliberately eschew topographical exactness
and use the individual motifs like pieces of movable scenery to build up the composition.[93] The large version
Plate 43 of "Stein on the Danube", which is reproduced here, does, however, keep largely to the features of the
place, apart from one or two inessential details. Near the onion-dome of the parish church in the centre,

38

there rises, to its right, the exaggeratedly high spire of the Frauenberg church, touching the top edge of the painting. The square format of the picture is thus divided into smaller areas harmoniously balancing each other. The diagonal of the mountain slope to the right is disregarded in the picture, whose background remains completely unified.[94] This severity of composition, which was connected with the expression of the monumental, particularly occupied Schiele at this time.

Plate 44

In 1913, the artist was working on his largest pictures. Unfortunately, they are lost, or have come down to us only in fragments, so that we have insufficient knowledge of them. The great masters of the turn of the century, Munch, Hodler and Klimt, had already regarded large-scale painting as the fulfilment and crowning of their endeavours.[95] Although conditions now were different, Schiele may have had something similar in mind when he set about the execution of those huge pictures without any commission or idea as to their use. In any case, his artistic development had reached that stage of maturity which enabled him to master such projects. His painting of the "Resurrection", also called "Graves", should be mentioned here, as the first of these works, even larger in size than the "Hermits", till then his biggest picture. It was exhibited as early as spring 1913 in Budapest, and years later was entitled by Schiele "Fragment for a Mausoleum" in the 1917 war exhibition in the Prater in Vienna.[96] The dead are seen rising from two coffins ranged one above the other. Three hands and a double head can be clearly made out on the upper figure, as if separate phases of rising and getting out of the coffin were meant to be represented. The picture is lost, and can be described only on the evidence of photographs. It is conceivable, however, that the colours could have assisted in solving this enigma.

There followed a huge painting, measuring 6 ft by 9 ft and entitled "Conversion, Experiment for a Mural", of which only fragments are extant.[97] Otto Benesch described it from memory as a composition with about twelve almost life-size figures.[98] As we learn from a letter written by Schiele on June 8, 1913, "the preaching godlike person", whose arms are said to have been stretched out on both sides, dominated the middle of the picture; a detail not without interest, considering the important formal function of this gesture already described in connection with the "Double Portrait". Finally, the painting "Encounter" also belongs in this context; it, too, is lost and is known only from a photograph taken in 1914.[99] Since Schiele himself appears in the photo, we can judge the scale of the figures in the picture: they were life-size. By extending his right arm horizontally, Schiele here placed himself in a formal relationship with them. The artist regarded this picture as only a part of a large composition, and had in mind a lateral extension of 15 to 18 ft. That Schiele submitted this picture for a competition promoted by the industrialist and art-collector Carl Reininghaus—though it failed to gain him a prize—, proves how seriously he took his artistic ambitions at the time.

The many drawings of "Torsos" dating from 1913 are also to be regarded in the context of monumental painting. In them he experimented with forms which are not encumbered, as it were, with psychological burdens. In the female nude with a green blouse, who seems to stride steadily forward out of the space, Plate 41 one seems to discover—and not only in the choice of the torso form—a secret link with the art of Rodin.[100] Monumental art does not—as the torsos prove—necessarily involve large format, but is an expression of artistic form. It is not surprising, therefore, that it found its most convincing realization in a comparatively small picture of 1914, the "Blind Mother". The figure of the mother is yet another variant inspired by Plate 50

Rodin's bronze sculpture of a squatting woman, which probably caught Schiele's imagination as early as 1912, and whose influence is still discernible in his later masterpiece, "The Family".[101] The fact that examples from the field of sculpture could exercise such a persistent influence on Schiele's art is explained by its close affinity with plastic form. This affinity had already shown itself early on in Schiele's reaction to the work of Minne and became of still greater importance with his progressive mastery of suggesting volume in

Plate 50

pictorial space. The "Blind Mother" was to remain his highest achievement in this tectonic rendering of the human form. The way in which individual limbs are used like building bricks, which are felt to support and to press down on each other, lend it the nature of an architectonic structure. Between the support of the legs planted at the sides, there are thrust forward the sphere of the mother's right shoulder and the heads of the two children, arranged as if hanging on a chain. The tendency towards geometrization governs the figure, from its general structure down to the smallest detail, whether it be the circular shape of the kneecaps or the semicircular hollows of the eye-sockets. The lifeless stiffness of the figure and the mask-like quality of the face produce an impression of irrevocable finality. It is the aim of symbolist art to find visual allegories for general truths, for what is permanent. Similarly the forms eschew the fleeting nature of appearances and seek what is invariable and regular. In this lies the deeper basis of all attempts at simplification and geometrization. It would therefore certainly be misunderstanding the aim behind the picture, if one were to interpret it as the expression of an individual human destiny. Its content and spiritual message go far beyond the anecdotal. Schiele's "Blind Mother" seems to be the sister of Jakob Asmus Carstens' "Night with Her Two Children, Sleep and Death".[102] The art of this great master of the late eighteenth century has also in common with that of Schiele an ambivalence of rational and emotive values of expression, and a combination of a simple, classicizing form with the profundity of the theme.

Schiele's figures of 1914 attain to a plasticity and corporeality by means of the most daring foreshortenings and intersections of forms, without thereby losing their close relationship with the plane surface. They also fulfil the function of ornamentation, which, as it was understood at the time, does not mean decoration or subsidiary embellishment, but was conceived of as a mode of expression lying beyond the imitation of nature. It should be understood in this sense when Maier Graefe, writing in the journal "Pan", called Minne's figures "sculptural ornaments", and Hevesi wrote that Munch had made an ornament out of fear.[103] Ornamental form, nature and feeling enter into a close symbiosis. A simple surface geometry in the "Jugendstil" manner is extended to a three-dimensional relief by means of stereometrically solid bodies. Even though the individual elements are tightly joined to each other, they are largely complete in themselves, and can be considered separately from the whole. In some paintings of 1914, the cube-like blocks of the houses are, as it were, attached to the horizontal strips of the landscape. The background is composed strand upon strand, like a piece of woven textile, and is given an indestructible density. In the "Houses with Coloured Washing", the separate motifs rise and fall like the heads of notes in a musical score.[104] This principle of structuring the composition like a series of strips was also used, in a modified

Plate 52
Fig. 29

form, in the painting "Windows". Its section of façades, parallel to the edges of the picture, is reminiscent of a view of the Krumau Town Hall made in 1910, but the painterly organization of the surface is now replaced by the plastically stratified depth of a relief. Between the two horizontal rows of roofs with their coloured tiles, the true life of the picture vibrates in the windows, which are shaped with an admirable

variety of forms. Their open shutters, placed at varying angles, some opening inwards, some outwards, create an area rich in movement and like a relief, and appear to lead to an unknown realm behind them.

The idea of "piercing through" a wall was further elaborated and given an interesting new interpretation in the painting "Woodland Prayer", dated 1915. Its subject is one of those popular devotional shrines in an open-air setting, such as are still occasionally chanced upon today in the surroundings of Vienna. But it will hardly prove possible to identify its exact location. In any case, as a preparatory pencil-study in one of Schiele's sketch-books shows considerable differences from the painting, it seems that the conception of the picture came to be developed and matured while he was working on it. The sketch, still in upright format, is dominated mainly by the vertical lines of the tree-trunks, which overshadow the few horizontal accents. For the picture Schiele chose an oblong format. But he did not extend the view at the sides; instead he expanded the composition of the sketch in breadth, as can be seen from the increased distance between the two crucifixes with triangular gables. An important innovation is the addition of a group of crosses with large transverse beams, which form a lattice behind the tree-trunks. The suggestion for this may have come from a sketch, "The Crucified".[105] The small religious pictures on the trees, all arranged in a plane parallel to the surface of the canvas, add up to what may be called a "picture wall", whose open-work diaphanous structure goes back ultimately to Gothic tracery. In this painting, Schiele's love for folk-art comes out very strongly and palpably. The division of the surface into small pictorial units is found in several later compositions, for example, in the gouache "Mother with Two Children and Toys", which is related to a painting begun in 1915, and in the interesting pages in his sketch-books with prehistoric motifs.

The year 1915 brought about decisive changes in the artist's life. After the final separation from Wally Neuzil, who had been his model for many years, on June 17 he married Edith Harms, whom he had met at the beginning of 1914. Four days after the wedding, Schiele was called up for military service in Prague. He served first in Bohemia and subsequently in the neighbourhood of Vienna, where he carried out administrative duties and was detailed to escort Russian prisoners of war. Many experiences connected with these events agitated him deeply and were reflected in his art, which reacted like a seismograph and must also be taken as one of the main sources for his biography. We feel we recognize in it once again a stronger, very personal involvement, and an interpretation calls certainly for the greatest discretion and restraint. Tragic isolation and loneliness, which even a physical embrace cannot overcome, is movingly depicted in two water-colours of couples of lovers. We feel the presence of death, and there is an unmistakable connection with a painting of 1915, to which Schiele gave the titles, "Man and Girl", "Embracing Couple" and also "Death and Girl". The vividly perceived connection between Eros and death takes up that variation on the "Dance of Death", which had already, in the work of Rodin and Munch, shown a woman embracing Death and surrendering herself to him voluntarily.[106] In Schiele's picture Death is no longer a skeleton, but, as in his earlier painting, "Pregnant Woman and Death", a monk-like figure in the rough habit of a penitent. The woman's arms clasping her beloved are, in part, concealed by the cowl and thus have an extraordinary suggestive power. It is tempting to compare Oskar Kokoschka's painting of "The Bride of the Wind" (1914), which can be interpreted as a hymn of love, but also as the epilogue to his love for

Plate 57

Fig. 60

Fig. 57
Plate 67
Fig. 59

Fig. 53
Fig. 54
Plate 59

41

Alma Mahler.[107] This comparison also shows, however, that Kokoschka and Schiele, who, in their artistic beginnings, had had points of contact, later took quite different paths.

Plate 58 A stylistically closely-related painting, "Levitation", must be close in date too. With its somewhat angular shapes, it is probably the earlier of the two. The figures have still much in common with the portrait of

Fig. 51 Friederike Maria Beer, which was commissioned in the autumn of 1914 and which Schiele had suggested should be hung on the ceiling. This intention of dispensing with visual direction is also one of the characteristics of "Levitation", despite the presence of a high landscape horizon. The two figures, each complementary to the other, move in a rotating rhythm reminiscent of flamboyant Gothic ornamentation. They are surrounded by a circular line barely visible in the tapestry-like background. Whilst the lower figure raises itself weightlessly from the ground with wide-open eyes and a lifelike flesh colour, the upper figure is already moving on its course—not unlike the endless, timeless gliding of the "Water Sprites" of 1907–8. The colour of its flesh is as pale and livid as that of a dead man, the eyes are tired and dull. This indicates a continuity of movement, such as the title of the work also seems to express so tellingly.[108] The suggestion for this might have come from Hodler, who had already shown a way of splitting up an allegorical representation into consecutive phases.[109]

Fig. 56 However, the remarkable double self-portrait of Schiele made in the same year has nothing to do with this problem. It is not the first example of a strange visual device, which cannot be discussed here in detail. A drawing with water-colour dating from 1913 brings together three self-portraits, and repeats the composition on the same sheet, as a small sketch.[110] Even earlier in time he had painted pictures such

Fig. 36 as the "Self-observer" or "Deliriums", which give rise to the further problem of whether Schiele saw himself as a person or as a model.[111] The combination of different views of a portrait head has a long tradition in the history of art and appears, for example, in Rodin's etching of Henri Becque (1885).[112] It occurs also in photography. There is a double portrait of Toulouse-Lautrec in a photo-montage,[113] and in the Schiele Archive in the Albertina there exists a double-exposure plate, which shows a full-face view and a profile of Schiele merged into each other. It could be a fascinating and fruitful task to consider the numerous and often artistically valuable photographic portraits of the artist, who was himself a great mimic, in their relation to his work, and to examine their range of expression.

Self-portraits of 1915 show him as an over-sensitive person filled with great nervous tension.[114] This turbulent excitement spent itself in the course of the year, and gave way to a well-balanced calmness. The union with Edith certainly helped to ease the psychological tensions; but the reasons for the profound change in Schiele's art are of a more complex nature and cannot be traced back to a single event in his life. He now looked at the world and human beings with different eyes. His art became less problematic and less troubled by tensions. An intensive observation of objective facts led to a stronger realism in artistic

Plate 61 representation. The portrait of his wife Edith shows how well he was able to combine the expression of moods and feelings with this new outlook. The studies for the portrait are, with their poetry and tenderness of feeling, among the most enchanting of his creations. Schiele painted "Diderle", his pet-name for her, full-length and life-size. The brightly-striped, colourful dress, with its unmanageable, obstinate stiffness, surrounds the figure like a bell. The awkward stance, the gesture of the hands expressing hesitancy and a shy embarrassment remind us of Schiele's early drawings of children. The face, too, betrays a childlike,

DieAktion

WOCHENSCHRIFT FÜR POLITIK, LITERATUR, KUNST
VI. JAHR.HERAUSGEGEBEN VON FRANZ PFEMFERT NR. 35/36

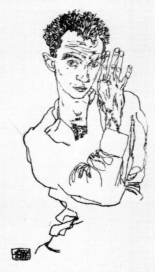

Von dieser Büttenausgabe sind 100 Exemplare
gedruckt worden. Dieses Exemplar trägt die Nummer

VERLAG · DIE AKTION · BERLIN · WILMERSDORF

TITLE-PAGE OF A NUMBER OF THE WEEKLY JOURNAL "DIE AKTION"
DEVOTED TO SCHIELE AND HIS WORK 1916
This number (VI, 35-36) contains, in addition to the self-portrait on the title-page, five other drawings by Schiele as well as the woodcut "Bathing Men". In number 39-40 of "Die Aktion" a second woodcut, "Head of a Man", was published (Kallir, "Druckgraphik", Nos. 13, 14).

moving simplicity and innocence. Just how deliberately Schiele strove to convey this impression emerges

Plate 60 from a preparatory study, in which Edith appears much more self-assured, with an open expression and her hands on her hips.

Plate 64 The portrait of Schiele's father-in-law, Johann Harms, is of a similarly moving simplicity. Painted in April 1916, it shows the same power of psychological empathy as the portraits of the Russian prisoners whom Schiele had the opportunity to draw whilst on escort duty. The sitter is placed before an empty background on a plain chair, without really occupying it. The frailty of old age is joined with the nobility of mind. His left arm rests on the arm of the chair and, together with it, forms a vertical axis, as a counter-balance to the diagonal direction of the body. It also has another function, however: as can be deduced from the lines on the floor, it marks the corner of the room. The few lines produce a composition that is masterly in its simplicity. The picture was the prelude to a series of portraits of men dating from 1917 and 1918, but none of these is so convincing in the interpretation of forms.

Plate 65 From May till the end of August 1916, Schiele was quartered at the officers' prison-camp at Mühling, near Wieselburg in Lower Austria, where he was employed in the catering office. A drawing, which is very remarkable also in its composition, records his place of work in a very matter-of-fact way. The view into the office is given across the table, which is only indicated by one edge, and on which there is a box containing various writing implements drawn with the greatest precision. Here, Schiele employed a "frame-work motif", as if he were showing the interior through a window. In order to achieve spatial clarity, he used the whole rich gamut of his graphic technique. In the following year, Schiele was commissioned as a military draughtsman by his superior, Lieutenant Dr. Hans Rosé, to record in drawings the rooms of the supply depot for the army employees in the field, in Vienna, and also those of the affiliated establishments throughout the country.[115] These drawings—intended to be reproduced in a publication that was not realized—are of a similar nature to those made at Mühling, but inferior in quality and power of expression. They are far more slick in execution and less important as works of art.

Plate 66 There is also something of the nature of an objective record about the picture of a ruined mill. According to a war diary kept by Schiele in the period between March 8 and September 30, 1916, it was begun on June 1.[116] It has rightly been said that there is something mannerist about the colour scheme, yet on the other hand there is an access of naturalistic detail and visual effects till then unusual in Schiele's paintings. Narrow slats of wood cast shadows on the bright wall in the background, the wood has moss on it, and the water rushes frothing with white foam through the decayed sluice worn down by age. Nature intrudes

Plate 68 with equal intensity in the great landscape of 1917, the "Four Trees", although its composition reveals special deliberation and austerity. The trees are ranged in a row, with an almost equal distance between them, against a background of sky divided into horizontal strips. In spite of this, there is a convincing impression of truth to nature, owing to the treatment of light and the resultant uniformity of mood. While the overcast sky absorbs the red reflections of the sun just before its setting, a dusky darkness is spreading in the foreground, and this allows the eye to find its way only with difficulty and effort.[117] By contrast to Schiele's earlier landscapes with trees it is noticeable that here none of the branches reaches near the edge of the picture, and still less is cut off by it, a device particularly favoured and widespread in the art of the Secession as a means of covering the picture surface with ornamental elements. These trees are

44

embedded in the atmosphere and wrapped in the expanse of space, which swells to romantic dimensions. How much the painting owes to Romantic art, which was always of great importance to Schiele, appears in the intensity of the light reflections and in the effect of spatial depth produced by stratified horizontal layers. In dispensing with a construction depending on centralized perspective, the picture differs essentially from Hodler's painting "Autumn Evening", of 1892, which may, however, have influenced the form which Schiele gave to the trees.[118]

In the painting "Embrace", to which Schiele also gave the title "Man and Woman" and "Lovers", the theme already treated two years earlier in "Death and Girl" reappears with a completely different accent. The picture is not dated, but it is definitely datable to 1917, on account of its close stylistic relationship to the "Recumbent Woman".[119] Comparison with a preparatory study shows how Schiele succeeded in intensifying the expression.[120] The tightly clasping arms and the positioning of the woman's hands parallel to the heads may be cited as novel elements instrumental in achieving this. The broad sweep of the woman's hair, which fills the whole upper right-hand corner of the picture, is formally balanced by the arrangement of the cloth at the opposite end of the diagonal, which traverses the whole picture. Its extremely intricate tubular folds are reminiscent of the exuberant drapery in Gothic wood-block prints of the early fifteenth century, which were particularly admired in the expressionist period.

Plate 74

In the same year, Schiele also began work on his most popular late work, "The Family". In the catalogue of the 1918 Secession exhibition, it was listed as "Squatting Couple", and the title currently in use today was given it only after Schiele's death. If it is compared with the "Lovers", which we have just discussed, we seem to notice a widening of the theme: the representation of the erotic relationship between the sexes is followed by a natural extension into the realm of the family, a consideration of the basic duties and roles of man and wife. Recent attempts at interpretation go in this direction, and the suggestion has been advanced that it formed part of a cycle.[121] "The Family" is thus a correct title, even if it has to be given a more profound interpretation than the one expressed in the widespread view that Schiele had intended to depict himself and his wife, together with their then unborn child. Such an interpretation, which is drawn from the artist's biography and embellished with sentimental overtones, has been rightly criticized. The complex composition of the painting utilizes many of his experiences of the last years. There are important points of contact with the painting of the "Blind Mother" of 1914: the bed arranged horizontally in the background and the Rodinesque posture, which has now been transferred to the male figure. The arm bent over the knee is an important innovation and so is the man's raised head, a steady, fixed point, in its axial position, of a generally restless composition.[122] The three figures are ranged as in layers, one behind the other, and are built up to the top of the picture on successively higher levels, so that the man's head reaches almost to the upper edge. The masses are carefully disposed within the group. Supported by the child's position, the woman's form is tilted slightly towards the right, while that of the man is inclined more strongly in the opposite direction. The line of his left arm, bent downwards, also follows that of the bed and of the light strip of the floor, which tapers off towards the left. The apparent instability of the group results from the fact that it is developed from the base formed by the child up to the sprawling form of the man, with his eloquent gestures reaching out into space. Life unfolds from its origins towards an ever greater complexity and exposure to danger. A similar gradation can be found in the colour scheme.

Plate 75

The striking, gaily-coloured dress of the child, in front of a similar rug, contrasts with the lifelike body of the woman, richly modelled with light before a bright background, followed finally by the yellowish discoloured figure of the man set against the gloomy background of the room. Even if the intimate human bond between mother and child is not expressly accentuated, the oval mandorla-like shape of the woman's body gives them a unity, from which the man is separated and shut out. His head, with its wakeful, questioning eyes, is raised above the horizon line into a sphere of night-like darkness. This concept of the two sexes is closely connected with that in the picture of the "Holy Family" (1913).

Fig. 58
In the last two years of his life, Schiele won recognition as a portrait-painter, and the commissions for paintings in this genre mounted up, after his portrait-studies of Russian prisoners and Austrian officers, made in 1915–16, had become more widely known and appreciated. Among the first portraits of 1917 was that of the art-dealer Karl Grünwald, who, as first lieutenant in the supplies division of the army, was Schiele's superior.[123] In its artistic conception, it follows the portrait of Schiele's father-in-law, Johann
Fig. 65
Harms. The portrait of Dr. Franz Martin Haberditzl, who, as director of the Austrian State Gallery, was responsible for the first official purchase of works by Schiele, goes one step further. The sitter is shown holding a watercolour with sunflowers, his head raised, but without looking directly at the spectator. His "aloofness" is further underlined by the portfolio of drawings in the foreground, which serves as an additional barrier. In the portraits of Guido Arnot[124] and Dr. Hugo Koller, painted in 1918, this idea is
Fig. 64
further elaborated by means of the rows of books placed in front of them. Koller sits among the piled-up books as if in a "Hortulus conclusus". As in the portrait of Arnot, the books are bound in pigskin or vellum, and the variety of their spines seems to have fascinated Schiele as a graphic pattern, while at the same time they indicate an interest in the history of the past. The sitter's bearing is easy and relaxed, but is at an angle to the green armchair. Only shortly before, such a variation of directions was incorporated into the posture of the figure itself, as in the portrait of Dr. Victor Ritter von Bauer,[125] and particularly in the
Plate 76
portrait of his wife Edith. Whilst her face, following the line of the body, looks to the right, her trunk is turned sharply to the left, so that the shoulders and arms form a distinct oval, stressing the change of direction. The portrait, painted already in 1917, later underwent thorough changes. Originally, Edith wore a bright checkered skirt, which shows Schiele's delight in ornamentation, as does the patterned
Fig. 69
slipper of a recumbent woman or his self-portrait in a checkered shirt, also dating from 1917. There is
Fig. 68
no doubt that there were definite dangers in this detailed objective rendering of ornamentation, as there was in a calligraphy of lines amounting to virtuosity and an originality of composition that was often forced and unmotivated. In 1918, Schiele overpainted the skirt in the portrait of his wife—at the desire of Dr. Haberditzl of the Austrian State Gallery, which acquired the picture in that year. The free pictorial organization of a composition became an ever more pressing concern for the artist during the period of
Plate 77
his late paintings. An example of this is the portrait of Albert Paris Gütersloh, with its restless, flickering coloured lights and the masterly brushwork of the background. Although colour and drawing are not everywhere fully integrated, Schiele obviously regarded the picture as completed, and signed and dated it. As in the portrait of Robert Müller, which is stylistically closely related to this one but remained unfinished, the sitter is depicted strictly full-face in the front plane of the picture—confronting the spectator directly.[126] The eyes are fixed compellingly on him, the arms raised as if in hieratic conjuration. The meaning of this

46

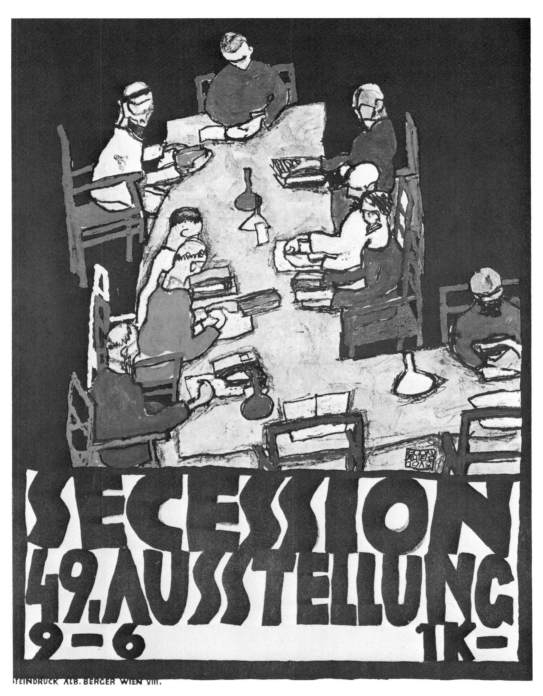

POSTER FOR THE FORTY-NINTH EXHIBITION OF THE VIENNA SECESSION, 1918
Lithograph in several colours. 68 × 53.2 cm
Printed by Albert Berger, Vienna
Graphische Sammlung Albertina, Vienna

gesture remains a mystery, and because of this it excites our attention and fascination. Arms and legs correspond to each other as with a mirror-image, separated by the symmetrical plane of the body. Schiele had already composed his 1917 painting of a "Recumbent Woman" in a similar way. The symbolic conception of the figure represents the greatest possible contrast to that of Dr. Koller. Its striving for monumentality relates it rather to the two paintings in which Schiele depicted squatting men and women in similarly archetypal images.[127]

The painter and author A. P. Gütersloh had been a companion of Schiele since the days of the "New Art Group", and had written an essay about him as early as 1911.[128] In 1917, he took part with Schiele in the wartime exhibition in the Prater in Vienna, for which they both undertook to select the works to be shown in room III.[129] These facts suggest a connection between the portrait of Gütersloh and Schiele's painting Fig. 72 "Round the Table", also called "The Friends". The latter came to light again only a few years ago, and shows Schiele among his painter colleagues and friends. Schiele himself is seated at the top end of the refectory-type table, and opposite him, at the near end, is a figure seen from behind, with a head shaved Fig. 73 like a tonsure. On a slight study for the picture in one of his sketch-books Schiele repeated this figure in a somewhat larger and clearer sketch. He also used the composition in his poster for the 49th exhibition of the Viennese Secession in March 1918, which brought him great public recognition and so became very important for him. It is remarkable that the figure with his back to the spectator is missing in the poster. It has therefore been suggested that it could have represented Gustav Klimt, who died on February 6, shortly before the opening of the exhibition, and that his seat was therefore left vacant on the poster.[130] Without going into the problem of the identity of the figure, it is worth mentioning one striking similarity with the portrait of Gütersloh, as this has never been pointed out before: in both portraits the arms are raised and the right hand is higher than the left.[131]

Fig. 75 In a preparatory study for the face of Gütersloh, drawn with black chalk, the artist varied the strength of his strokes, to make a clear distinction between the precise delineation of the plastic form and the modelling of the surface by means of light and shade. The same range of painterly values can be seen in the deeply Plate 80 moving portrait of Schiele's mother. In his last drawing, dated October 27 and 28, a portrait of his dying Fig. 76 wife, he also succeeded, by using this technique, in suggesting the fading light of the eyes, the ebbing of life. Three days later, on October 31, Egon Schiele himself fell victim to Spanish influenza.

Schiele's development as an artist took place in the space of a single decade, and even a brief survey is sufficient to show the dynamism and richness of his accomplishment. While his late work soon attracted sympathetic attention and also led to the first purchases by the State, the early works received a wider appreciation only gradually. Their expressionist pathos and uncompromising forms required greater sophistication on the part of the onlooker. A revolution in aesthetics had led to the discovery of the beauty of so-called "ugliness". Rodin once said that only that which has character, that which is able to give expression to a great inner truth, is beautiful in art: this seems no longer a paradox.[132] "Ugliness" was deliberately sought after as something novel, as a basis of regeneration with an inherent potential for new developments. This process, often to be observed in times of crisis and radical change, entailed of necessity also such a modification in the former scale of values that Ludwig Hevesi could coin a lapidary formula

48

for the realm of aesthetics: "beautiful means ugly, and ugly, beautiful".[133] It goes without saying that this redefinition of terms was not restricted to aesthetic matters alone. A whole flood of contemporary theoretical treatises deals with these problems.

Schiele scholarship, previously concerned with establishing a canon and a chronology of his works, has recently turned more and more to examining more complex art-historical questions.[134] This approach is particularly suitable for throwing his individuality and creative originality into relief, and one of its results is a new assessment of his early, pre-expressionist work, which for a long time was misconstrued as standing almost exclusively in the shadow of Klimt. In fact, it confirms that predecessors of a great artist can only nurture and bring to fruition what was there in him from the very beginning, and that a confrontation brings about, not a diminution, but a revelation of his importance. Today Schiele's art, which unites a strong realism with alienation effects resulting from his recognition of the autonomy of stylistic means, has again acquired a particular immediacy and power of conviction. The intensity of its spiritual message seems to call for interpretation, but even less can be said here about this aspect of Schiele's oeuvre than about its style, and more must be left to the perception and response of the spectator. The complexity of a work of art creates impassable frontiers which compel the interpreter to limit himself to certain aspects, but must not lead him to lapse into vagueness and hazy generalities.

An assessment of the iconographic range of Schiele's art would go far beyond the scope of this essay, yet we shall at least make mention of the very important theme of the erotic, which played such a decisive part in the arts at the turn of the century. In the visual arts we have only to recall the drawings of Beardsley, Rodin or Klimt. Schiele's eroticism has nothing in common with the decadent sensual knowingness or spiciness of the "fin de siècle". Instead it expresses human bondage and is to be understood as a burden that is painful to bear. Aimed, from the beginning, at outspokenness and truthfulness, it assumes almost inevitably a daring form. With a rare directness the barriers are removed and sexuality reveals itself nakedly and unsparingly. Along with the impressionistically sensitive eroticism of Rodin and Klimt, that of the Belgian Felicien Rops seems to have been a particularly strong influence. This artist, who had begun his career, characteristically, under the influence of those unmasking caricaturists Gavarni and Daumier, had an international reputation for his graphic works and enjoyed great acclaim in Vienna too.[135] Schiele knew Rops' work, and also referred to it. The affinity between the two artists is shown by their effective use of clothes and accessories which reveal more than they hide, and so enhance the erotic impact.

Schiele's eroticism is difficult to define. It is often accompanied by an expression of almost childlike, naïve astonishment, and can suddenly take on the nature of helpless terror and deepest despair. Many of his exhibitionist representations of himself reflect this panic and a fear that closely borders on hysteria. More and more, however, Schiele's art probes the unfathomable depths of human relationships. But his subject is neither the demonic mystery of the sphinx nor the battle between the sexes, which was waged in those years in Vienna in such a self-torturing, self-destructive way by the young philosopher Otto Weininger.[136] The man and the woman are seen as sharing a common destiny, and this makes them companions in suffering, but without relieving their loneliness. Schiele's eroticism does not exclude death. For him these two forces, which determine the human condition, are, rather, closely linked to one another. "Everything is dead

while it lives", he wrote at the time he was working on the painting "Dead Mother", in which nascent life is already wrapped in the cloak of death. The cycle of birth and death, of coming into being and passing away, is here interpreted by one whose view of the world was imbued with a profound pessimism weighed down by melancholy grief and an indeterminate longing. Being so sensitive and only slowly coming to terms with himself, the young Schiele was doubly vulnerable. This significance of Schiele's art goes far beyond the fascination of ornamental form and may well be the reason why its recognition is steadily increasing and its impact reaches ever wider circles.

NOTES

Abbreviations of books quoted in the Notes, in the List of Plates and in the captions to the text figures:

K.; Kallir: O. Kallir, "Egon Schiele, Œuvre-Katalog der Gemälde", Vienna 1966 (bilingual, English and German)

Kallir, Druckgraphik: O. Kallir, "Egon Schiele, Das druckgraphische Werk", Vienna 1970 (bilingual, English and German)

L.; Leopold: R. Leopold, "Egon Schiele, Gemälde, Aquarelle, Zeichnungen", Salzburg 1972; English edition: "Egon Schiele, Paintings, Watercolours, Drawings", London and New York 1973

Novotny-Dobai: F. Novotny and J. Dobai, "Gustav Klimt", Salzburg 1967

Wingler: H. M. Wingler, "Oskar Kokoschka, Das Werk des Malers", Salzburg 1956; English edition: "Oskar Kokoschka, The Work of the Painter", London 1958

1
The "International Art Exhibition of the Fellowship of West German Art-lovers and Artists in Cologne, 1912" took place from May 25 till September 30 in the city exhibition hall at the Aachen Gate. The preface to the catalogue was written by the executive president, the museum director Dr. Richard Reiche. A photostat reprint of the illustrated catalogue was made in Cologne in 1962 for the Wallraf-Richartz Museum, on the occasion of its retrospective exhibition "European Art in 1912".

2
Glaser, Curt, "Edvard Munch", Berlin, 1917, p. 10.

3
The following pictures by Schiele were on show: "Lady in Black", "Mother and Child", "Self-observer". The working committee for the exhibition included the painter Dr. Junk and the university lecturer on the history of art Dr. Tietze, who obviously selected the Austrian contribution.

4
Novotny-Dobai, Nos. 162, 163.

5
Tolstoy took this idea even further in his book "Against Modern Art", which appeared shortly afterwards.

6
Musil, Robert, "Die Verwirrungen des Zöglings Törless", Vienna and Leipzig, 1906, p. 248 (1st edition).

7
Hartlaub, G. F., "Kunst und Religion, Ein Versuch über die Möglichkeit neuer religiöser Kunst", Leipzig, 1919.

8
The first edition appeared in 1916, published by the Delphin-Verlag, Munich. The dedication to Alfred Roller, however, has the date "Salzburg, Ascension Day, 1914".

9
"Der Blaue Reiter", edited by W. Kandinsky and F. Marc, Munich, 1912, p. 77 (Kandinsky, "Über die Formfrage").

10
Myers, Bernard S., "The Painting of Expressionism, A Generation in Revolt", Cologne, 1957, p. 39 (with a detailed bibliography).

11
"Frau mit Kind auf Hindin reitend" (Albertina, Inv. No. 31.346). Reproduced in Rathenau, Ernest, "Der Zeichner Kokoschka", foreword by Paul Westheim, New York, 1961, No. 1.
The four illustrations for Kokoschka's one-act play, "Mörder, Hoffnung der Frauen", whose première took place on July 4, 1909, in Vienna, were reproduced in 1910 in the periodical "Der Sturm", published by Herwarth Walden, Berlin.

12
Wingler, No 4; Sotriffer, Kristian, "Vincent van Gogh und sein Einfluss in Wien" in "Alte und moderne Kunst", 74, Vienna, 1964, pp. 26 f.

13
Kirsch, Fritz Peter, "Aspekte der französischen Literatur zur Zeit Toulouse-Lautrecs", in "Henri de Toulouse-Lautrec und seine Zeit" (lectures of the "Institut für Wissenschaft und Kunst", Vienna, 1966, p. 43).

14
Kandinsky, Wassily, "Réflexions sur L'Art Abstrait", in "Cahiers d'Art", No. 1/1931.

15
Bisanz, Hans, "Gedanken zu einem Lebensbild", in "Egon Schiele, Leben und Werk", exhibition catalogue of the Historisches Museum der Stadt Wien, Vienna, 1968, p. 8; Schöny, Heinz, "Die Vorfahren des Malers Egon Schiele", in "Adler, Zeitschrift für Genealogie und Heraldik", 1968, I, pp. 1 ff.

16

For the history of the Vienna Secession see: Waissenberger, Robert, "Die Wiener Secession, Eine Dokumentation", Vienna and Munich, 1971; Sotriffer, Kristian, "Malerei und Plastik in Österreich", Vienna and Munich, 1963, pp. 32f. (chronology).

17

The information that the paddle-steamer was probably one of those on Lake Constance was kindly supplied by Herr Ph. Grellet, Bregenz. (Albertina exhibition catalogue, 1968, No. 192).

18

Elfriede Baum has shown that this loose painting style is similar to that of Richard Gerstl (exhibition catalogue, Österreichische Galerie, Vienna, 1968, No. 8). Works by Richard Gerstl (1883-1908), who is still largely unknown today, were exhibited, after he had been completely forgotten, by Otto Nirenstein (Kallir) in the Neue Galerie, Vienna, in 1931. A monograph on this important Austrian painter is still lacking.

19

Compare the works by Alfred Roller, Johann Viktor Krämer or Friedrich König, reproduced in "Ver sacrum", IV, 1901, pp. 69, 179, 230.

20

This kind of drawing on tinted paper has a long tradition in academic teaching, but was also used by the French artist Eugène Carrière (1849-1906), whose style was then very popular. A large number of his works were shown in the 27th exhibition of the Vienna Secession in 1906.

21

Cf. also the self-portrait of 1909, Graz (K. 91; L. 134), in which the ornamental strip to the left and the frieze-like arrangement of the hands, suggesting an unending continuity, produce a similar effect.

22

For an analysis of the drawing (the title "Water Sprites" comes from R. Leopold) cf. Mitsch, E., "Bemerkungen zur Ausstellung Egon Schiele", in the Albertina exhibition catalogue, 1968, p. 78.

23

Novotny - Dobai, No. 131.

24

E.g. in the coloured chalk drawing of a woman's head, dated 1910, in the collection of R. Staechelin, Basle (repr. in Leopold, p. 86).

25

L. XV, p. 607.

26

Portrait of the painter Anton Peschka, K. 86; L. 131.

27

Sutton, Denys, "James McNeill Whistler", London, 1966, pl. 53, 57, 114.

28

L. 133, note 2.

29

Cf. "Water Sprites II" (pl. 1), and also the drawing "Naked Boy Lying on a Patterned Cover", in the collection of R. Staechelin, Basle (L. 121).

30

The preparatory study is reproduced in Leopold, p. 70.

31

Chrysanthemums, K. 96; L. 142.

32

The opening speech of Gustav Klimt is printed in the catalogue of the exhibition. There was also a "Provisorischer Katalog der Kunstschau, Wien 1908", which does not include the speech, and also has many other differences.

33

Leopold, p. 10.

34

In the 1908 art exhibition, Berthold Löffler devoted a separate room to poster art, after the "Viennese Graphic Society" had held a poster exhibition in 1906. Among the most important figures participating in the exhibition's poster section were Oskar Kokoschka and Rudolf Kalvach.
Kossatz, Horst Herbert, "Ornamentale Plakatkunst, Wiener Jugendstil 1897-1914", publications of the Albertina, No. VII, Salzburg, 1970.

35

Hofstätter, Hans H., "Jugendstil—Druckkunst", Baden-Baden, 1968 For the art of printing in Vienna, cf. the exhibition catalogue "Wien um 1900", Vienna, 1964 (edited by H. Bisanz). An important example was the first programme of the cabaret "Fledermaus" produced by the Viennese Workshop in 1907.

36

Cf. also the drawing "Woman in a Green Dress with a Large

Hair Ornament", private collection, Albertina exhibition catalogue, 1968, No. 129.

37

Wingler, Hans Maria, "Oskar Kokoschka, Die Träumenden Knaben und andere Dichtungen", Salzburg, 1959, p. 15 ("Das Schiff"). The identification of the two figures on Schiele's post-card as Klimt and Schiele was apparently made first by Otto Benesch.

38

Schmidt, Gerhard, "Neue Malerei in Österreich", Vienna, 1956, p. 16.

39

L. 143a. The picture was exhibited among those of the Klimt group in room VI (reproduction, Leopold, p. 549). The exhibition was opened on May 7, so that the picture must have been painted before that date.

40

The frieze, with its overall length of 78 feet, decorated the left side-room of the Secession; it later came into the collection of Carl Reininghaus and, in 1913, into the collection of August Lederer. Cf. Novotny - Dobai, No. 127. Since 1986 the frieze has again been exhibited in the Secession, Vienna.

41

The second number of "Ver sacrum", in 1901, was devoted to George Minne and contains a reproduction of the fountain.

42

The picture is in the gallery of the Academy of Fine Arts in Vienna. Cf. the exhibition catalogue "Wien um 1900", Vienna, 1964, No. 85, fig. 13.

43

Hevesi, Ludwig, "Acht Jahre Secession" (March 1897–June 1905), "Kritik—Polemik—Chronik", Vienna, 1906, pp. 293 ff.

44

K. 109–112; L. 140–141, 144–145.

With the exception of the work reproduced on plate 6, the whereabouts of these pictures are unknown.

45

E.g. in the painting "Embrace" of 1917, pl. 74.

46

Rodin, Auguste, "Die Kunst, Gespräche des Meisters", collected by Paul Gsell, Munich, 1920, pp. 16 ff.; Nostiz, Helene, "Rodin in Gesprächen und Briefen", Dresden, 1927, p. 28; Pirchan, Emil, "Gustav Klimt", Vienna, 1956, p. 35 (qu. Servaes).

47

The acquaintance with the art of Michelangelo became decisive: for Rodin he was the culmination of all Gothic ideas, the last and greatest of the Gothic artists. Cf. Gantner, Joseph, "Rodin und Michelangelo", Vienna, 1953.

48

The head was later used again several times, e.g. on a poster for a lecture by Egon Friedell, whose correct date (April 11, 1912) was established by Leopold (p. 144). See p. 21 above.

49

There was a Toulouse-Lautrec exhibition at the Miethke Gallery in Vienna in 1909. However, Schiele could have seen works by Toulouse-Lautrec and other modern masters in the collection of Dr. Oskar Reichel, whom he had met in 1910. There was also an exhibition of works from the collection of Dr. Reichel at the Miethke Gallery in 1913, and a printed catalogue.

50

Michel, Wilhelm, "Max Oppenheimer", Munich, 1911.
Mopp (Max Oppenheimer), "Menschen finden ihren Maler", Zurich, 1938.

51

The year of composition is given as 1911 in Michel (op. cit.), and 1910 in Mopp (op. cit.). The years of composition of other works also vary in these two books.

52

K. 111; L. 140. The painting is lost. There is a preparatory study in a private collection in America, reproduced in Leopold, pl. 33. Leopold also indicates the probable influence of Kokoschka's title vignette for "Die Träumenden Knaben". Schiele also used the motif of the leg bent back in a portrait study of Anton Peschka, dating from 1910.

53

James T. Demetrion, in the exhibition catalogue of The Solomon R. Guggenheim Museum, New York, 1965, p. 64.

54

Leopold, p. 552.

55

Mopp (Max Oppenheimer), op. cit., p. 24.

56

Cf. Leopold, pl. 51, 52.

57

On the use of the mirror in Schiele's art, see Schwarz, Heinrich, "Schiele, Dürer and the Mirror", in "The Art Quarterly", vol. XXX, No. 3/4, 1967, pp. 210 ff.

53

58
On the importance of symbolist art for expressionism, cf. Hofstätter, Hans H., "Symbolismus und die Kunst der Jahrhundertwende", Cologne, 1965. This is a stimulating book on various counts.

59
Anzelewsky, Fedja, "Albrecht Dürer, Das malerische Werk", Berlin, 1971, cat. No. 9.

60
The preparatory study for this work is a pencil drawing dated 1914, now in a private collection in New York. Reproduced in the exhibition catalogue "Egon Schiele", Darmstadt-Mathildenhöhe, 1967, No. 62.

61
This has been pointed out by Leopold (p. 194), who also included a reproduction of the vase and gave the painting the new title.

62
Mittelstädt, Kuno, "Die Selbstbildnisse Paul Gauguins", Vienna and Munich, 1968, Nos. 16 and 9. The picture was in the Maurice Denis collection.

63
There was a Paul Gauguin exhibition at the Miethke Gallery in Vienna in 1907; Ludwig Hevesi discussed it in detail in "Altkunst—Neukunst", Vienna, 1909, pp. 514ff.
Gauguin was also represented in the art exhibition of 1909 with the work "Young Couple".

64
As Leopold has pointed out, the work is related to Kokoschka's poster for the summer theatre of the 1909 art exhibition and to Klimt's painting "Mother with Children" (Novotny - Dobai, No. 163).

65
The suggestion has been made that it could have been inspired by a plaster relief made by Margaret Macdonald-Mackintosh in 1902 (Demetrion, James R., in the exhibition catalogue of The Solomon R. Guggenheim Museum, New York, 1965, p. 67). Cf. also the painting "Take your Son, Sir" by Ford Madox Brown, begun in the 1850's (Schmutzler, Robert, "Art Nouveau—Jugendstil", Teufen, 1962, fig. 254).

66
Künstler, Gustav, "Egon Schiele als Graphiker", Vienna, 1946, pp. 12f., fig. 5.

67
"The Birth of Genius" ("Dead Mother II"); K. 136; L. 176.

68
Gustav Klimt, "Hope I" (1903); Novotny - Dobai, No. 129.

69
"Briefe und Prosa von Egon Schiele", edited by Arthur Roessler, Vienna, 1921, p. 157. This passage from the letter was related by Leopold to the painting K. 132; L. 195.

70
"Madonna", K. 134; L. 186.

71
"Crucifixion with Darkened Sun", 1907. K. 24; L. 57. For the painting by Stuck see Ostini, Fritz von, "Franz von Stuck, Gesamtwerk", Munich, Hanfstaengl, n. d., repr. p. 117. The picture was painted in 1906.

72
La Faille, J. B. de, "The Works of Vincent van Gogh", London, 1970, F. 484, p. 630.

73
Cf. in particular studies made by Van Gogh in the park of the mental asylum at Saint-Rémy, e.g. de la Faille 672 or Cooper, Douglas, "Zeichnungen und Aquarelle von Vincent van Gogh", Basle, 1954, Nos. 26 and 27.

74
Quoted from Leopold, p. 212.

75
Similar crystalline net-like formations and prismatic light refractions occur in Kokoschka's art, both in the illustrations made in 1911 for Albert Ehrenstein's "Tubutsch" and in a group of opaque pictures devoted mainly to religious themes. They were particularly important for Schiele's "Double Portrait" (Heinrich and Otto Benesch) of 1913, pl. 40.

76
This relationship has often been pointed out, and comparisons were made between the two paintings, most recently by H. Bisanz and E. Baum in the exhibition catalogue of the Österreichische Galerie, 1968, and by Leopold in his book on Schiele.

77
Exhibition catalogue "Wien um 1900", Vienna, 1964, colour plate 13. In a study for the picture (Leopold, pl. 100), the model holds the dress gathered up over the knees.

78
On Schiele's period of imprisonment see Roessler, A., ed., "Egon Schiele im Gefängnis, Aufzeichnungen und Zeichnungen", Vienna and Leipzig, 1922; Comini, A., "Egon

Schiele in Prison", in "Albertina-Studien II", 1964, vol. 4, pp. 123 ff.; Comini, A., "Schiele in Prison", New York Graphic Society Ltd., 1973. R. Leopold strongly disputes the authenticity of the notes in A. Roessler's edition, said to have been made by Schiele in prison (op. cit., pp. 248, 666).

79
"The Birth of Genius", K. 136; L. 176.

80
Albertina, Inv. No. 27942. Albertina exhibition catalogue, 1968, No. 202.

81
A drawing first published by Leopold (p. 15) is entitled: "Recollection of the Green Stockings". In addition to the self-portraits, he also drew the still-life with the three oranges on the bedcover, and the preparatory drawing for this. The drawing "Fishing-boats in Trieste Harbour" has rightly been questioned as being one of the works executed in prison. It was therefore placed in another section of the Albertina exhibition in 1968 (No. 194).

82
It is possible that the two objects were drawn lying on the floor, but Schiele has succeeded in evoking the impression of a free suspension in space.

83
Letter from Schiele from Sattendorf on Lake Ossiach to Franz Hauer; Albertina, Schiele archive.

84
Hagenbund, catalogue of the spring exhibition, 1912, No. 235 (quoted in K. 166).

85
K. 144 ("A Tree"); L. 199 ("Small Tree in Late Autumn").

86
Cf. Mondrian's picture "The Red Tree" in the Gemeente Museum, The Hague. Seuphor, Michel, "Piet Mondrian, Leben und Werk", Cologne, 1957, p. 83 (colour plate) and figs. 169 ff. The last leaves on the bare branches are surrounded by a similar halation as in Schiele's painting.

87
Nostiz, H., op. cit., pp. 22 f. and 31.

88
Cf. also the two self-portraits of 1912, exhibition catalogue The Galerie St. Etienne, New York, 1965, pl. 16, and especially pl. 22.

89
O. Benesch's first work on Schiele was the introduction to the catalogue of the collective exhibition of the artist in the Galerie Arnot in 1914-15. Further essays on Schiele's art published in Benesch, Otto, "Collected Writings", vol. IV, ed. by Eva Benesch, London, 1973.
In the memorial year 1948, the Albertina organized the largest Schiele exhibition so far, with 336 works in the catalogue; there was, however, no printed catalogue.

90
Albertina exhibition catalogue, 1968, No. 214.

91
K. 180; L. 228. Formerly in the collection of B. F. Dolbin, New York. A large colour reproduction of the fragment appeared in the catalogue "Expressionists", Serge Sabarsky Gallery, New York, 1972, No. 70.
The completely architectonically constructed group of two girls embracing is a particularly mature work in this context. A comparison with similar subjects dating from 1911 shows the enormous change of conception. Reproduction in the exhibition catalogues of The Galerie St. Etienne, 1965, pl. 12, and 1968, No. 56.

92
The chronology of the pictures was resolved by Leopold, on the basis of the artist's statements in his letters.

93
Leopold, R., "Egon Schiele—Ein Genie aus Osterreich", in "BP-Querschnitt", vol. I, 1959; Feuchtmüller, R., "Egon Schieles Städtebilder von Stein an der Donau", in "Alte und moderne Kunst", 103, 1969, pp. 29 ff.

94
Cf. Leopold, p. 652 (subject guide).

95
Benesch, O., "Hodler, Klimt und Munch als Monumentalmaler", in "Wallraf-Richartz-Jahrbuch", XXIV, 1962, pp. 333 ff.

96
K. 176; L. 236. The new title given to the painting for the 1917 "War Exhibition": "Heroes' Graves—Resurrection", is clearly connected with the theme of the exhibition, in which Schiele mainly showed portraits of soldiers and captured Russians (cat. Nos. 113-133).

97
L. XLIX, pp. 612 f. The fragments extant: K. 178, 179; L. 237, 238, formerly in the collection of B. F. Dolbin,

New York. "Expressionists" catalogue, Serge Sabarsky Gallery, New York, 1972, No. 62.

98

Benesch, O., "Erinnerungen an Bilder von Egon Schiele, die nicht mehr existieren", in Kallir, O., "Egon Schiele", Vienna, 1966, pp. 37 f.

99

K. 177; L. 243. The photograph was taken by Anton Josef Trčka (repr. p. 11 above). Historisches Museum der Stadt Wien, Inv. No. 75.406.

100

The shortening of the figures to torsos came about because they were cut off by the edge of the paper.

101

Cf. the text to fig. 44.

102

Jakob Asmus Carstens, born 1754 at Sankt Jürgen (Schleswig), died 1798 in Rome. The picture of "Night and Her Children" is in the Staatliche Kunstsammlungen, Weimar.
The children in Schiele's picture are dressed in black and blue.

103

Hevesi, L., "Acht Jahre Sezession", Vienna, 1906, p. 256.

104

K. 204; L. 251.

105

Repr. Leopold, p. 500.

106

Rodin, "Dance of Death", c. 1882, pen and pencil drawing, Musée Rodin, Paris, No. 1986 (repr. Goldscheider, C., "Auguste Rodin—Zeichnungen", Munich, 1962, No. 28).
Munch, "Girl and Death", etching, 1894.

107

Wingler, No. 96.

108

That Schiele also gave the painting the title "The Blind" must not be taken as definite proof that two different people are depicted. The facial features in both cases correspond to those of Schiele. Cf. also Leopold, pl. 170.

109

Cf. Hodler's picture "The Day", 1899–1900 (Berne version).

110

Benesch, O., "Egon Schiele und die Graphik des Expressionismus", op. cit., repr. opposite p. 37.

111

The picture "Deliriums" dating from 1911 shows five heads with features suggesting self-portraits. K. 138; L. 170.

112

Elsen, Albert, and Varnedoe, J. Kirk T., "The Drawings of Rodin", New York, 1971, fig. 50.

113

Huisman, Ph., and Dortu, H. G., "Lautrec par Lautrec", Paris, 1964, repr. p. 74.

114

Self-portrait from the E. W. K. collection, Berne. Albertina exhibition catalogue, 1968, No. 247. Cf. the photos reproduced on p. 12 above.

115

Fischer, W., "Egon Schiele als Militärzeichner", in "Albertina-Studien IV", 1966, pp. 70 ff.

116

Comini, A., "Egon Schieles Kriegstagebuch 1916", in "Albertina-Studien IV", 1966, pp. 86 ff.

117

The stronger realism becomes clear by comparison with the painting "Sinking Sun" of 1913 (K. 183; L. 235). The element of deliberate ornamentation, with the rings of light glowing in the darkness—in which a Secessionist echo of Whistler's "Nocturne" pictures may be discerned—has completely disappeared (Leopold, colour plate 128).

118

Ankwicz-Kleehoven, Hans, "Ferdinand Hodler und Wien", in "Neujahrsblatt der Zürcher Kunstgesellschaft", 1950.

119

"Recumbent Woman", K. 222; L. 278.

120

The study was executed in black chalk and gouache in 1917 and is reproduced in Leopold, p. 438.

121

Hofmann, Werner, "Egon Schiele, Die Familie", Reclams Werkmonographien zur bildenden Kunst, No. 132, Stuttgart, 1968. In his analysis of the picture, Hofmann refers several times to the "protective shield" of the man. This has a significance bearing on both the form and the content. The painting may possibly have been related to studies for a fresco cycle intended for a mausoleum (cf. Leopold, p. 604). The project came to nothing, but we have information regarding it from notes and drawings by Schiele (reproduced in Kallir). According to them, the mausoleum was to have

been octagonal, and would have had a rich iconographic programme. The pictures planned for the galleries included: (Earthly Existence), Religion, Idea of the World, Stages of Life.

122

The position of the left arm is prepared in the two drawings of 1917, figs. 66, 67. For the steeper inclination of the right arm, with the hand pointing almost vertically upwards, as opposed to that in the preparatory drawing (Albertina, Inv. No. 31.345) cf. the self-portrait dated 1916 and published in the periodical "Die Aktion".

123

"Portrait of Karl Grünwald". K. 219; L. 279.

124

"Portrait of Guido Arnot". K. 235; L. 292.

125

"Portrait of Dr. Victor Ritter von Bauer". K. 233; L. 286.

126

"Portrait of Robert Müller". K. 237; L. 295.

127

K. 241; L. 296 and 297. The two pictures may have had some connection with the projected mausoleum building. Cf. note 121.

128

Gütersloh, Paris von, "Egon Schiele—Versuch einer Vorrede", Verlag Brüder Rosenbaum, Vienna, n. d. (1911). In the same year there appeared an essay on Schiele by Arthur Roessler in "Bildende Künstler", 3. These were the first publications about the art of Schiele.

129

This comes from a copy of the printed catalogue corrected by Schiele himself, in the Schiele archive of the Albertina. Cf. Leopold, p. 17.

130

Kallir, "Druckgraphik", p. 19.

131

The frequent change of motifs in Schiele's art do not permit any conclusive identification. According to Kallir, who refers to a letter from the painter Georg Merkel, dated January 13, 1964, the second person to the right of Schiele represents Gütersloh.

132

Rodin, Auguste, "Die Kunst, Gespräche des Meisters", collected by Paul Gsell, Munich, 1920, p. 32.

133

Hevesi, L., "Acht Jahre Sezession", Vienna, 1906, p. 41.

134

For the place of Schiele in the wider context of the history of art, the reader may refer particularly to: Benesch, O., "Egon Schiele und die Graphik des Expressionismus", in "Continuum", n. d. (1958), pp. 19 ff., and Demetrion, James T., "Egon Schiele—Paintings", in The Solomon R. Guggenheim Museum exhibition catalogue, New York, 1965, pp. 63 ff.

135

On the death of Felicien Rops, there appeared in "Ver sacrum", in 1898, a sentimental obituary. In 1910, the wellknown Viennese poster collector Ottokar Mascha published his detailed catalogue of Rops' work (Albert Langen, Munich).

136

Weininger, Otto, "Geschlecht und Charakter", Vienna, 1903 (first edition).

BLACK AND WHITE ILLUSTRATIONS

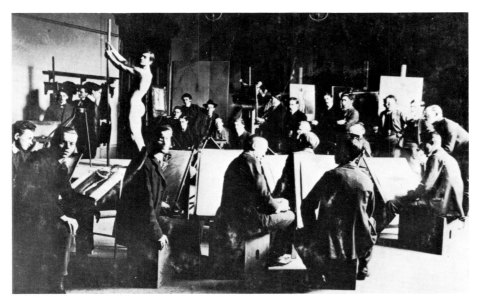

Fig. 1
LIFE CLASS AT THE VIENNA ACADEMY OF FINE ARTS
Photograph, c. 1906-7
Schiele archive, Albertina, Vienna
Egon Schiele is standing on the far left in the background.

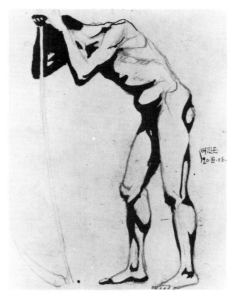

Fig. 2
STANDING MALE NUDE
LEANING ON A SCYTHE 1906
Pencil and black Indian ink.
22 × 17 cm
Signed and dated: Schiele, 20. XI. 06.
Collection of Frau Kammersängerin
Hilde Zadek, Vienna

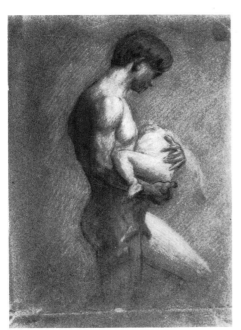

Fig. 3
STANDING MALE NUDE WITH A
CHILD IN HIS ARMS 1908
Black and white chalk, red chalk, on
greyish-blue cardboard. 36.6 × 25 cm
Monogrammed and dated: E S 08
Private collection

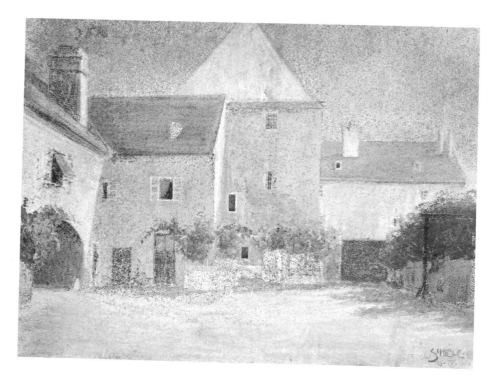

Fig. 4
COURTYARD IN KLOSTER-
NEUBURG 1906

Water-colour and gouache, partly
sprayed. 36.9 × 47.6 cm
Signed and dated: Schiele. 6. IX. 06
(dated twice)
K. 2 ("Estate"); L. 4 (subject guide,
p. 632)
Private collection, Vienna

The courtyard is that at Albrechts-
bergergasse 4, where Schiele lived for
a while, with the family of the master
blacksmith Johann Gierlinger, during
his time at school in Klosterneuburg.

Fig. 5
AUTUMN LANDSCAPE 1907
Oil on cardboard. 18 × 26.5 cm
Signed and dated: Schiele Egon 07.
K. —; L. 67
Private collection, Vienna

64

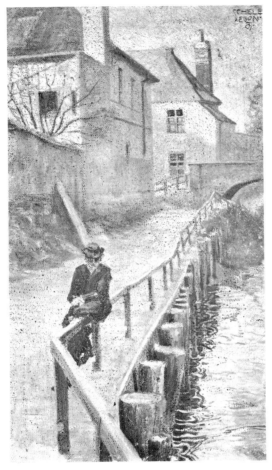

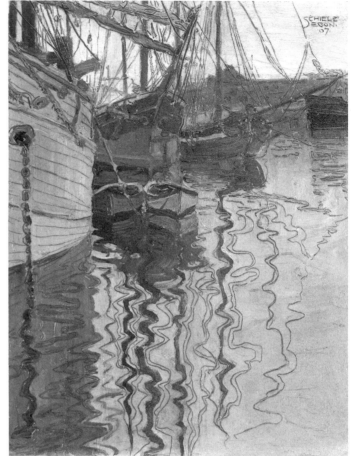

Fig. 6

PATH ALONG THE KIERLING BROOK, KLOSTERNEU-
BURG 1907

Oil on canvas. 96.5 × 53 cm

Signed and dated: Schiele Egon. 07.

K. 13 ("Klosterneuburg" [Path by the Brook]); L. 11 (subject
guide, p. 633)

Oberösterreichisches Landesmuseum, Linz

Because Schiele rubbed off some layers of paint over the
coarse canvas, the blue underpainting is visible in places,
as Leopold points out. The painting has therefore taken on
the appearance of a water-colour with spraying technique.

Fig. 7

SAILING-SHIPS IN TRIESTE HARBOUR 1907

Oil and pencil on cardboard. 25 × 18 cm

Signed and dated: Schiele Egon. 07.

K. 21 ("Trieste Harbour"); L. 73 ("Sailing Ship in Choppy
Sea" [Trieste])

Neue Galerie am Landesmuseum Joanneum, Graz

Schiele went on his first trip to Trieste with his sister
Gertrude. A painting of fishing-boats with the title "At the
Mole" (L. 72 and p. 693) is also dated 1907.

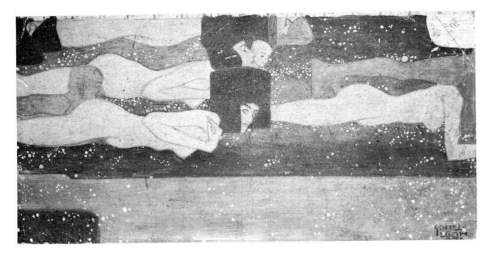

Fig. 8
WATER SPRITES I 1907
Gouache, crayon, gold and silver paint
on paper. About 24 × 48 cm
Signed and dated: Schiele Egon 07
K. —; L. 82
Private collection, Switzerland
This picture was published by Leopold.
The second version of the subject, made
in the following year, is reproduced on
pl. 1.

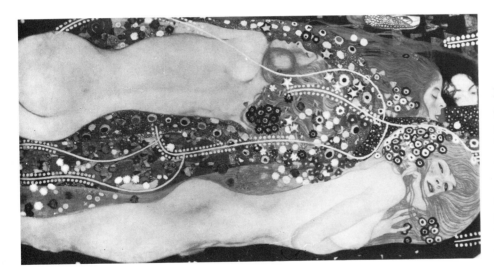

Fig. 9
GUSTAV KLIMT
(born July 14, 1862, at Baumgarten near
Vienna—died Feb. 6, 1918, in Vienna)
WATER SNAKES (FRIENDS) II
1904, reworked 1907
Oil on canvas. 80 × 145 cm
Signed: Gustav Klimt
Private collection
Novotny - Dobai, No. 140

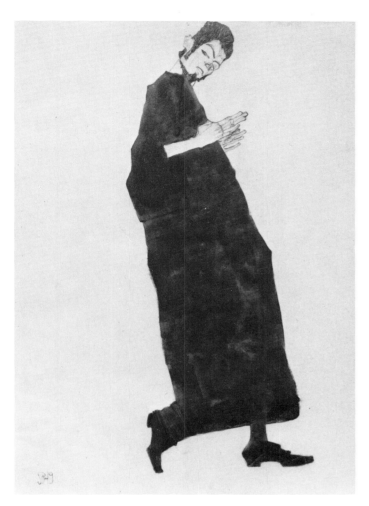

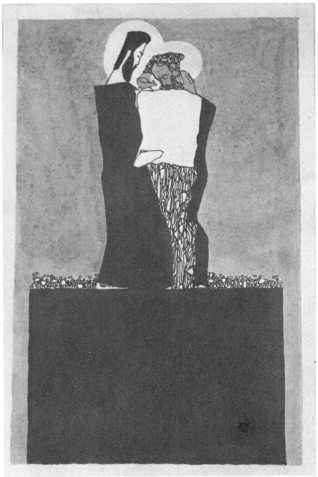

Fig. 10

MALE FIGURE FROM THE RIGHT 1909 (Self-portrait)

Pencil, water-colour, crayon. 45 × 31.1 cm

Monogrammed and dated: Sch 9

On the back there is a pencil study of a figure

Collection of E. W. K., Berne

The garment is worked with horizontal, rigidly parallel, thin gold threads. Cf. the picture "Standing Woman in a Long Cloak" of 1908 (pl. 2). The caricatural roots of Schiele's art, and its difference from that of Gustav Klimt, can be seen in the posture of the body and the gestures, as well as in the stylish shape of the shoes. As in fig. 11, Schiele has a beard and whiskers.

Fig. 11

TWO MEN STANDING ON A PEDESTAL 1909 (Klimt and Schiele)

Black Indian ink and wash. 15.5 × 9.9 cm

Graphische Sammlung Albertina, Vienna. Inv. No. 31.391

The drawing belongs to a series of four stylistically related postcard sketches in the Albertina, which were not used. In one of them (Inv. No. 31.393), the unusual, elongated bald shape of the skull recalls that of the half-nude of a youth on the back of the painting "Schiele's Desk", L. 149 and 253 (photograph in the Schiele archive of the Albertina collection).

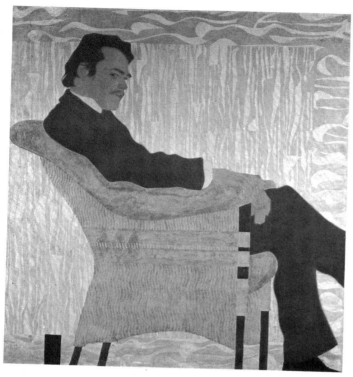

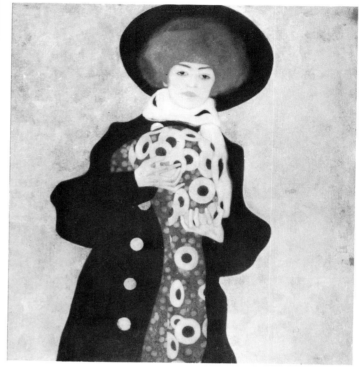

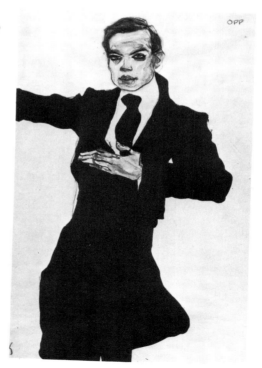

Fig. 12
PORTRAIT OF THE PAINTER HANS MASSMANN 1909
Oil and silver and gold paint on canvas. 120 × 110 cm
Signed and dated: Schiele Egon 1909
K. 87; L. 132
Private collection, Switzerland

Fig. 13
PORTRAIT OF GERTRUDE SCHIELE I 1909
Oil and silver and gold paint on canvas. 100 × 100 cm
Monogrammed and dated: 19 ES 09 (interlaced)
K. 88 ("Portrait of a Woman in a Black Hat"); L. 133
Georg Waechter Memorial Foundation, Geneva

Fig. 14
MAX OPPENHEIMER 1910
Black chalk, Indian ink, water-colour. 45 × 29.9 cm
Monogrammed: S; inscribed: OPP
Graphische Sammlung Albertina, Vienna. Inv. No. 32.438
Max Oppenheimer, known as Mopp, or Opp, was an Austrian
painter and draughtsman, born 1885 in Vienna, died 1954
in New York.

68

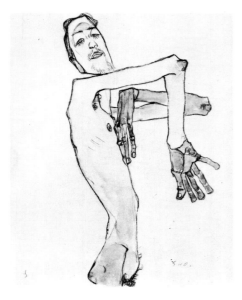

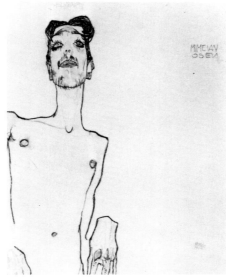

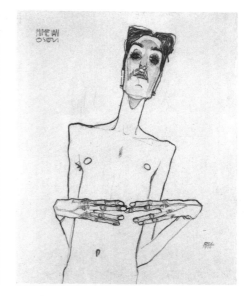

Fig. 15
MALE NUDE 1910
(Erwin Dominik Osen)
Black chalk, water-colour and gouache.
44.4 × 30.8 cm
Monogrammed and dated: S (twice) 10.
Collection of Dr. Rudolf Leopold, Vienna

Fig. 16
MIME VAN OSEN 1910
Black chalk, water-colour.
37.8 × 29.7 cm
Signed and dated: Egon Schiele 1910
Inscribed as above
Neue Galerie am Landesmuseum
Joanneum, Graz. Inv. No. 6.334

Fig. 17
MIME VAN OSEN 1910
Black chalk, water-colour and gouache.
38.3 × 30 cm
Signed and dated: Egon Schiele 1910
Inscribed as above
Collection of Dr. Rudolf Leopold, Vienna

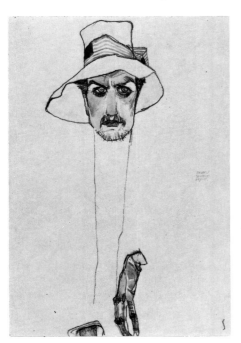

Fig. 18
PORTRAIT OF A MAN IN A SOFT
HAT 1910
(Erwin Dominik Osen)
Black chalk, water-colour
Monogrammed: S.; signed and dated:
Egon Schiele 1910
Collection of Hans Dichand, Vienna

The painter Dominik Osen, known as
Dom Osen, was a member of the "New
Art Group". Schiele was friendly with
him, and rented his studio in Vienna
IX, Höfergasse 18, after his imprison-
ment. In his recollections of Egon
Schiele, A. Roessler gives an account of
a Mr. Neso, no doubt intended for Osen
(the name is written backwards), in the
chapter "Encounter with the Adven-
turer". When the second edition of the
book was published in 1948, E. D. Osen
brought an action for libel against
A. Roessler on account of this.

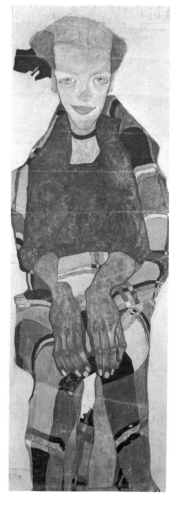

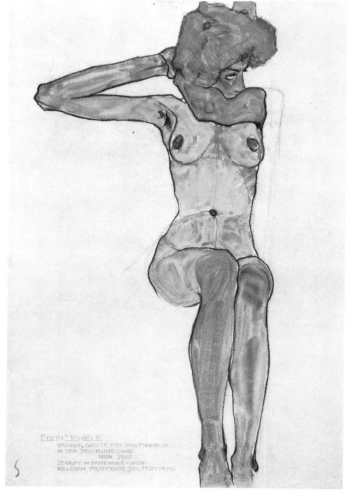

Fig. 19
POLDI LODZINSKY

Gouache and oil on canvas. 109.5 × 36.5 cm
Signed and dated: E S. (interlaced) 08.
K. 63; L. 143
Collection of Dr. and Mrs. Ferdinand Eckhardt, Winnipeg

A sketch for a glass window for the Palais Stoclet in Brussels, but not used. Although the picture is dated 1908, it may well, as Leopold argues on stylistic grounds, date from 1910.

Fig. 20
SEATED FEMALE NUDE WITH HER RIGHT ARM BENT AT THE ELBOW
1910

Black chalk, water-colour. 45 × 31.5 cm
Monogrammed: S.
Historisches Museum der Stadt Wien, Vienna. Inv. No. 96.030/2

A study for the painting, which is lost today, for the "First International Hunting Exhibition" in Vienna, 1910. L. 143a. The picture comes from the estate of Otto Wagner, who inscribed on it the following information: "Egon Schiele original sketch for the Pannaux (sic) in the Hunting Exhibition Vienna 1910 bought in the coffee-house through my colleague Professor Jos. Hoffman (sic)".

70

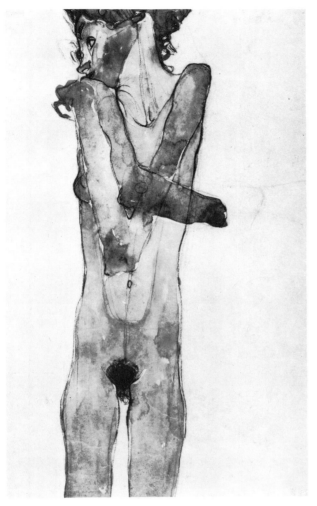

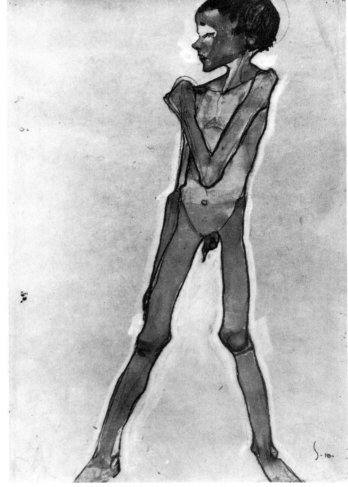

Fig. 21

STANDING FEMALE NUDE WITH CROSSED ARMS
1910

Black chalk, water-colour. 48.8×28 cm

Monogrammed and dated: S 10

Graphische Sammlung Albertina, Vienna. Inv. No. 30.772

This drawing is a study for a painting originally in the possession of Carl von Reininghaus, but lost today (K. 110; L. 141). In the painting, the figure was represented down to the ankles and, owing to the square format of the canvas, was dominated by the blank space.

Fig. 22

STANDING NUDE BOY 1910

Black chalk, water-colour, white body-colour. 44.7×23 cm

Monogrammed and dated: S. 10.

Museum of Fine Arts, Budapest. Inv. No. 1925-1160

The figure is similar to that reproduced in fig. 21, in its linear structure and the motif of the arm placed in a V-shape on the breast. The contour and the bony angularity of the body is more strongly accentuated however, and is thus nearer in type to the great pictures of nudes painted in the same year.

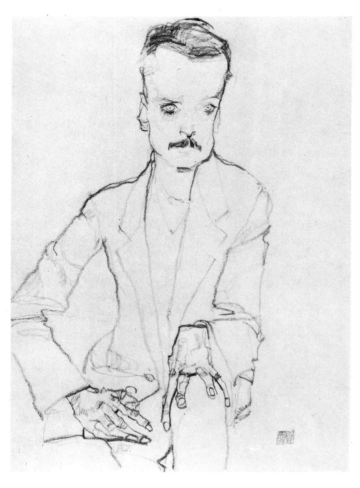

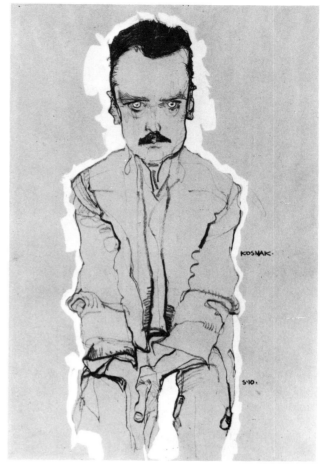

Fig. 23
PORTRAIT OF EDUARD KOSMACK

Black chalk. 45.3×31.7 cm
Signed and dated: Egon Schiele 1911
Staatliche Graphische Sammlung, Munich. Inv. No. 13.573.
Gift of S. and E. Fohn

Despite the date 1911, this is obviously a study for the
painting (pl. 12) and therefore dates from 1910, a date
supported by the style (Kurt Martin, "Schenkung Sophie und
Emanuel Fohn, Bayerische Staatsgemäldesammlungen",
Munich, 1965, Catalogue by Wolf-Dieter Dube, p. 46).

Fig. 24
PORTRAIT OF EDUARD KOSMACK 1910

Black chalk. White body-colour. 44.4×28.7 cm
Monogrammed and dated: S. 10. Inscribed: Kosmak (sic)
Private collection

Schiele portrayed the publisher Eduard Kosmack (1880–1947)·
several times. The composition of this drawing is the direct
preliminary study for the painting in the Österreichische
Galerie, Vienna (pl. 12).

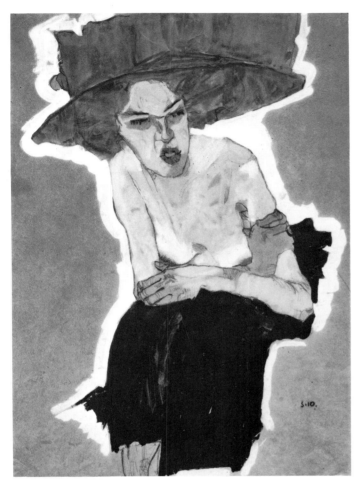

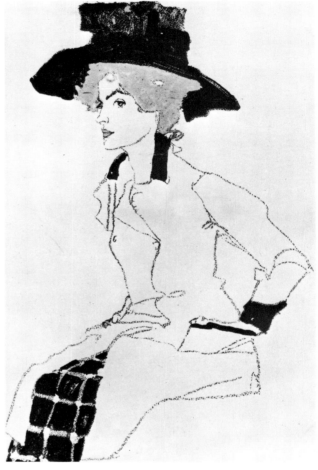

Fig. 25
MISCHIEVOUS WOMAN 1910
Black chalk, water-colour and gouache. White body-colour.
45 × 31.4 cm
Monogrammed and dated: S. 10.
Private collection
Gertrude Schiele, the younger sister of the artist, sat as model for this study, which is so close to the art of Toulouse-Lautrec. Cf. also the painting by Klimt "The Black Feathered Hat", which also dates from 1910 (Novotny - Dobai, No. 168).

Fig. 26
PORTRAIT OF A WOMAN WITH A LARGE HAT 1910
Postcard of the "Viennese Workshop"
Historisches Museum der Stadt Wien, Vienna
This, like fig. 25, is a portrait of Schiele's sister Gertrude. The "Viennese Workshop", with which Schiele had been in contact since 1909, brought out three postcards after sketches by the artist, all dating from 1910 (Nos. 288–290).

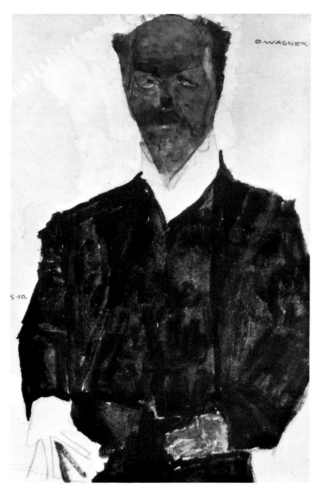

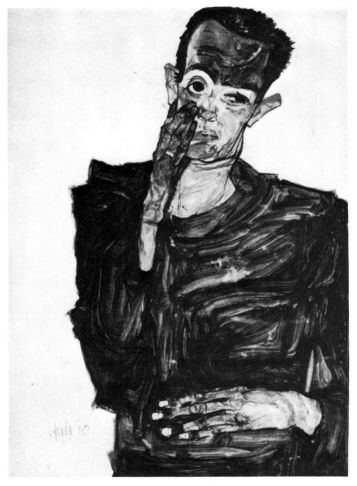

Fig. 27
PORTRAIT OF OTTO WAGNER 1910

Pencil, water-colour, white body-colour. 42.5 × 26 cm
Monogrammed and dated: S 10. Inscribed: O. Wagner
Historisches Museum der Stadt Wien, Vienna. Inv. No. 96.030/1

The portrait was owned by the great Viennese architect Otto
Wagner (1841–1918), who ousted historicism in Vienna and
occupies a similar position in the history of architecture as
Klimt does in painting.

Study for a picture of which only a fragment is preserved
(K. 107; L. 151).

Fig. 28
SELF-PORTRAIT 1910

Black chalk, water-colour and gouache. 44.3 × 30.5 cm
Signed and dated: Schiele 10
Graphische Sammlung Albertina, Vienna. Inv. No. 30.395

Leopold refers to the 1909 self-portrait in the Albertina
collection (Inv. No. 30.771), and sees in the picture a study
for the painting "World's Anguish" (K. 114; L. 165).

74

Fig. 29

KRUMAU TOWN HALL 1910

Black chalk, water-colour and gouache.
31.2 × 44.5 cm
K. —; L. 156
Private collection

The very arbitrarily chosen view is a clear renunciation of the decorative beauty' of the "Jugendstil". Schiele took up the same motif again in a picture of 1911 (L. 178). For the composition, cf. the 1885 water-colour by Rudolf von Alt, "Façade of the Government House at Graz", Albertina, Inv. No. 42.508. Rudolf von Alt (1812-1905) was the honorary president of the Viennese Secession, and still admired by the younger generation of artists.

Fig. 30

HILL BY THE RIVER 1910

Oil on cardboard. 30 × 44 cm
Monogrammed and dated: S. 10.
K. 120; L. 163
Galerie Maercklin, Stuttgart

The completely flat formation of the hill corresponds in conception to the realization of the façade of Krumau Town Hall (fig. 29). Both pictures also have a free painting structure in common.

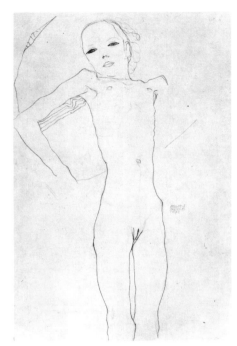

Fig. 31
NUDE GIRL 1911
Pencil. 48.2 × 31.5 cm
Signed and dated: Egon Schiele 1911
Private collection

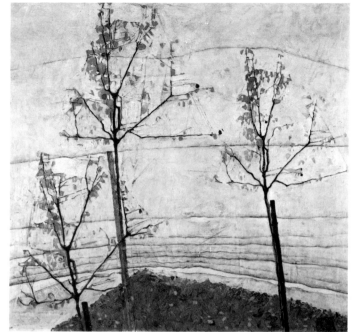

Fig. 32
AUTUMN TREES 1911
Oil on canvas. 79.5 × 80 cm
Signed and dated: Egon Schiele 1911
K. 145; L. 189
Private collection

Vernal sprouting and autumnal withering are two important poles in Schiele's work, though the main accent is on the latter. The sky, divided by horizontal red and blue strips, reflects the rays of the setting sun. Schiele also used coloured, fluorescent radiating lines for the contours of his human figures at this time.

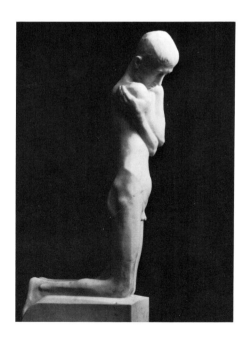

Fig. 33
GEORGE MINNE
(born 1866 at Ghent—died 1941 at Laethem-St. Martin)
KNEELING YOUTH
Marble. Height: 79 cm
Museum des 20. Jahrhunderts, Vienna

Minne's elegiac art first found recognition in Vienna, and not only influenced Klimt, but also made a great impression on the younger artists, particularly Kokoschka and Schiele.

76

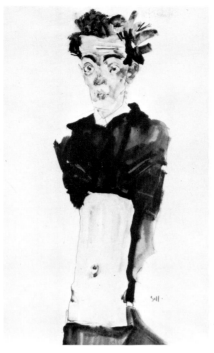

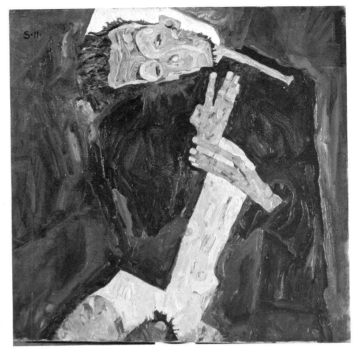

Fig. 34
SELF-PORTRAIT 1911

Pencil, water-colour. 55.2 × 36.4 cm
Monogrammed and dated: S. 11.
Graphische Sammlung Albertina, Vienna. Inv. No. 33.358

Fig. 35
LYRICIST 1911

Oil on canvas. 80.5 × 80 cm
Monogrammed and dated: S. 11.
K. 128; L. 172
Collection of Dr. Rudolf Leopold, Vienna

Fig. 36
SELF-OBSERVER II (DEATH AND MAN) 1911

Oil on canvas. 80.5 × 80 cm
Monogrammed and dated: S. 11.
K. 129; L. 173
Collection of Dr. Rudolf Leopold, Vienna

The first version was created in 1910 and is lost (K. 113; L. 161). A study for it is the double self-portrait on the back of the portrait of A. Roessler in the Albertina (Inv. No. 31.247). In its second version, reproduced here, the theme is translated into the visionary, ghostly sphere.

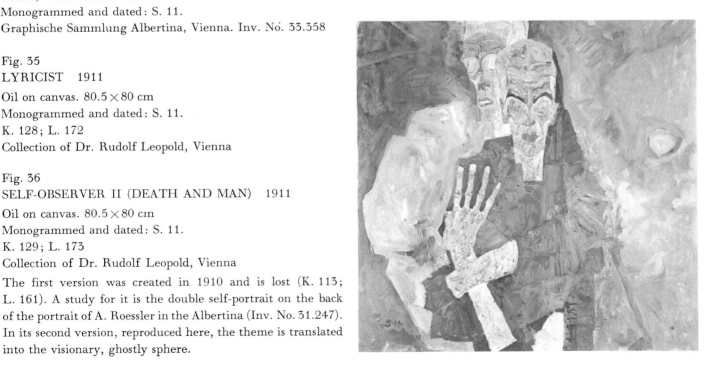

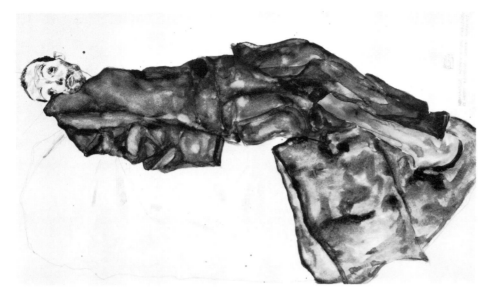

Fig. 37
SELF-PORTRAIT AS A PRISONER
1912

Pencil, water-colour. 31.7 × 48.7 cm
Signed and dated: Egon Schiele 23. IV. 12
(beneath which is the stylized letter D).
Inscribed: "It is a crime to confine the
artist, it means murdering life in the
bud!"
Graphische Sammlung Albertina,
Vienna. Inv. No. 31.162

The D under the date indicates the day
of the week: Tuesday (Dienstag), see
James T. Demetrion in the exhibition
catalogue of the Des Moines Art Center,
1971.

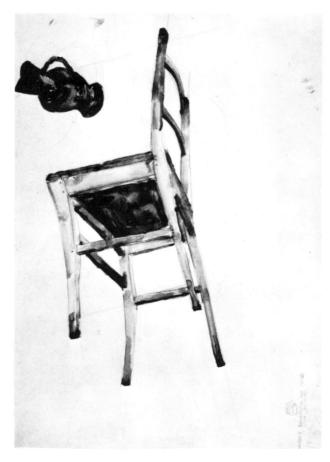

Fig. 38
STILL-LIFE WITH CHAIR AND JUG
1912

Pencil, water-colour. 48 × 31.8 cm
Signed and dated: Egon Schiele 21. IV. 12
(beneath which is the stylized letter G).
Inscribed: "Organic Movement of the
Chair and Jug"
Graphische Sammlung Albertina,
Vienna. Inv. No. 31.030

The stylized letter G appears on five
other drawings dating from the period
of Schiele's imprisonment at Neuleng-
bach, and stands for "Gefängnis"
(Prison), or "Gefangenschaft" (Cap-
tivity).—James T. Demetrion, op. cit.

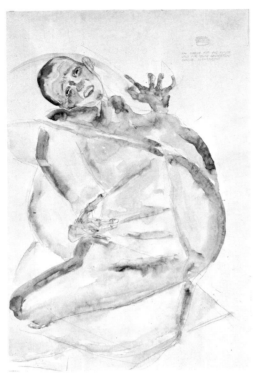

Fig. 39
SELF-PORTRAIT AS A PRISONER 1912
Pencil, water-colour. 48.2 × 31.8 cm
Signed and dated: Egon Schiele 25. IV. 12 (beneath which
is the stylized letter D: Donnerstag [Thursday]). Entitled:
"I will gladly endure for the sake of art and my loved ones!"
Graphische Sammlung Albertina, Vienna. Inv. No. 31.027

Fig. 40
STUDY FOR THE "HOLY FAMILY" 1913
Pencil, water-colour. 47.7 × 31.7 cm
Signed and dated: Egon Schiele 1913
Graphische Sammlung Albertina, Vienna. Inv. No. 25.793

Fig. 41
WALLY 1912

Pencil, gouache. 29.7 × 26 cm
Signed and dated: Egon Schiele 1912
Private collection

Already before his imprisonment Schiele had painted a
portrait of his model Wally Neuzil, who lived with him.
It forms the companion piece to the "Self-portrait with
Chinese Lantern Fruit" (K. 151, 152; L. 211, 212). The
drawing reproduced here shows great similarity in style and
expression to the self-portrait (pl. 35) painted at the end of
the year.

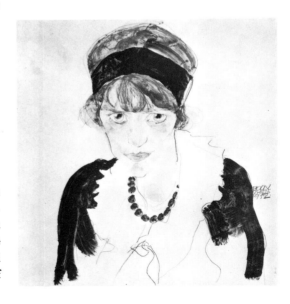

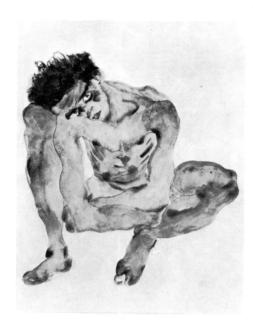

Fig. 42
CROUCHING FIGURE (Self-portrait) 1912
Pencil, water-colour. 44×30 cm
Signed and dated: Egon Schiele 1912
Collection of Dr. Eugene A. Solow and Family, Chicago

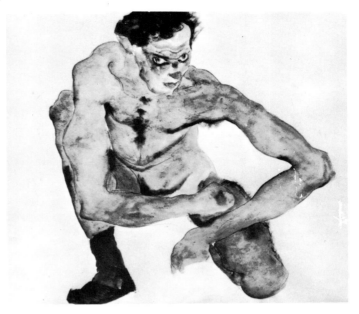

Fig. 43
SQUATTING MALE NUDE WITH STOCKINGS (Self-portrait) 1912
Pencil, water-colour. 31.5×42 cm
Private collection

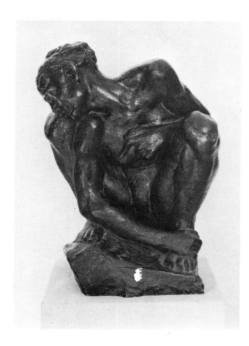

Fig. 44
AUGUSTE RODIN
(born 1840, in Paris—died 1917, at Meudon)

FEMME ACCROUPIE 1882
Bronze. Height: 85 cm
Neue Pinakothek, Munich

The influence of this sculpture on Schiele was first suggested by Werner Hofmann with reference to the female figure in the 1914 painting "Blind Mother" (pl. 50; Hofmann, W., "Egon Schiele: Die Familie", Reclams Werkmonographien zur bildenden Kunst, No. 132, Stuttgart, 1968). Despite some differences—in the position of the head, for example, which is supported on the knee and shoulder, or in the left arm— Rodin's sculpture could already have influenced the self-portrait of 1912. A 1914 drawing, which is close to an etching of the same year entitled "Grief" (Kallir, "Druckgraphik" No. 7), is similarly a free variation on this model (Leopold, pl. 148).

80

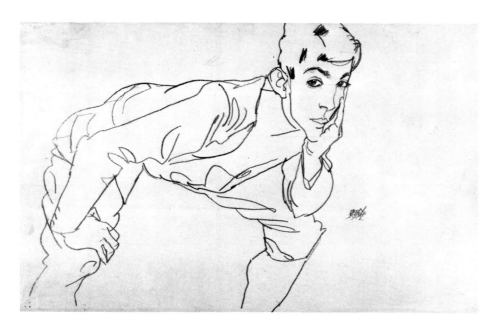

Fig. 45

PORTRAIT OF ERICH LEDERER
1912

Pencil. 32.1 × 48 cm
Signed and dated: Egon Schiele 1912
Private collection

On December 21, 1912, Schiele went to Györ (Raab), in Hungary, on the invitation of the industrialist August Lederer, and here he made several studies and a portrait in oils of Lederer's son Erich (K. 174; L. 223). Cf. pl. 36.

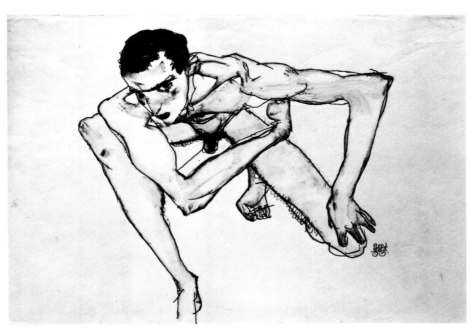

Fig. 46

SELF-PORTRAIT IN CROUCHING POSITION 1913

Pencil and gouache. 32.3 × 47.5 cm
Signed and dated: Egon Schiele 1913
National Museum, Stockholm.
NMH 93/1952

The picture shows several points in common with works of 1912. It combines the posture of the squatting nude (fig. 43) and the balanced posture of the portrait of Erich Lederer, with its thrusting into the background (fig. 45). For the facial expression, cf. the self-portrait, pl. 35.

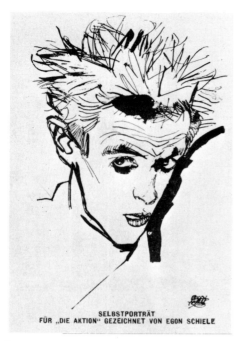

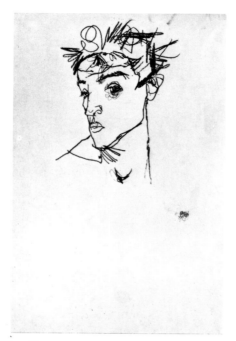

Fig. 47
SELF-PORTRAIT 1913

Postcard, from an ink drawing by Schiele of 1913, published by the Berlin weekly newspaper "Die Aktion". Some of the cards also appeared without the descriptive text (an example in the Schiele archive of the Albertina). The card was also issued without the text by the book-shop of Richard Lanyi in Vienna. Cf. Nebehay, C. M., "Egon Schiele, Frühe Werke und Dokumentation", Vienna, 1968, No. 24c. The Berlin periodical "Die Aktion", a weekly newspaper about politics, literature and art, was founded in 1911 by Franz Pfemfert, and published works by Schiele from 1913 onwards. The self-portrait on this postcard was reproduced in No. 21 on May 21, 1913.

Fig. 48
SELF-PORTRAIT 1913

Pencil. 44.8 × 31.3 cm
Signed and dated: Egon Schiele 1913
National Museum, Stockholm.
NMH 94/1952

This drawing shows great similarities with the self-portrait of pl. 39, and may be directly connected with it.

Fig. 49
HEINRICH BENESCH 1913

Pencil. 48.3 × 32 cm
Signed and dated: Egon Schiele 1913
Graphische Sammlung Albertina, Vienna. Inv. No. 31.154

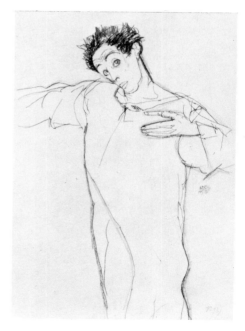

Fig. 50
SELF-PORTRAIT 1913

Pencil. 48 × 32 cm
Signed and dated: Egon Schiele 1913
Owner unknown

Study for the fragment of a painting "Self-portrait in a Monk's Habit with Wally" (K. 180; L. 228).

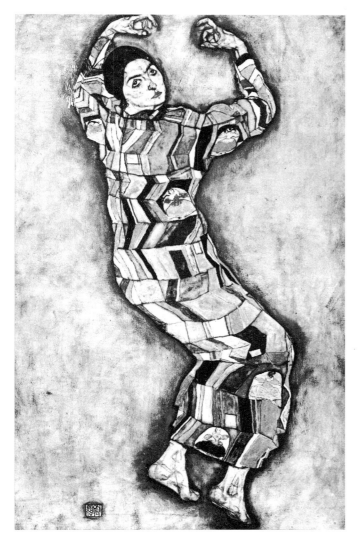

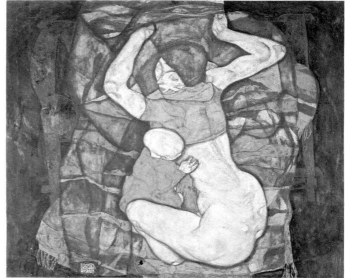

Fig. 52
YOUNG MOTHER 1914

Oil on canvas. 100×120 cm
Signed and dated: Egon Schiele 1914
Inscribed by the artist on the Verso: "Die Mutter"
K. 194; L. 250
Private collection

The position of the woman, with her arms raised up, is reminiscent of a caryatid. Schiele repeated this posture in the "Portrait of Friederike Maria Beer" (fig. 51), but in a changed, elongated form. The painting was used for a reversed etching of a female nude, "Squatting Woman" (Kallir, "Druckgraphik", No. 6), also made in 1914.

Fig. 51
PORTRAIT OF FRIEDERIKE MARIA BEER 1914

Oil on canvas. 190×120.5 cm
Signed and dated: Egon Schiele 1914
K. 192; L. 256
Private collection, U.S.A.

F. M. Beer, one of the daughters of the owner of the "Kaiserbar" in Vienna, was painted lying on the ground, yet an impression of light, weightless floating is conveyed. Cf. also the prison drawing "Organic Movement of the Chair and Jug", dating from 1912 (fig. 38), and the painting of 1915, "Levitation" (pl. 58). The Bolivian Indian dolls were added by the artist to the pattern of the Vienna Workshop dress. The sitter was also portrayed by G. Klimt in 1916 (Novotny - Dobai, No. 196).

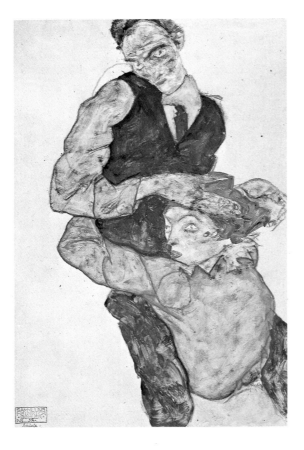

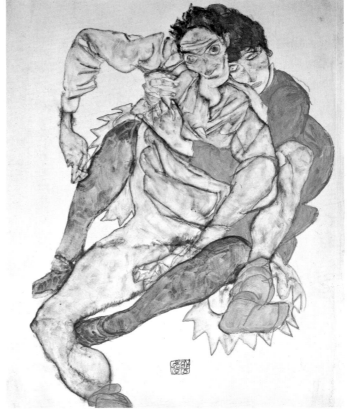

Fig. 53
LOVERS 1914–15

Pencil, water-colour and gouache. 47.5 × 30.5 cm
Collection of Dr. Rudolf Leopold, Vienna

The Lovers have the features of Schiele and his model Wally
Neuzil. As in the painting "Death and Girl" of 1915 (pl. 59),
the woman clasps her lover in her embrace. For the posture
of the man, cf. also the study in Kallir, "Skizzenbuch", p. 46.

Fig. 54
SEATED COUPLE 1915

Pencil, gouache. 52 × 41.1 cm
Signed and dated: Egon Schiele 1915
Graphische Sammlung Albertina, Vienna. Inv. No. 29.766

Leopold recognizes Schiele's wife Edith in the woman, yet
there is a definite similarity to the woman in the "Lovers"
(fig. 53). However, see also the drawing dated 1916 owned
by Serge Sabarsky, New York (ill. in the exhibition catalogue
of the Des Moines Art Center, 1970, pl. 52). The motif of
the body hanging as if lifeless in the woman's arms is—like
Kokoschka's poster for the summer theatre of the "1909
Vienna Art Exhibition"—inspired by representations of the
Pietà. A sketch for the composition shows the woman with
her legs closed (Leopold, p. 390). The facial expression of
Schiele is related to that in the woodcut of 1916, "Man's
Head" (Kallir, "Druckgraphik", No. 14).

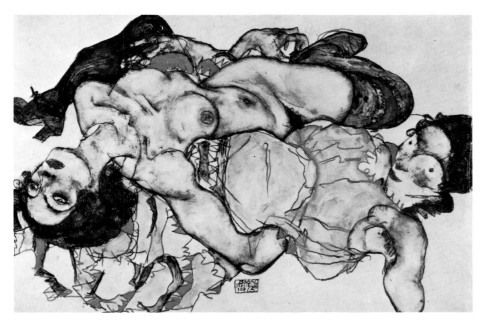

Fig. 55
TWO GIRLS LYING ENTWINED
1915

Pencil, gouache. 32.8 × 49.7 cm
Signed and dated: Egon Schiele 1915
Graphische Sammlung Albertina,
Vienna. Inv. No. 31.173

These are the same two models as in
pl. 56. Here too, the lifelike face of the
nude contrasts with the mask-like one
of the clothed figure. The circular
hollows of the eyes with their dot-like
pupils were already found in the art of
Edvard Munch, and in Berthold Löffler's
poster for the theatre and cabaret
"Fledermaus" of 1907 ("Wien um
1900", exhibition catalogue No. 572,
fig. 65). Cf. also Schiele's rubber-cut
"Head II" of 1916 (Kallir, "Druck-
graphik", No. 11).

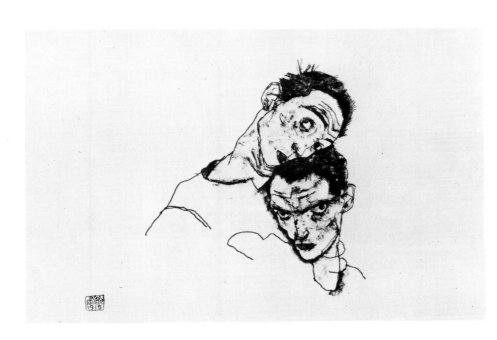

Fig. 56
DOUBLE SELF-PORTRAIT 1915
Pencil, water-colour and gouache.
32.5 × 49.4 cm
Signed and dated: Egon Schiele 1915
Private collection

Fig. 57
MOTHER WITH CHILDREN; AT
THE SIDES, TOYS AND
ORNAMENTS 1915
Pencil and gouache. 17.5 × 43.5 cm

Neue Galerie der Stadt Linz, Wolfgang
Gurlitt Museum. Inv. No. 300
The composition of the group of figures
is close to that in the oil-painting "Mother
with Two Children" in the Österreichi-

sche Galerie, Vienna (pl. 67). On the
back, Schiele notes "Sketch for a purse
for Edith", which accounts for the
asymmetrical arrangement of the small
panels flanking the main scene.

Fig. 58
RUSSIAN PRISONER OF WAR 1915
Pencil and gouache. 44 × 30 cm
Signed and dated: Egon Schiele 1915
Graphische Sammlung Albertina,
Vienna. Inv. No. 34.280

The drawing was formerly in the Öster-
reichische Staatsgalerie, for which it
was acquired direct from the artist in
1917.

Fig. 59
SKETCHES OF PREHISTORIC
THEMES
Double page from a sketch-book in the
Schiele archive of the Albertina
Pencil. Each, 20.2 × 16.5 cm

The sketches are enclosed in small areas,
which are not systematically arranged.

Fig. 60
WOODLAND PRAYER
Sketch from a sketch-book in the Schiele
archive of the Albertina
Pencil. 14 × 8,5 cm

A study for the picture of the same
subject (pl. 57). Schiele noted on the
opposite page: Tree-trunks grey, light,
transparent, glazed earth-green bark,
the wood sienna-grey-blue.

Fig. 61
STUDY FOR A DOUBLE PORTRAIT
OF EGON AND EDITH SCHIELE
Charcoal. 17.4 × 10.4 cm
Reproduced in "Ein Skizzenbuch von
Egon Schiele". Commentary by Otto
Kallir, Johannes Press, New York, 1967,
p. 107.

The picture, which the artist, according
to an entry in his war diary, painted
in April 1916, is not known (K. XLIX;
L. LIV). The two figures are shown
seated side by side in front of an
ornamentally conceived background,
which consists of small pictorial units.
Cf. also Schiele's sketch for a wall-
painting (Leopold, pl. 223).

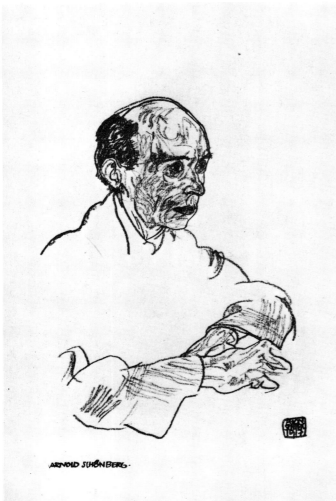

Fig. 62

PORTRAIT OF ARNOLD SCHÖNBERG 1917

Black chalk. 45.3 × 29 cm

Signed and dated: Egon Schiele 1917. Inscribed: Arnold Schönberg

Private collection, Vienna

The composer and pioneer of twelve-tone music Arnold Schönberg (1874-1951) was portrayed by Schiele also in two other water-colour drawings (Albertina exhibition catalogue, 1968, No. 263, and Des Moines Art Center exhibition catalogue, 1971, No. 55). Schönberg, Schiele, Klimt, J. Hoffmann and others formed the idea of founding a working-group, "Kunsthalle" (art gallery), which, however, was not realized.

Fig. 63

PORTRAIT OF ANTON WEBERN 1918

Black chalk. 47.1 × 30 cm

Signed and dated: Egon Schiele 1918

Collection of Sivvy Streli, Innsbruck

Anton Webern (1883-1945) was a pupil of Arnold Schönberg. A portrait study of the composer, in profile, dated 1917, is in a private collection in New York.

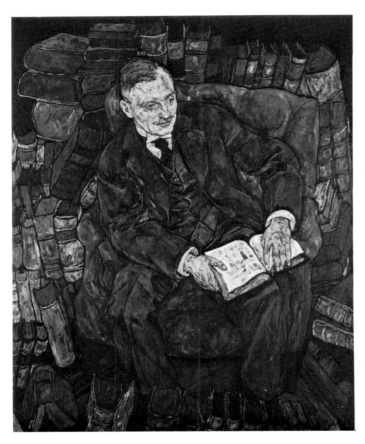

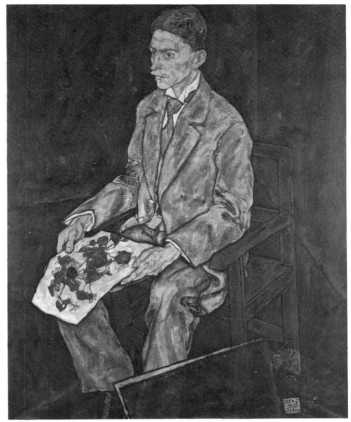

Fig. 64
PORTRAIT OF DR. HUGO KOLLER 1918

Oil on canvas. 140 × 110 cm

Not signed or dated

K. 236; L. 293

Österreichische Galerie, Vienna

The industrialist Dr. Hugo Koller (1867–1949) was married
to the painter Broncia Pinell. Schiele's water-colour drawings
of peasant pottery were made at Koller's country house in
Ober-Waltersdorf (cf. pl. 79).

Fig. 65
PORTRAIT OF DR. FRANZ MARTIN HABERDITZL
1917

Oil on canvas. 140.5 × 110 cm

Signed and dated: Egon Schiele 1917

K. 220; L. 282

Private collection, Vienna

F. M. Haberditzl, the director of the Österreichische Staats-
galerie from 1916 to 1938, was in close touch with Schiele,
and made the first purchases of his works in 1917 (Leopold,
p. 670). Already in 1916 he wanted to acquire the 1911
"Autumn Trees" (fig. 32), but the picture had already been
sold (E. Baum in the Österreichische Galerie exhibition
catalogue, 1968, No. 58). The sitter holds in his hands one
of Schiele's many pictures of sunflowers.

Fig. 66
SEATED FEMALE NUDE WITH DRAPERY 1917
Pencil. 45.8 × 30 cm
Signed and dated: Egon Schiele 1917
Private collection
The drawing, closely related to that reproduced in fig. 67 in the posture of the body, shows how Schiele was able, once he had found solutions, to vary them and to use them in very different contexts.

Fig. 67
SQUATTING MALE NUDE 1917
(Self-portrait)
Black chalk, water-colour, gouache. 46.1 × 29.1 cm
Signed and dated: Egon Schiele 1917
Graphische Sammlung Albertina, Vienna. Inv. No. 31.106
The extended arm, bent down at a right angle, was a favourite and frequently-recurring theme in Schiele's art. Here it points forward to the picture "The Family" (pl. 75) and was also used by Schiele in connection with the composition of "Round the Table" (The Friends). Cf. fig. 74.

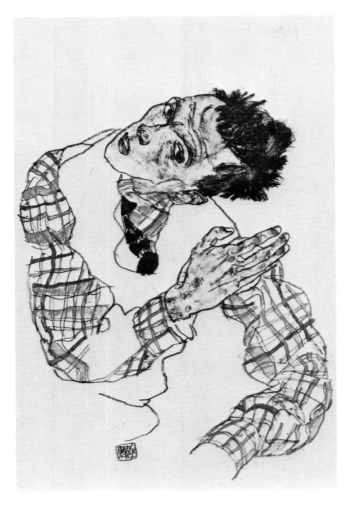

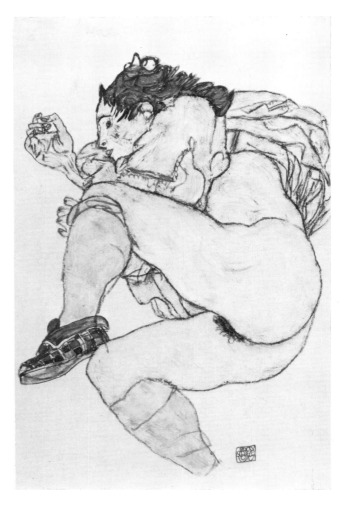

Fig. 68

SELF-PORTRAIT WITH CHECKERED SHIRT 1917

Pencil, water-colour, gouache. 45.5 × 29.5 cm

Signed and dated: Egon Schiele 1917

Private collection

Frau Jella Pollak, who, as a young art-student, paid a visit to Schiele in 1917, recounts in her memoirs: "He wore an—at that time—unusual shirt, large blue checks on a beige background" (Fischer, W., "Unbekannte Tagebuchblätter und Briefe von Egon Schiele und Erinnerungen einer Wiener Emigrantin in London", in "Albertina-Studien II", 1964, 4, pp. 172 ff.). In this drawing, the checks are still left white.

Fig. 69

RECUMBENT FEMALE NUDE WITH LEFT LEG DRAWN UP 1917

Pencil, water-colour, gouache. 46 × 29 cm

Signed and dated: Egon Schiele 1917

Private collection, Switzerland

Not only the checkered slipper, but the whole composition seems to be arranged as an ingenious decorative pattern. This drawing shows particularly clearly the close connection between ornament and realism in Schiele's works.

91

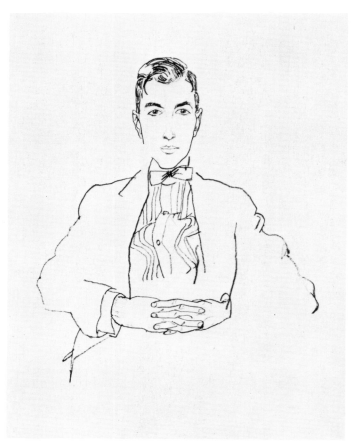

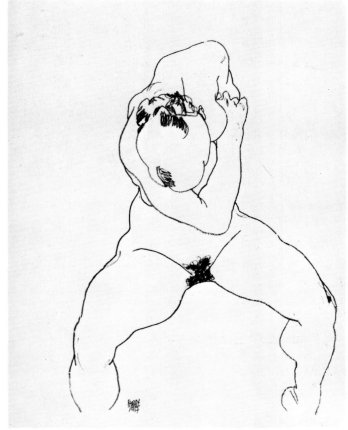

Fig. 70
PORTRAIT OF ERICH LEDERER 1917

Black chalk. 45.8 × 29.5 cm

Dated on the back: 1917

Private collection

Schiele made several portraits of his young friend Erich
Lederer and also gave him drawing lessons. See also pl. 36
and fig. 45.

Fig. 71
STANDING FEMALE NUDE WITH HEAD BENT DOWN
AND LEGS SPREAD OUT 1917

Black chalk. 46 × 29.7 cm

Signed and dated: Egon Schiele 1917

Private collection

The style, in its economy and clarity of line, is closely re-
lated to that of fig. 70.

92

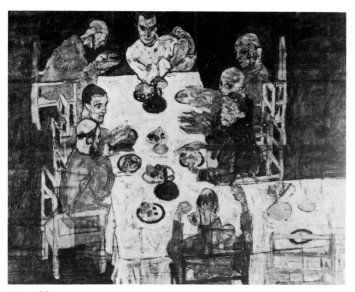

Fig. 72
THE FRIENDS (ROUND THE TABLE) 1918
(Large version, unfinished)
Oil on canvas. 99.5 × 119.5 cm
Not signed or dated
K. 244; L. 287
Private collection

Fig. 73
SKETCH FOR "THE FRIENDS" (ROUND THE TABLE)
Charcoal. 17.4 × 10.4 cm
Reproduced in "Ein Skizzenbuch von Egon Schiele". Commentary by Otto Kallir, Johannes Press, New York, 1967, p. 111.
Fig. 74
SKETCH FOR "THE FRIENDS" (ROUND THE TABLE)
1918
Pencil. 16.5 × 16.5 cm
Signed and dated: Egon Schiele 1918
On the back: studies for a portrait of a man and an exhibition poster
La Boetie exhibition catalogue, New York, 1971, No. 2
A detail study for Schiele himself, who is represented at the narrow end of the table, is reproduced in Kallir, "Skizzenbuch", p. 112. This was wrongly related by Leopold to the "Seated Couple" of 1915 (fig. 54).

93

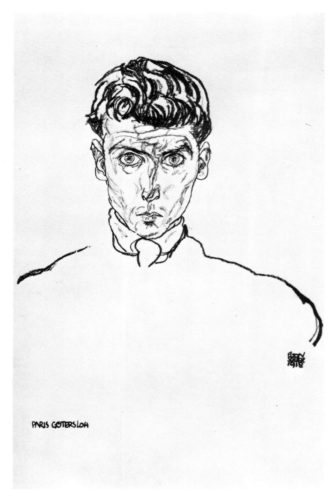

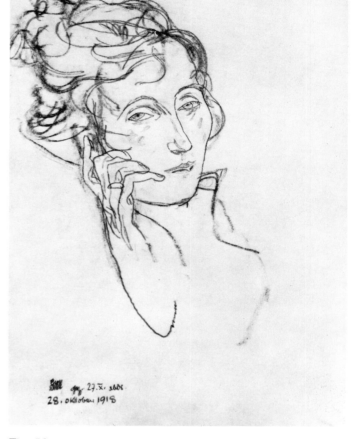

Fig. 75

PORTRAIT OF A. P. GÜTERSLOH 1918

Black chalk. 47 × 30 cm

Signed and dated: Egon Schiele 1918. Inscribed: Paris Gütersloh

Graphische Sammlung Albertina, Vienna. Inv. No. 31.250

Study for the painting K. 234; L. 294. The drawing also served as a basis for the lithograph which Schiele created on commission from the "Society for Graphic Art", and which was not accepted by the society (Kallir, "Druck-graphik", No. 16). A very similar study, also executed in black chalk and inscribed "Paris Gütersloh", is owned by Mr. and Mrs. D. Thomas Bergen, London, and is on loan to the Art Institute of Chicago (Des Moines Art Center exhibition catalogue, 1971, No. 60).

Fig. 76

EDITH SCHIELE 1918

Black chalk. 44 × 29.5 cm

Inscribed: Egon Schiele gez. 27. X abds. 28 Oktober 1918 (Egon Schiele: drawn on 27. X in the evening. October 28, 1918)

Collection of Dr. Rudolf Leopold, Vienna

The drawing shows the wife of the artist on the day before her death. Another drawing with the same inscription, but not showing the hand, is in a private collection in Vienna.

94

PLATES

Plate 1

Water Sprites II
1908

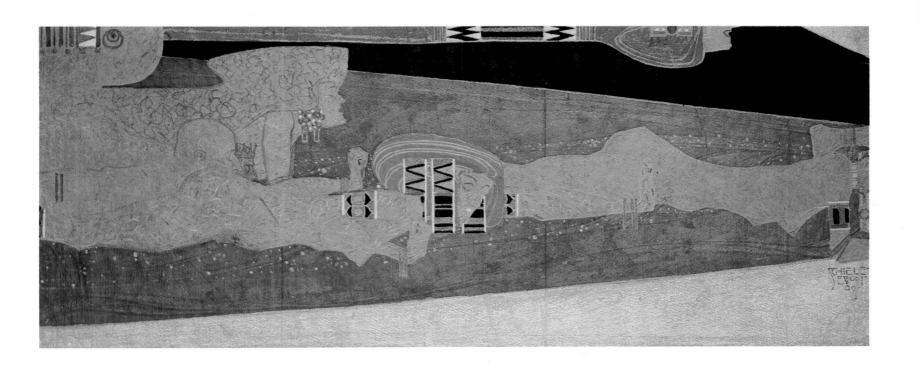

Plate 2

Standing Woman in a Long Cloak
1908

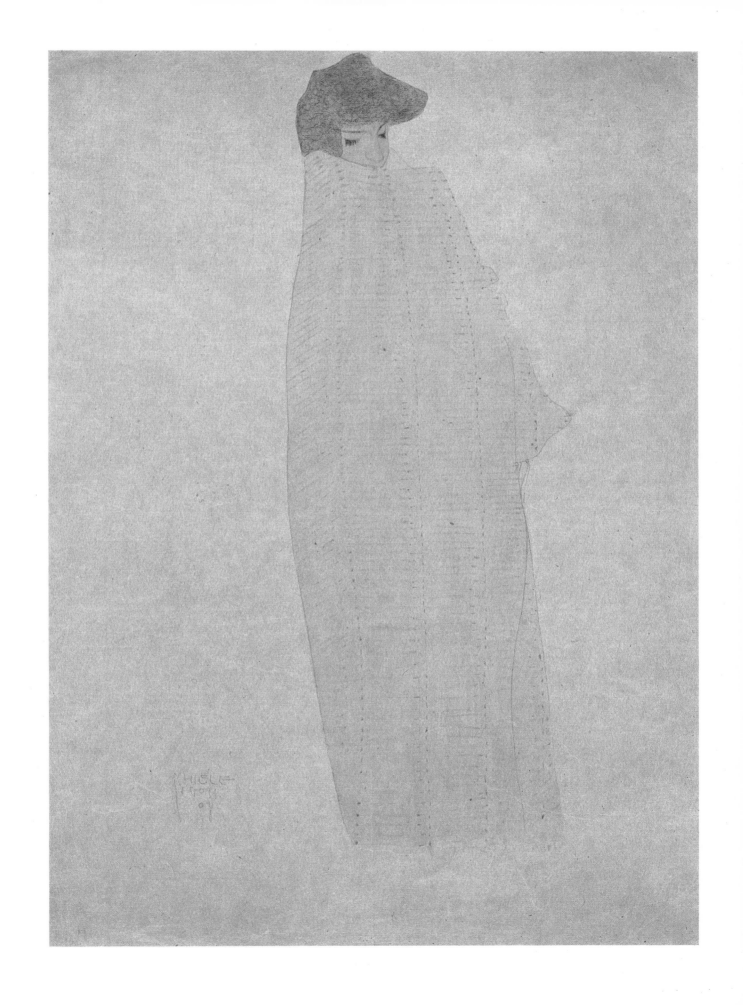

Plate 3
Portrait of the Composer Löwenstein
1909

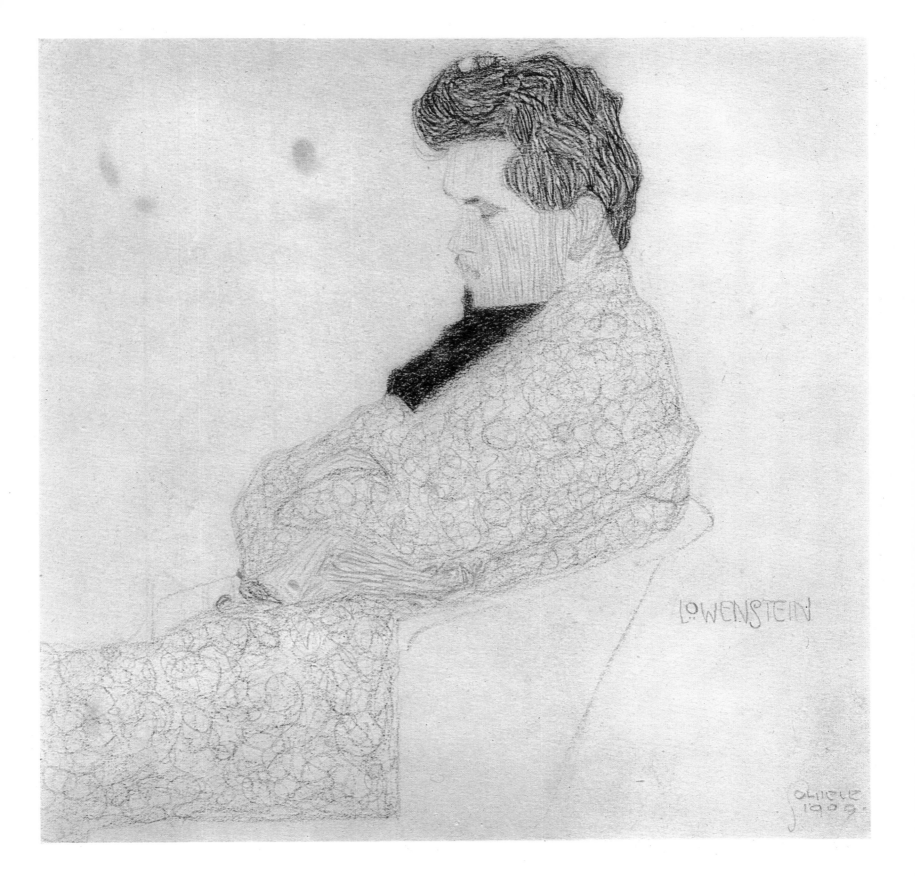

LÖWENSTEIN

SCHIELE
1909

Plate 4

Portrait of Gerta Schiele
1909

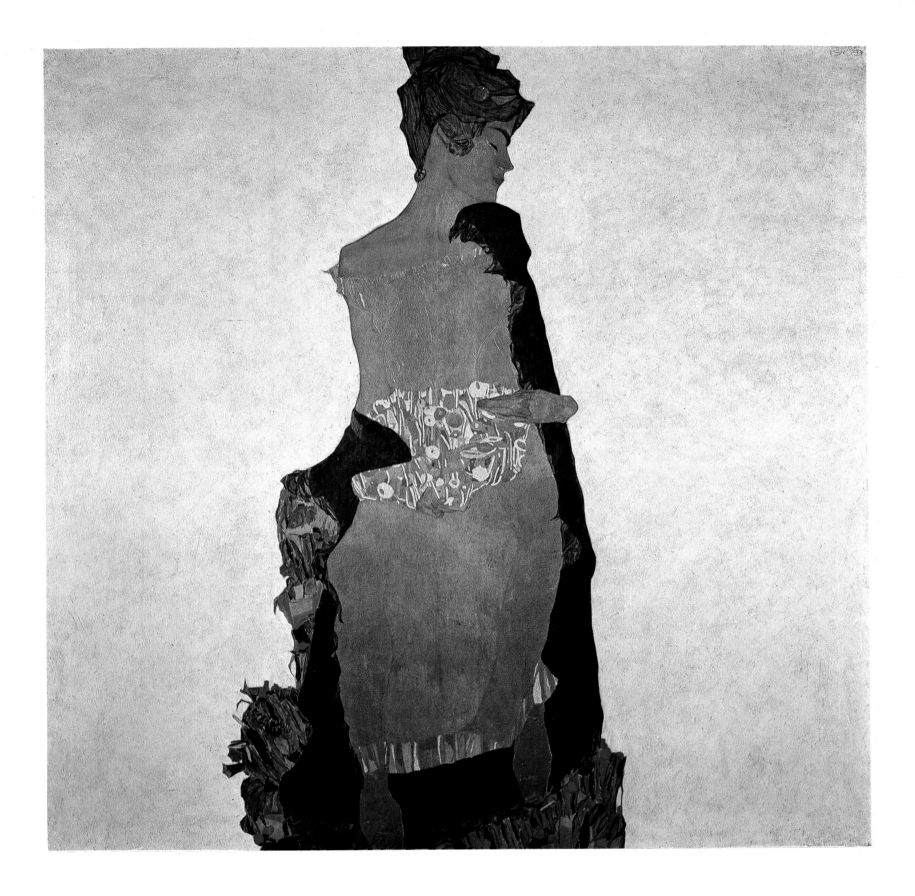

Plate 5

Sunflower
1909/10

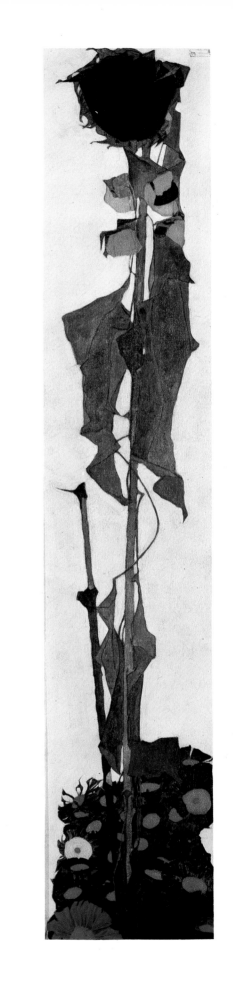

Plate 6
Seated Male Nude
1910

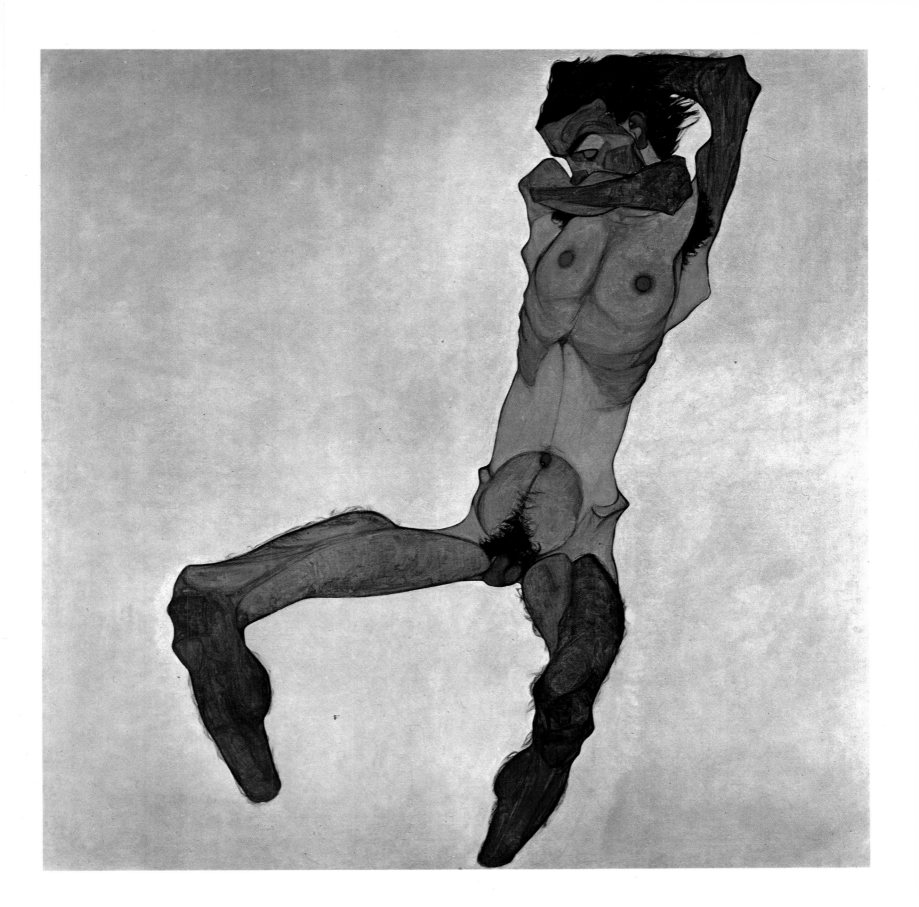

Plate 7
Field of Flowers
1910

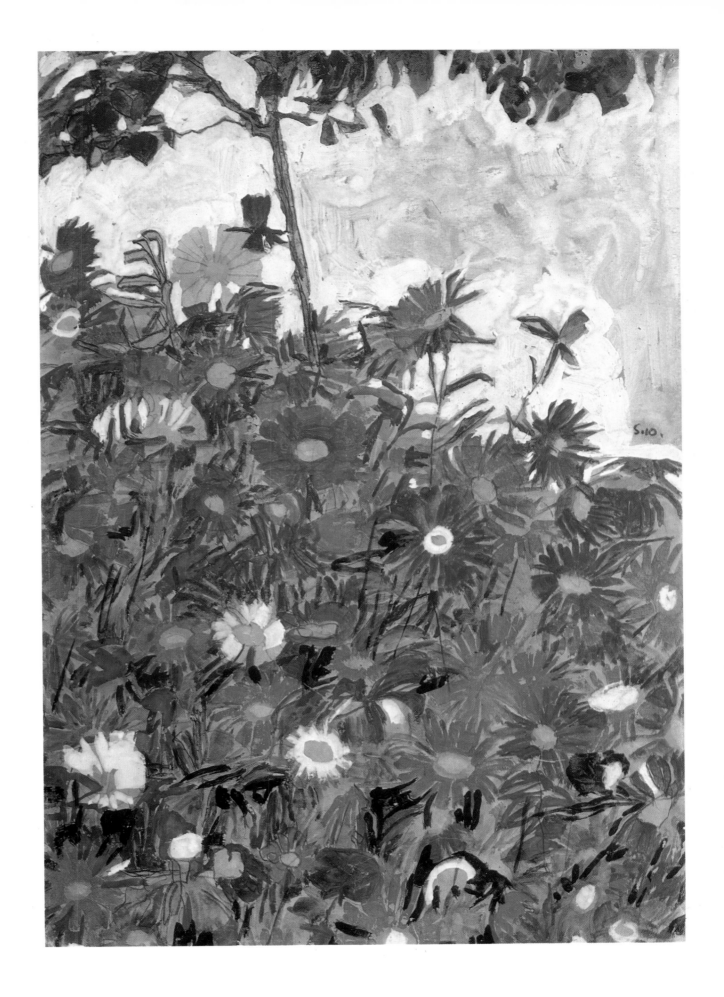

Female Nude
1910

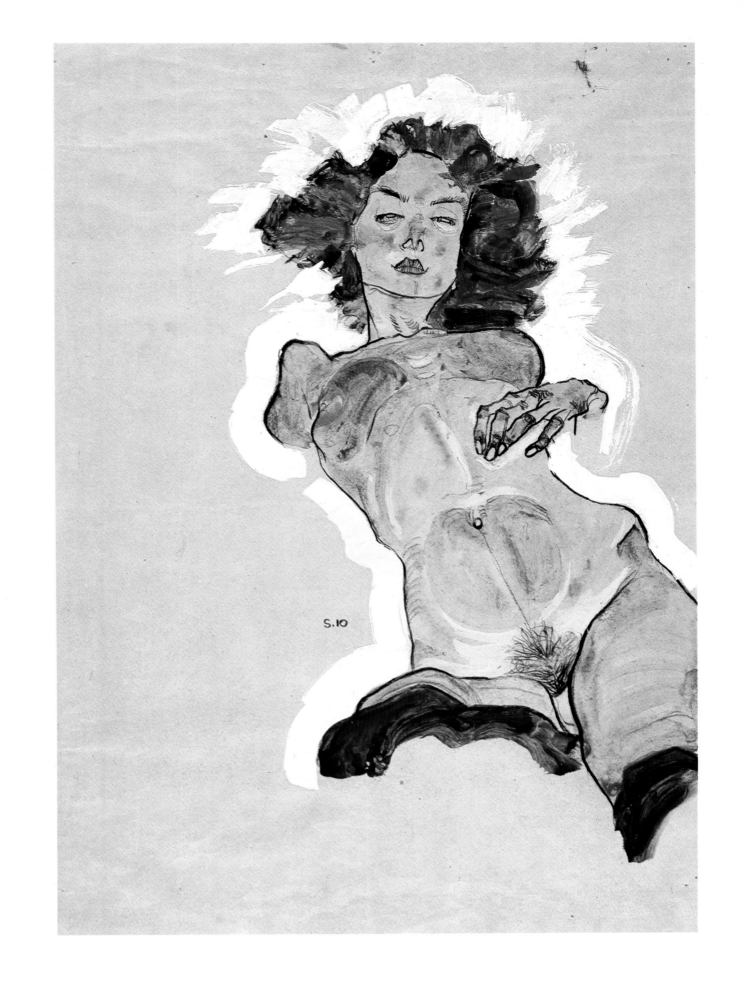

Plate 9
Nude Self-Portrait
1910

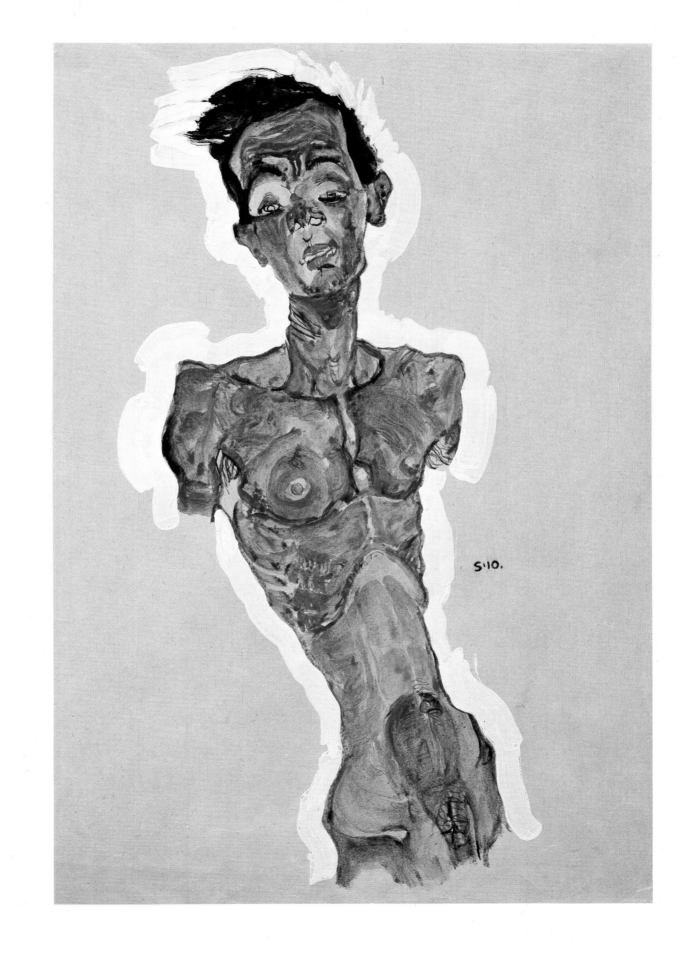

Plate 10
Three Street Urchins
1910

114

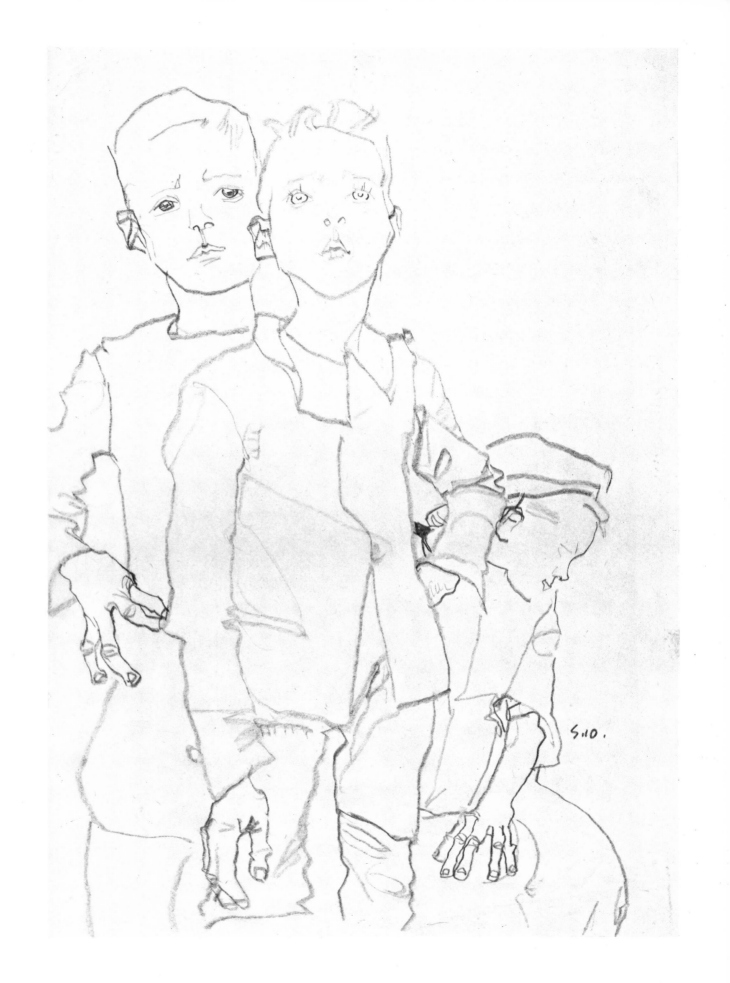

Plate 11

Portrait of the Art Critic Arthur Roessler
1910

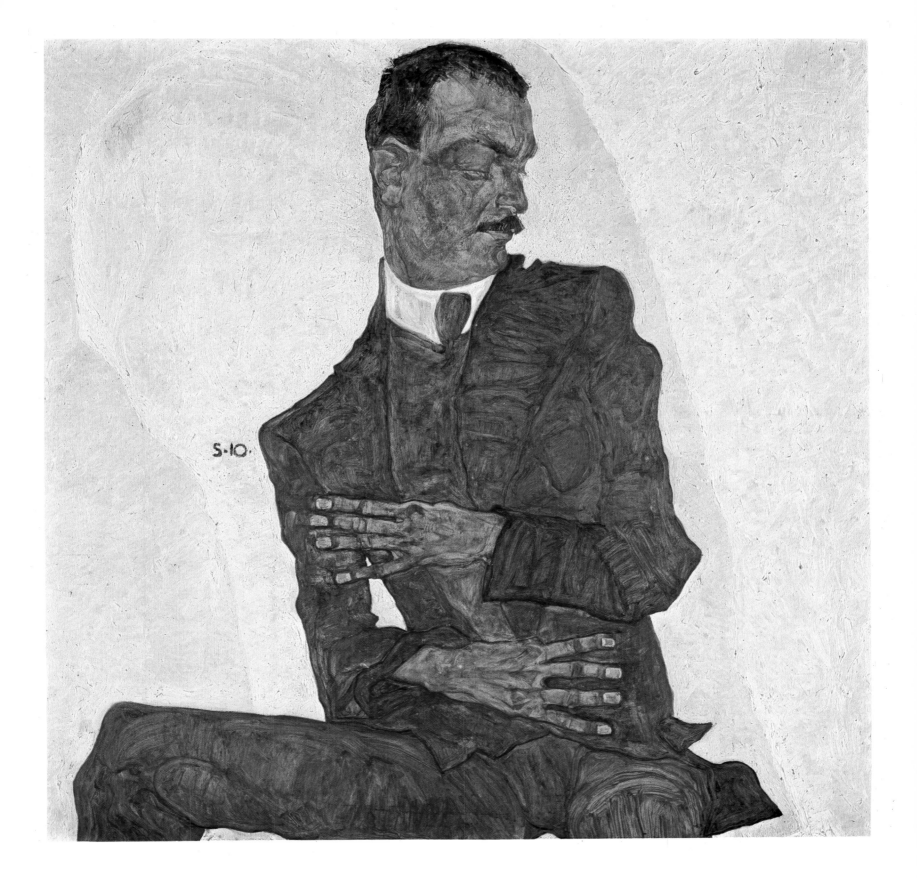

Plate 12

Portrait of the Publisher Eduard Kosmack
1910

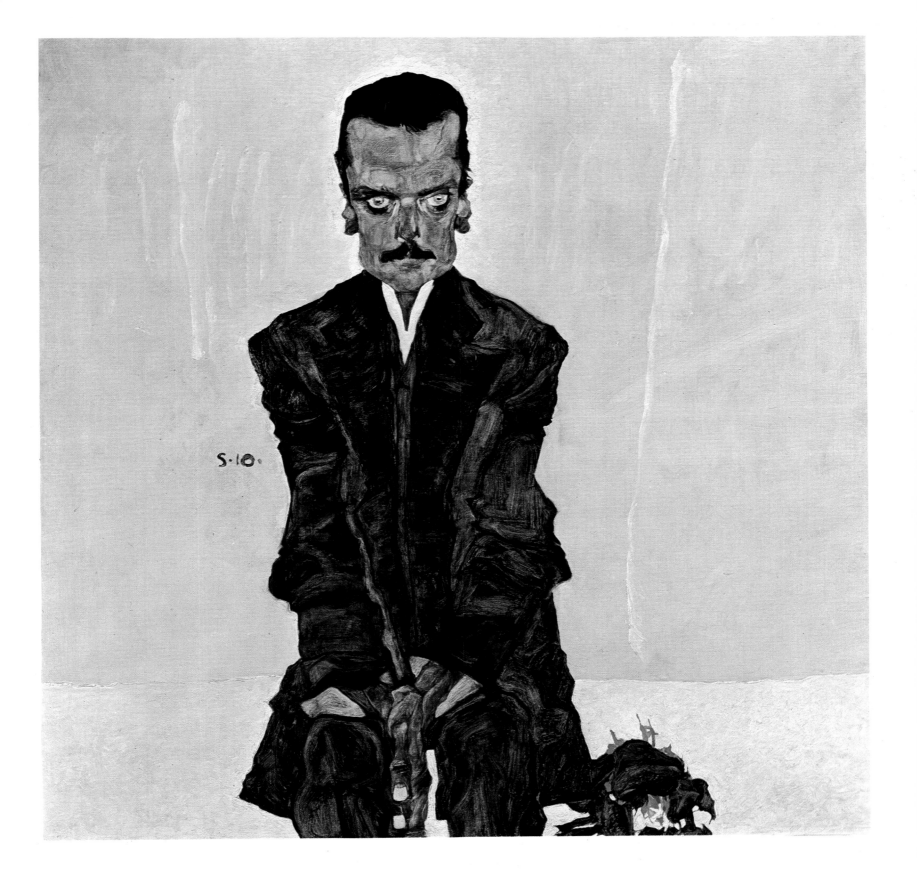

Plate 13
Standing Male Nude (Self-Portrait)
1910

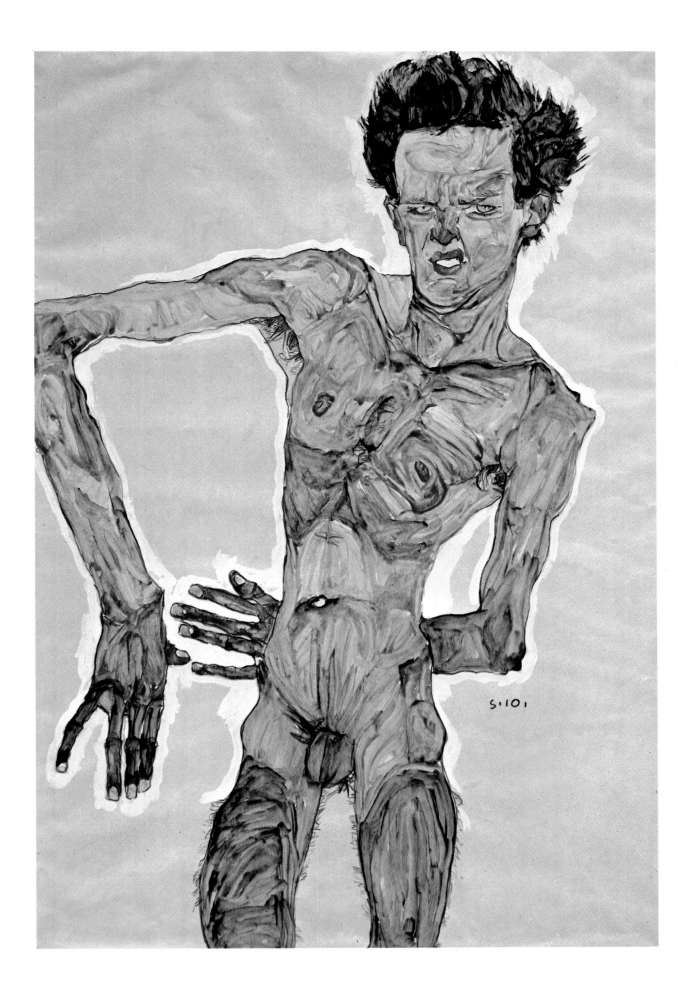

Plate 14
Dead Mother
1910

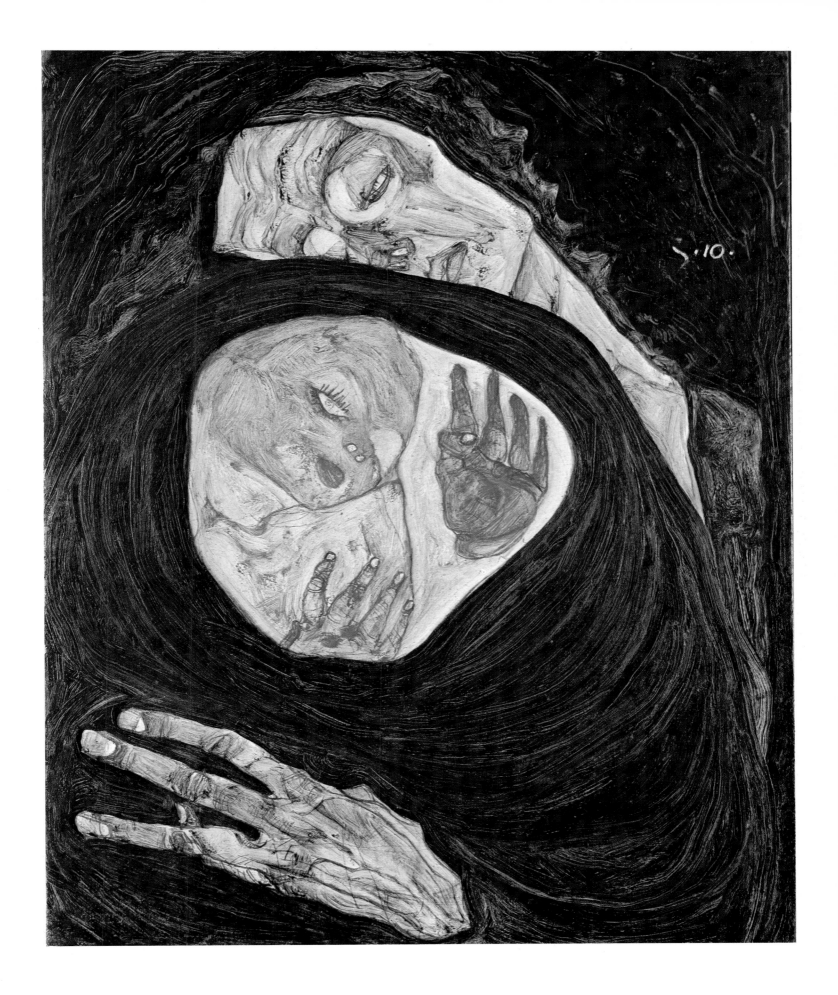

Plate 15

Schiele Drawing a Nude Model
before a Mirror
1910

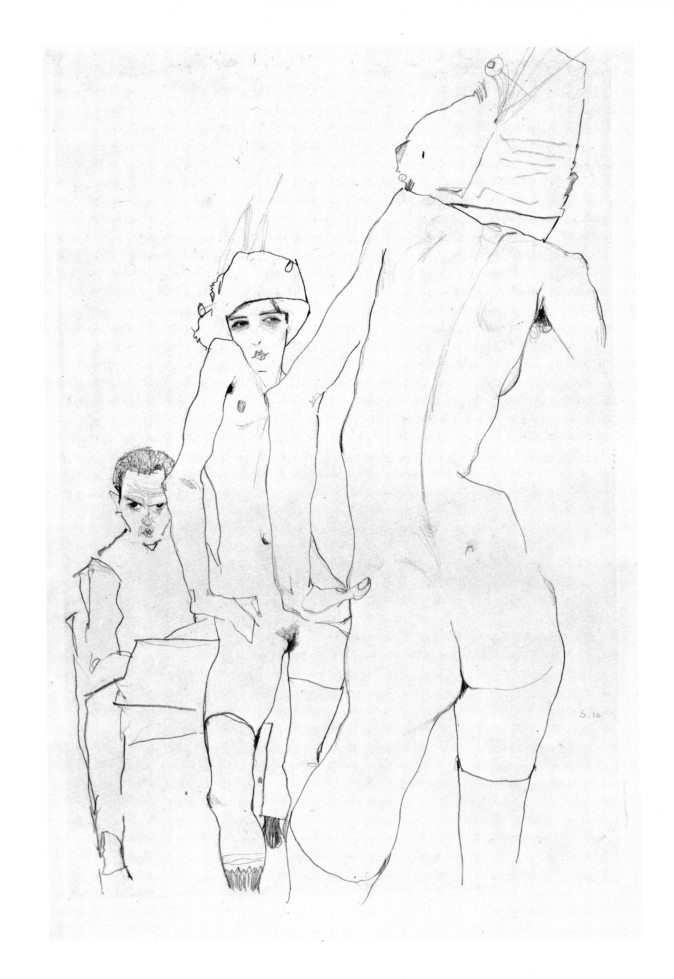

Plate 16

The Dancer Moa
1911

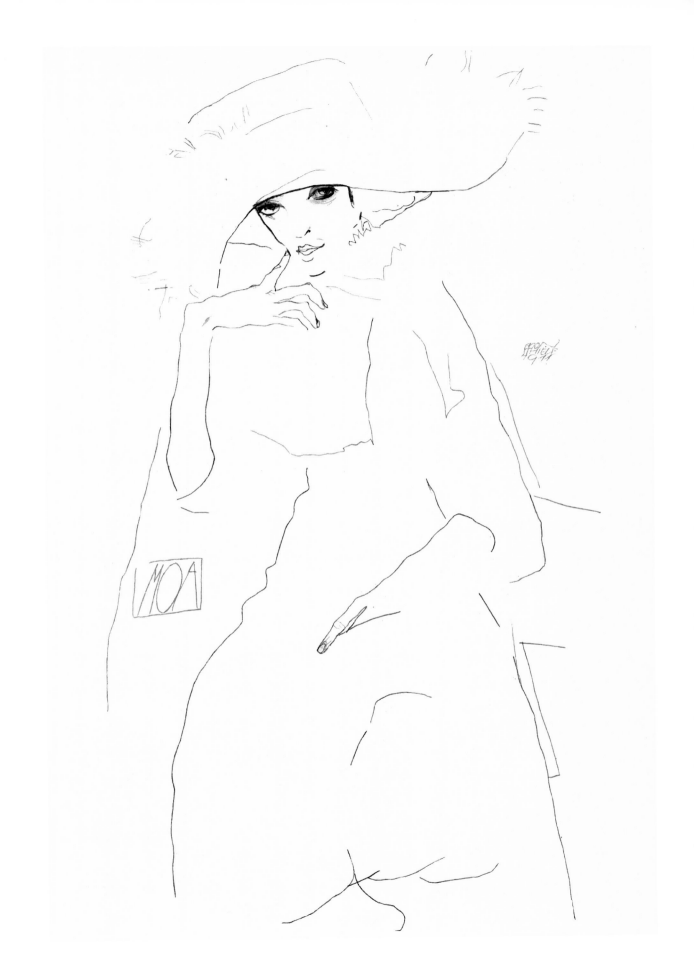

Plate 17

Gerta Schiele with Eyes Closed
1911

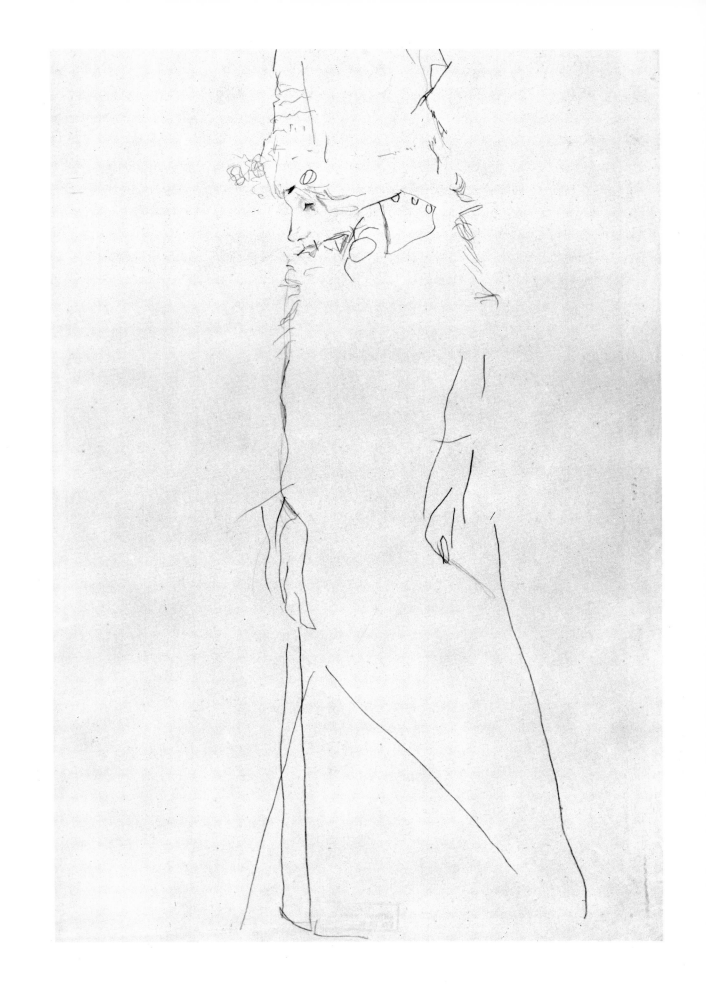

Plate 18

Composition with Three Male Figures
(Self-Portrait)
1911

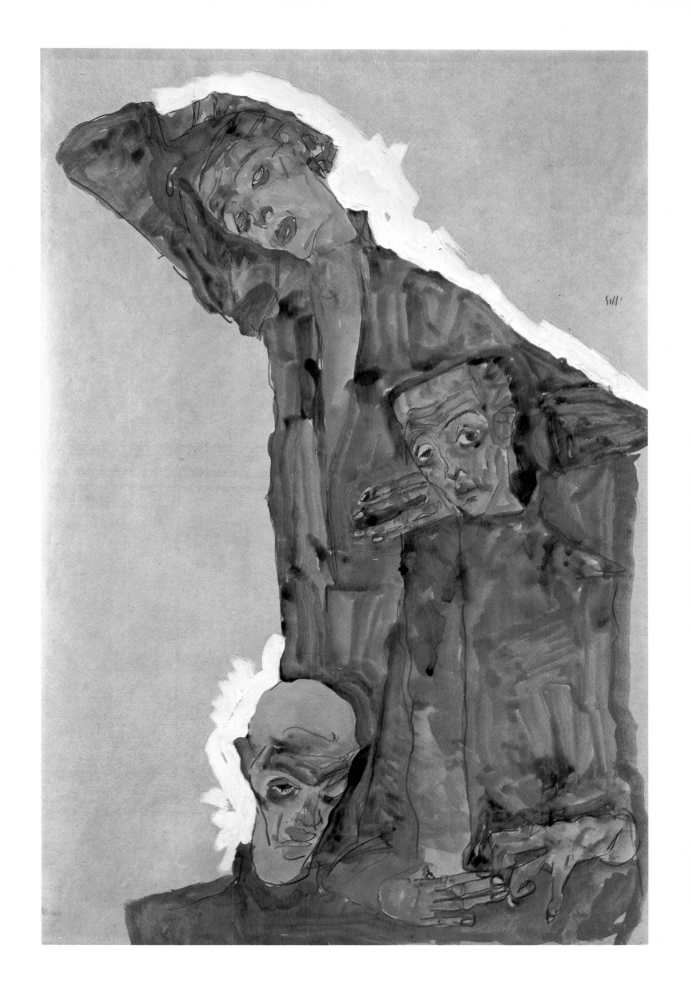

Plate 19
Dead City
1911

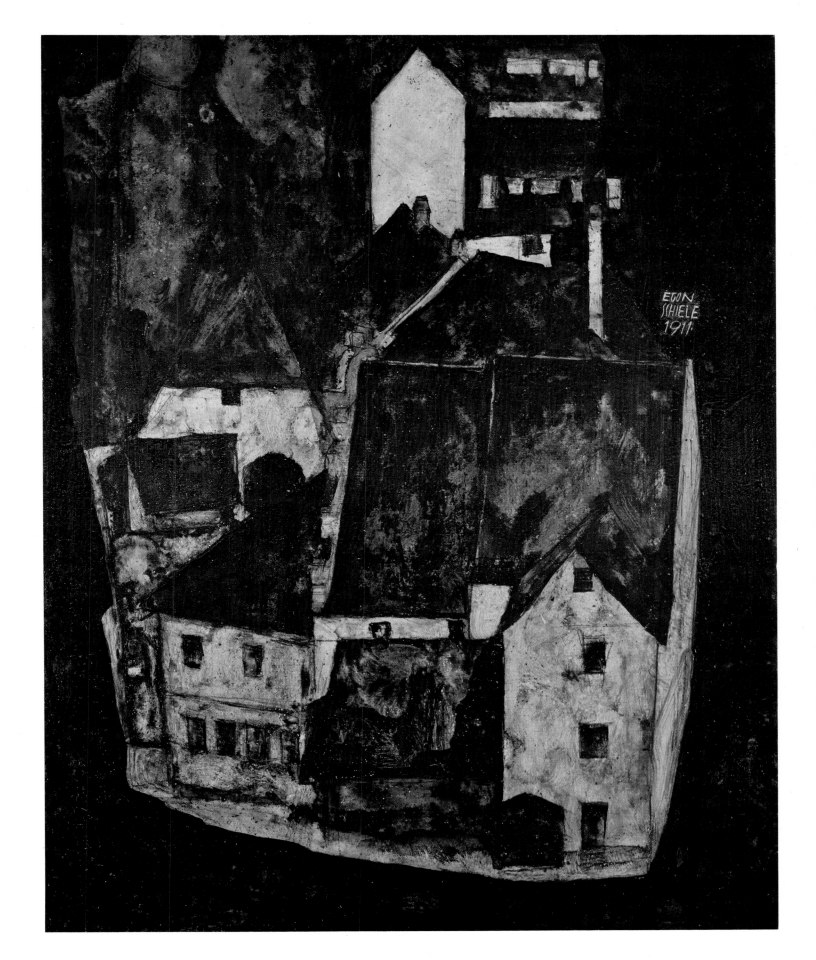

Plate 20

Girl in Black

1911

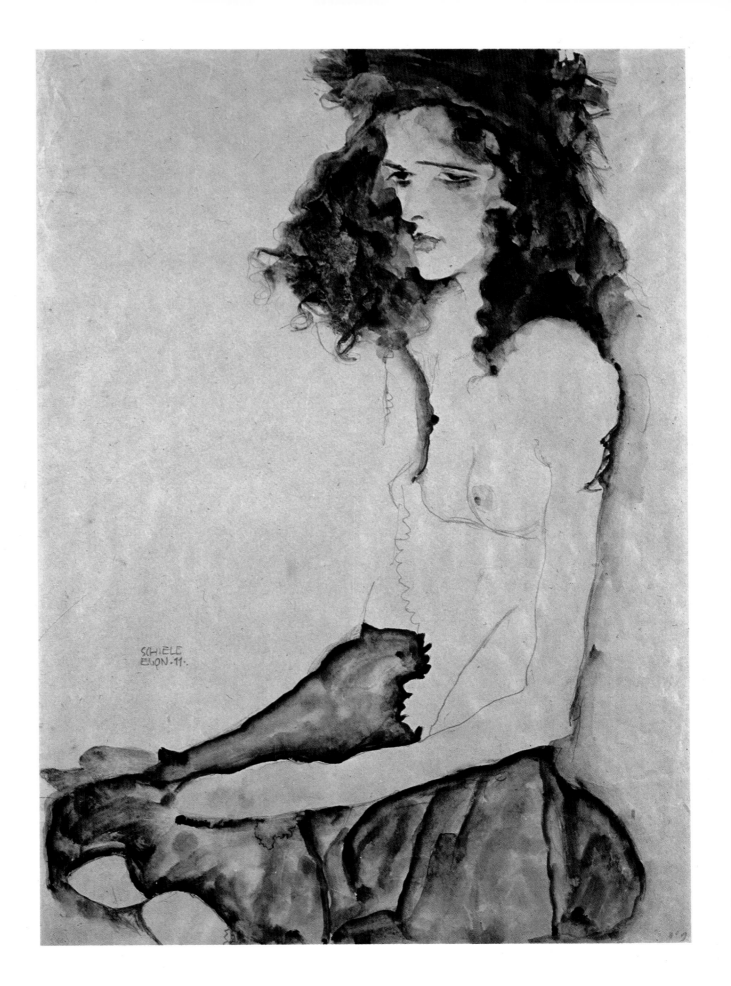

Plate 21

Two Little Girls
1911

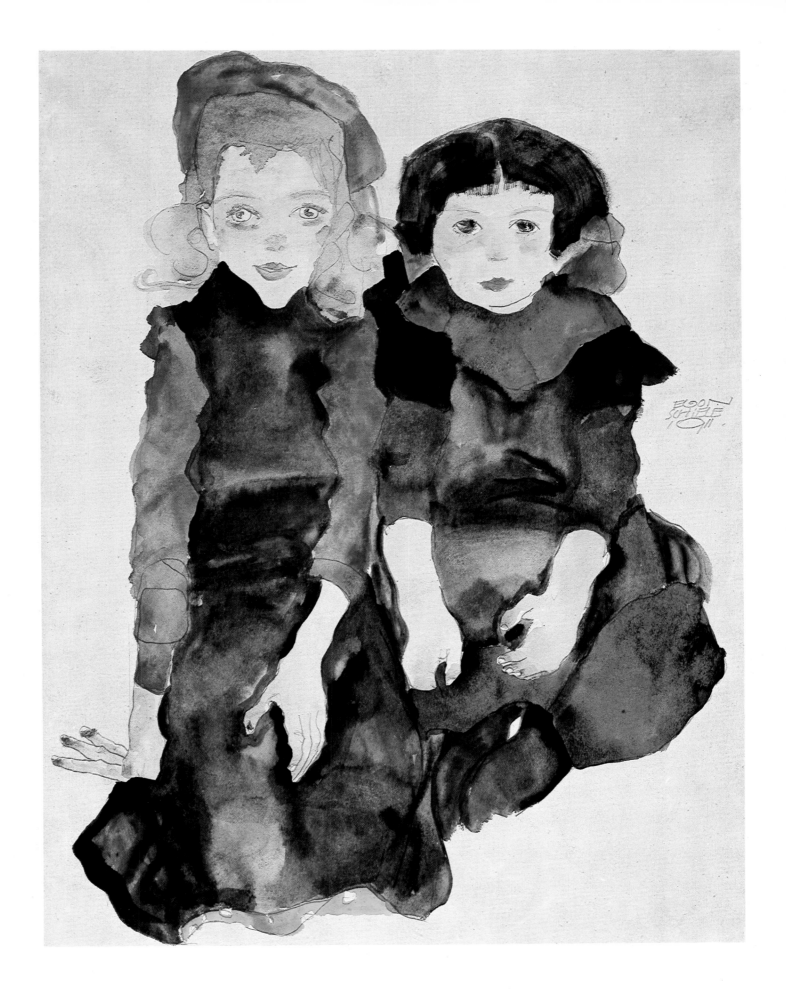

Plate 22
Schiele's Room in Neulengbach
1911

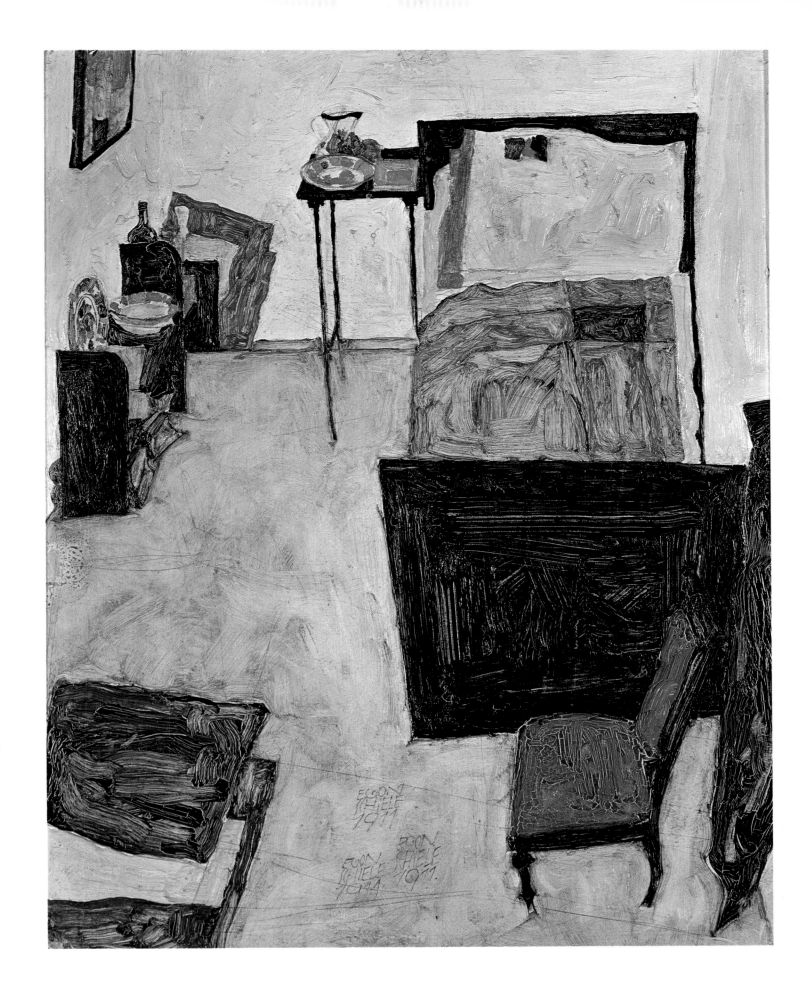

Plate 23
Self-Portrait with Black Vase
1911

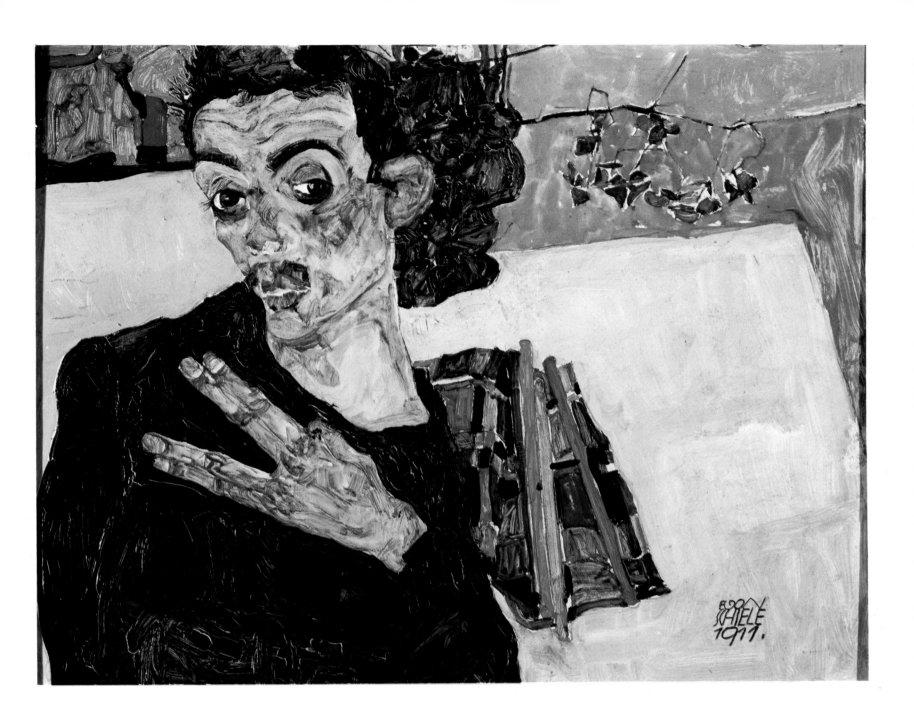

Plate 24
Two Girls
1911

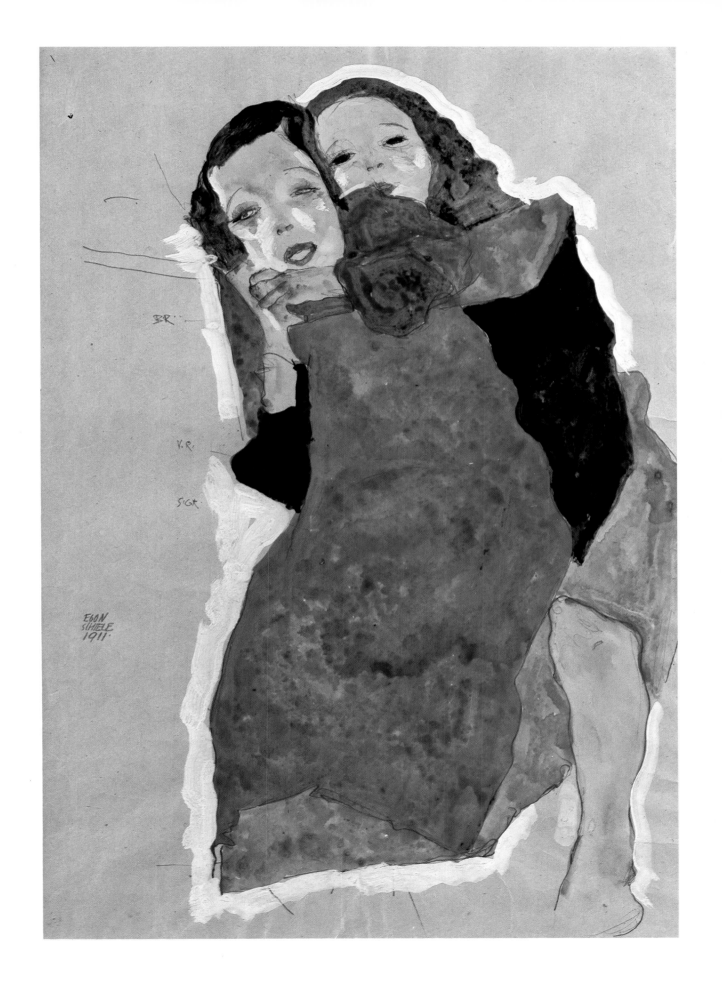

Plate 25
The Brother
1911

144

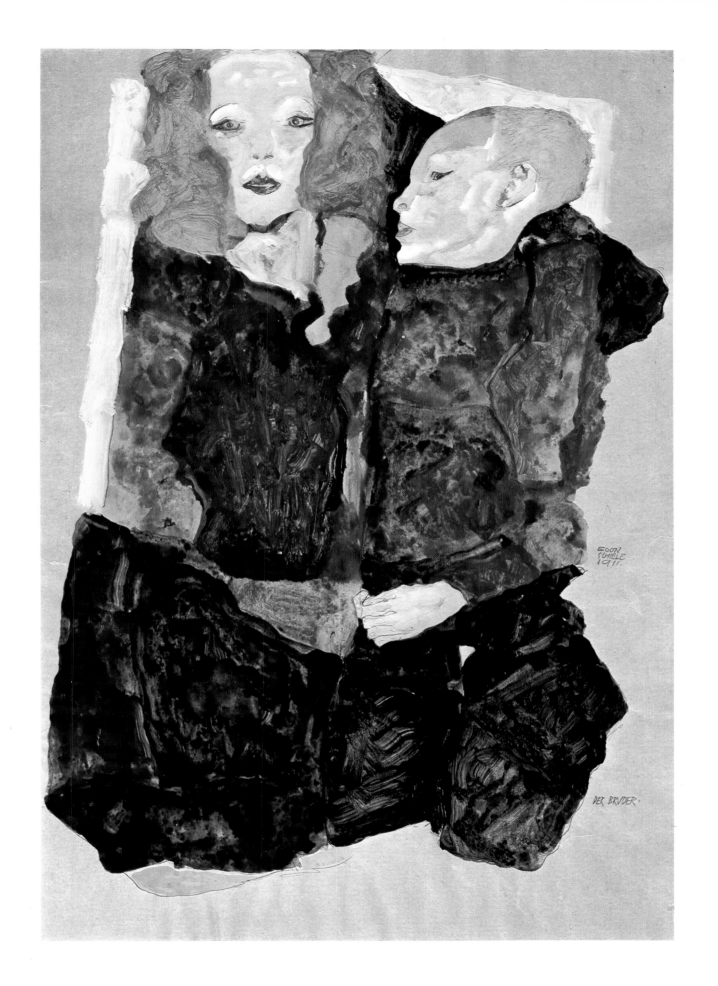

Plate 26
The Artist's Mother Sleeping
1911

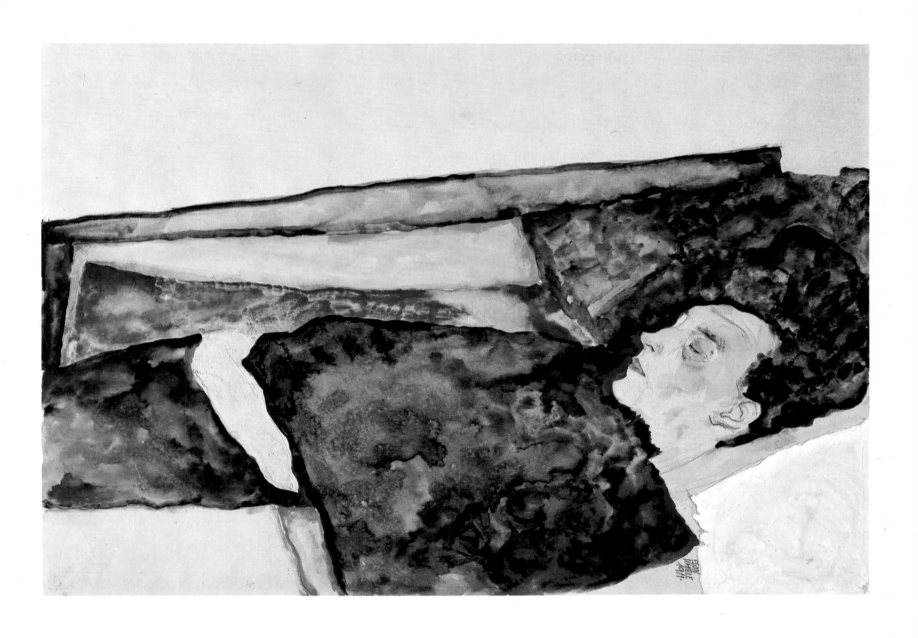

Plate 27

Pregnant Woman and Death
1911

148

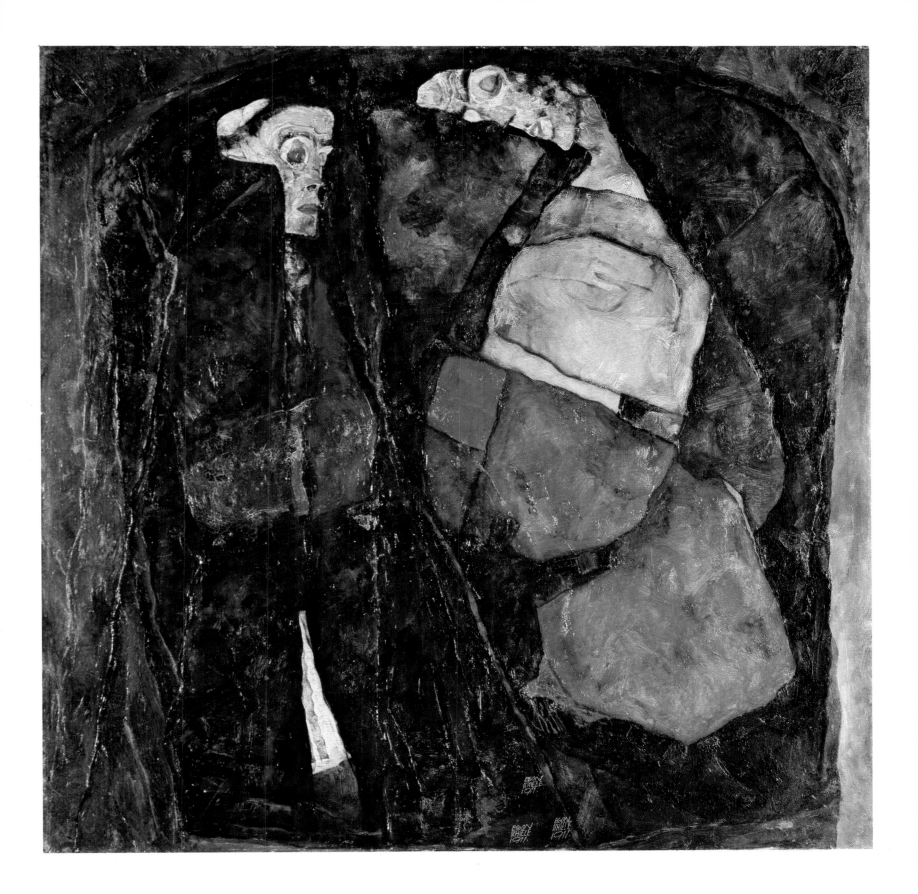

Plate 28

Nude Self-Portrait
1912

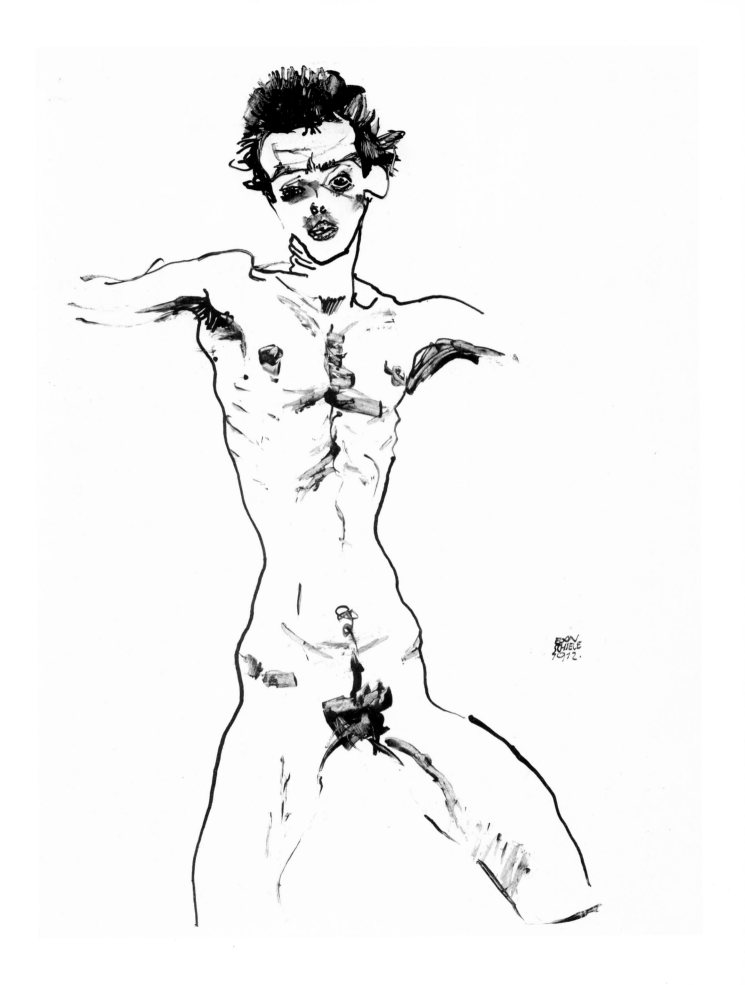

Plate 29

Hermits

1912

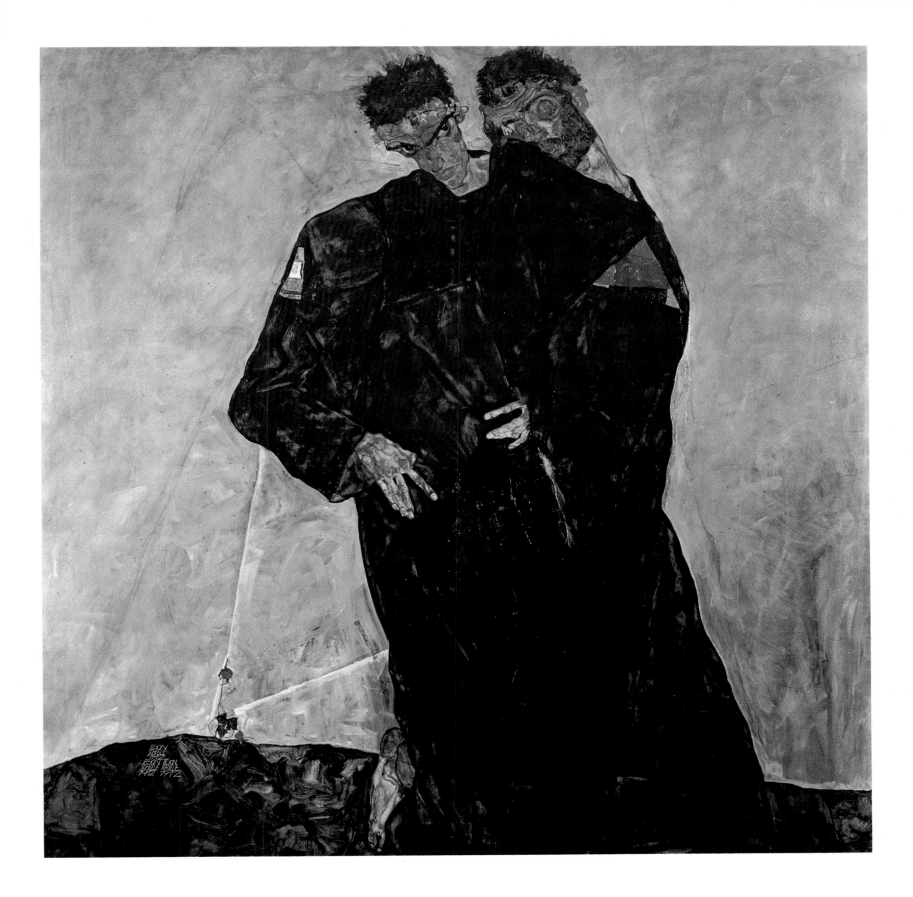

Plate 30
Cardinal and Nun
1912

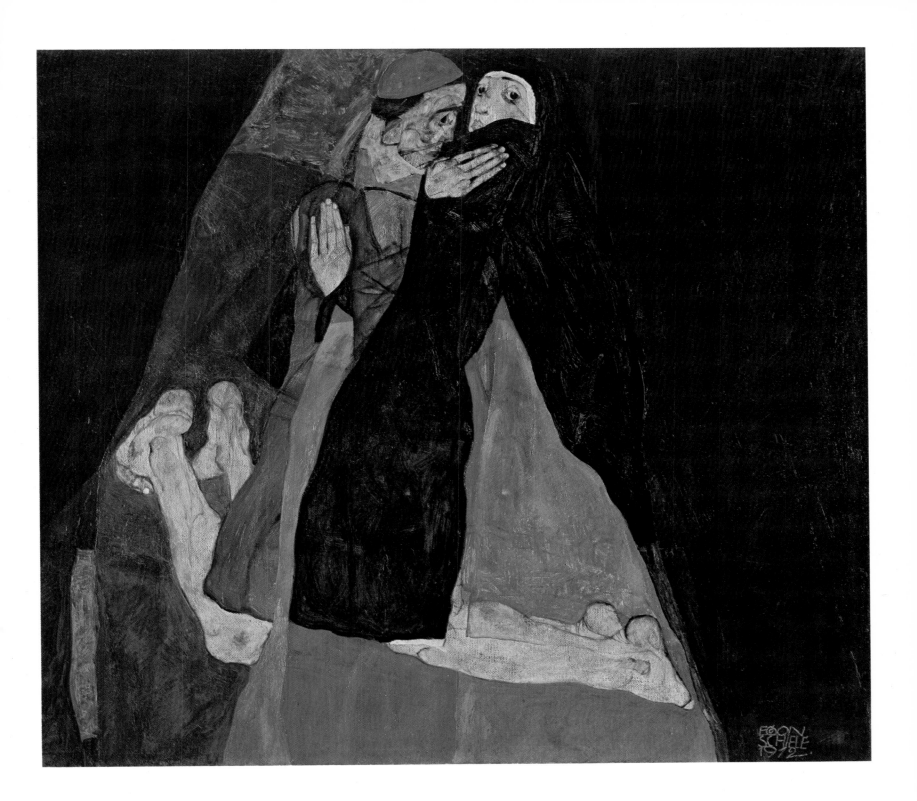

Plate 31

Female Nude
with Blue Stockings
1912

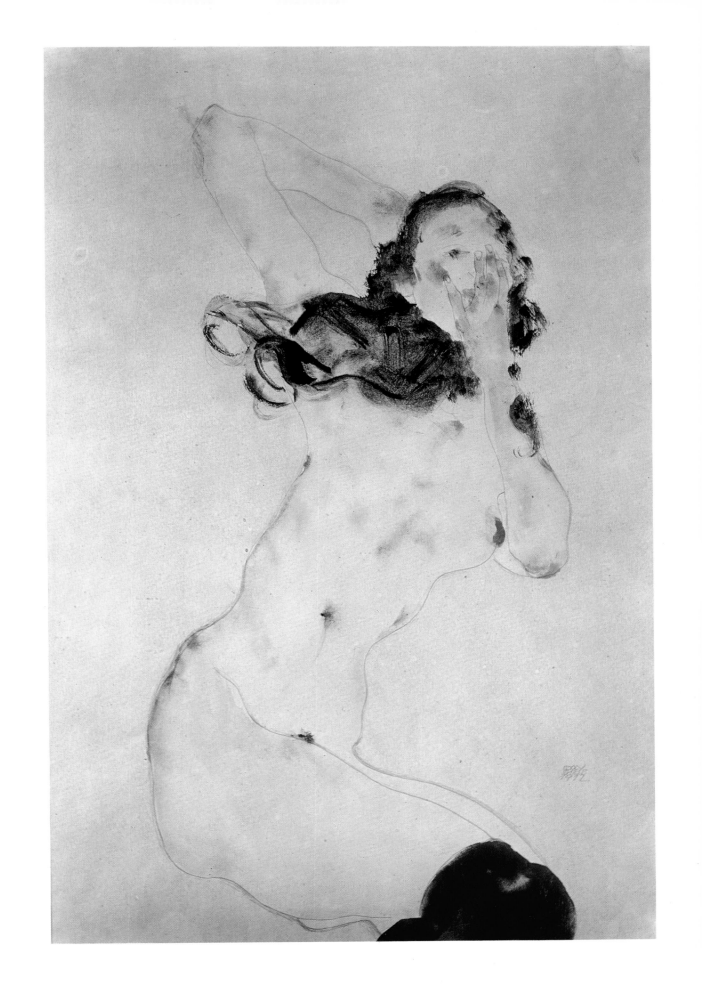

Plate 32
Winter Trees
1912

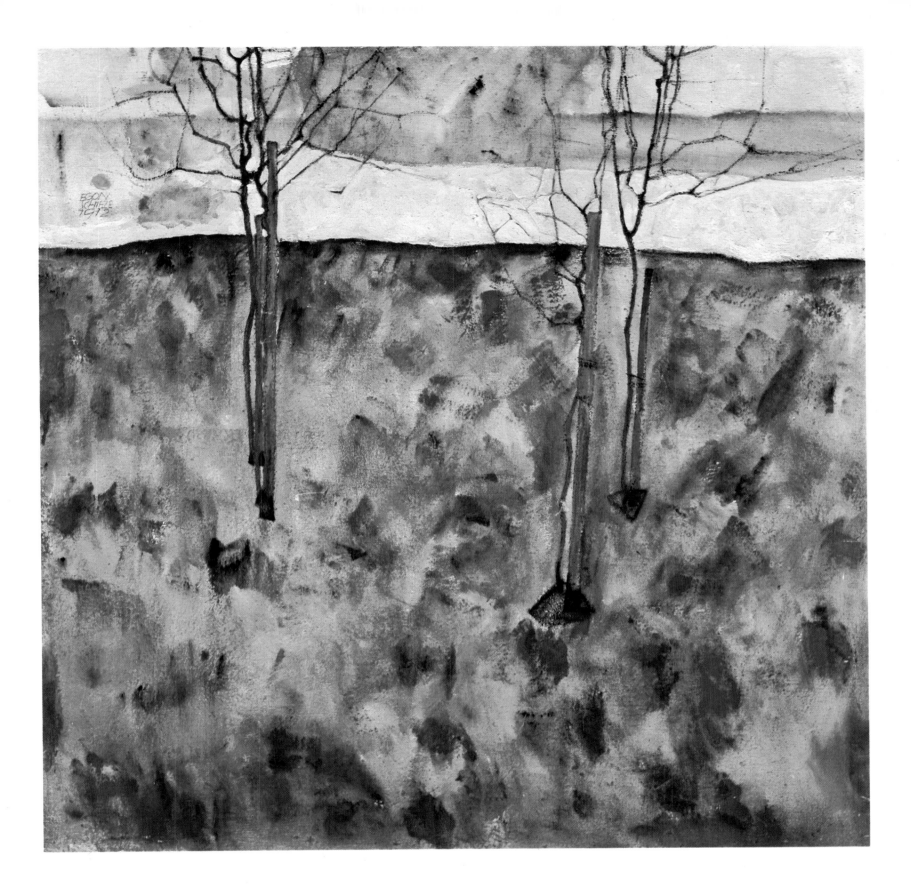

Plate 33

Autumn Tree in Movement
1912

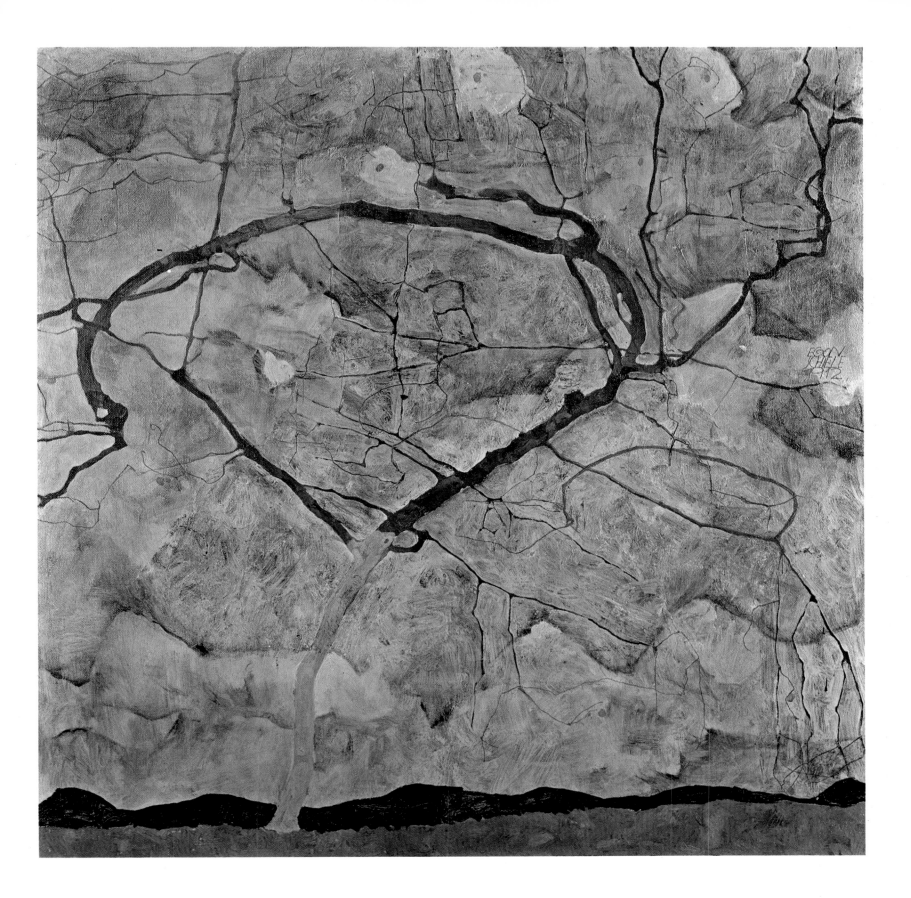

Plate 34
Ships at Trieste
1912

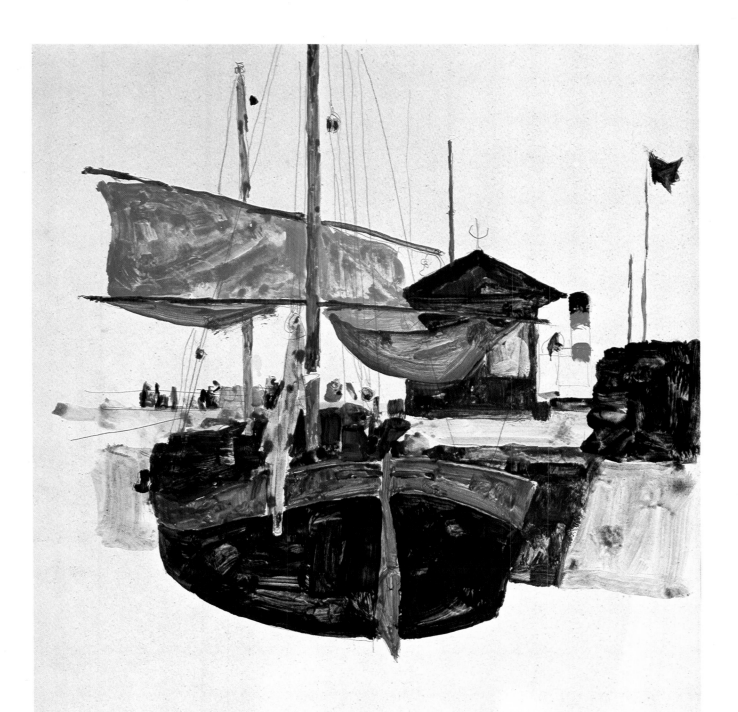

Plate 35
Self-Portrait
1912

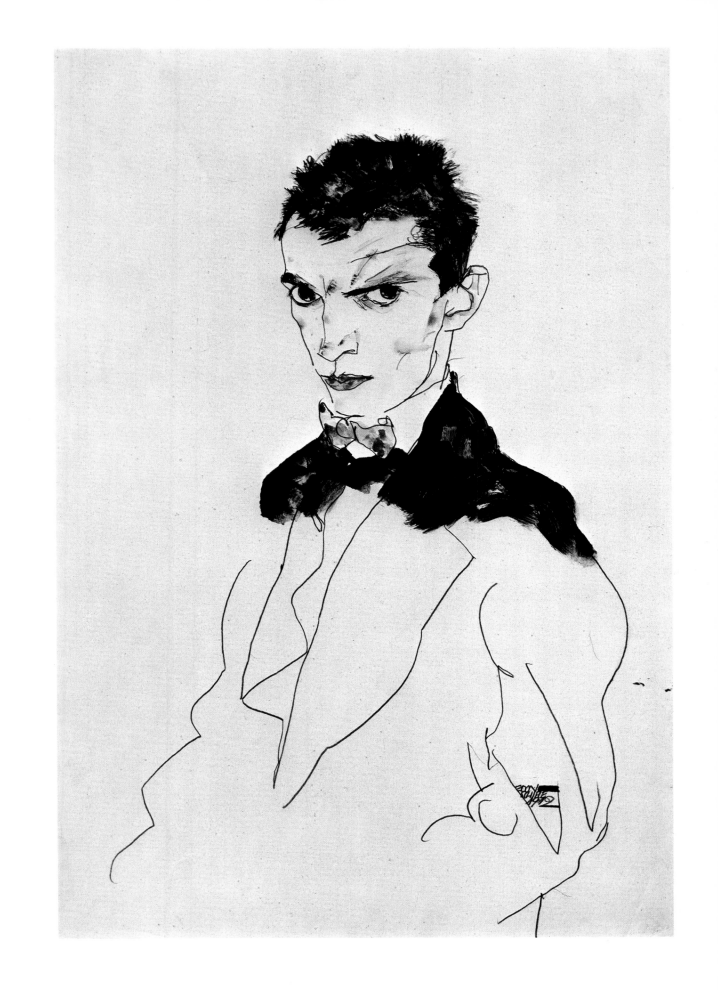

Plate 36

Portrait of Erich Lederer
1912/13

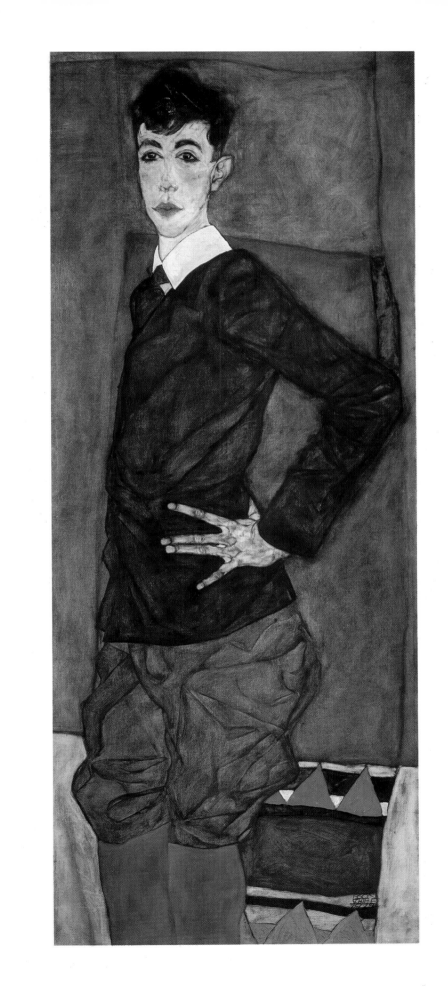

Plate 37

Holy Family
1913

168

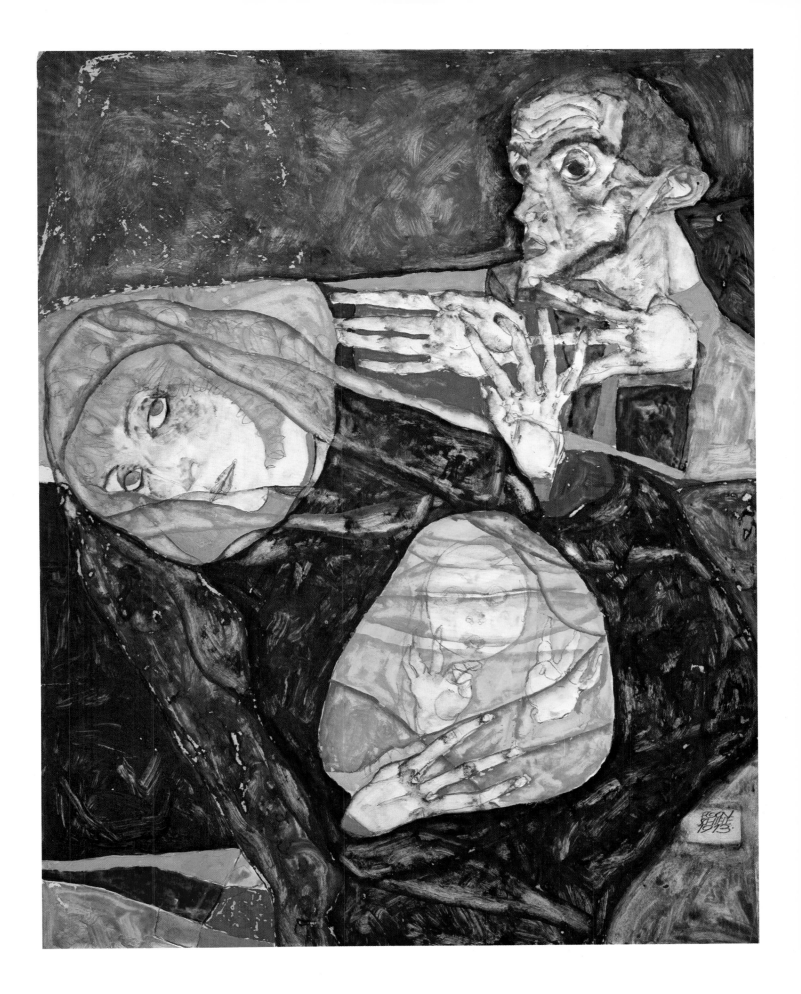

Plate 38
The Bridge
1913

170

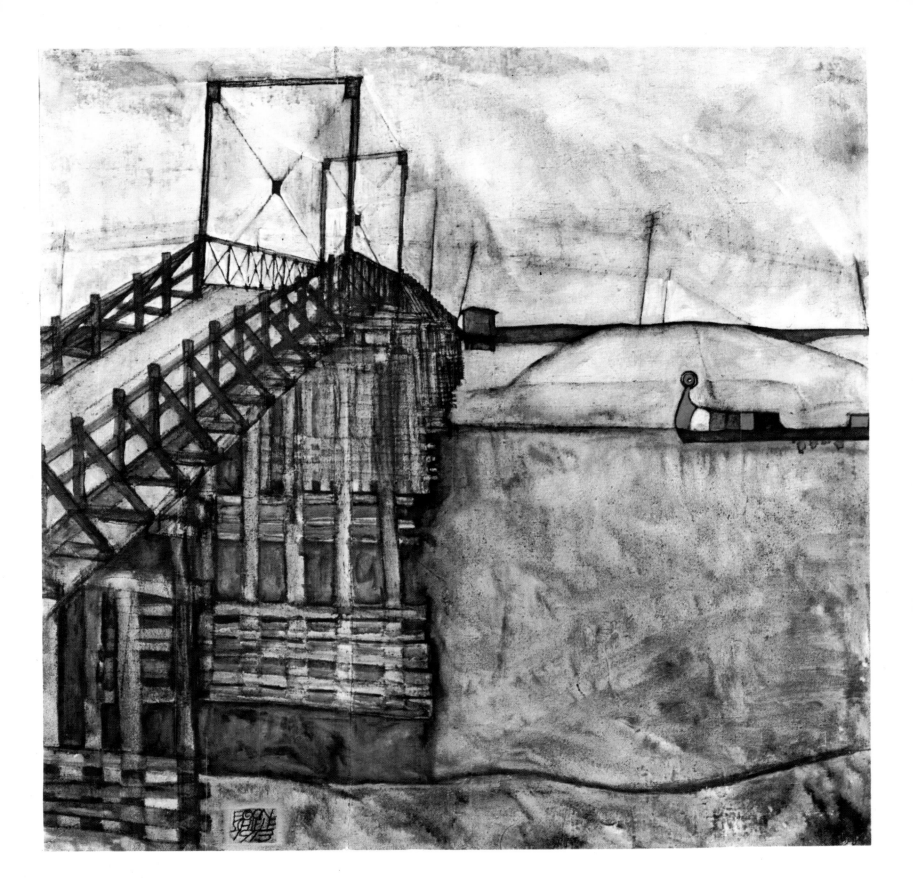

Plate 39
Self-Portrait
1913

172

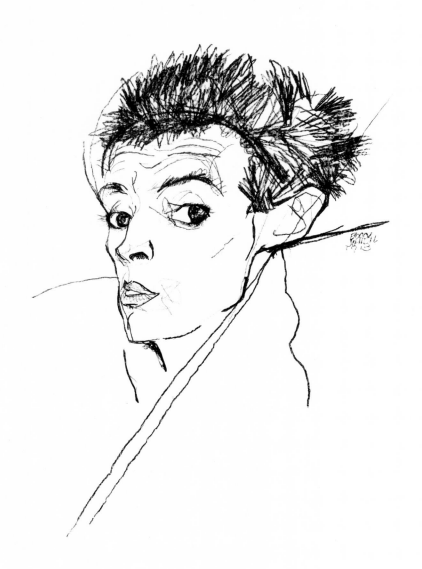

Plate 40

Double Portrait (Heinrich and Otto Benesch)
1913

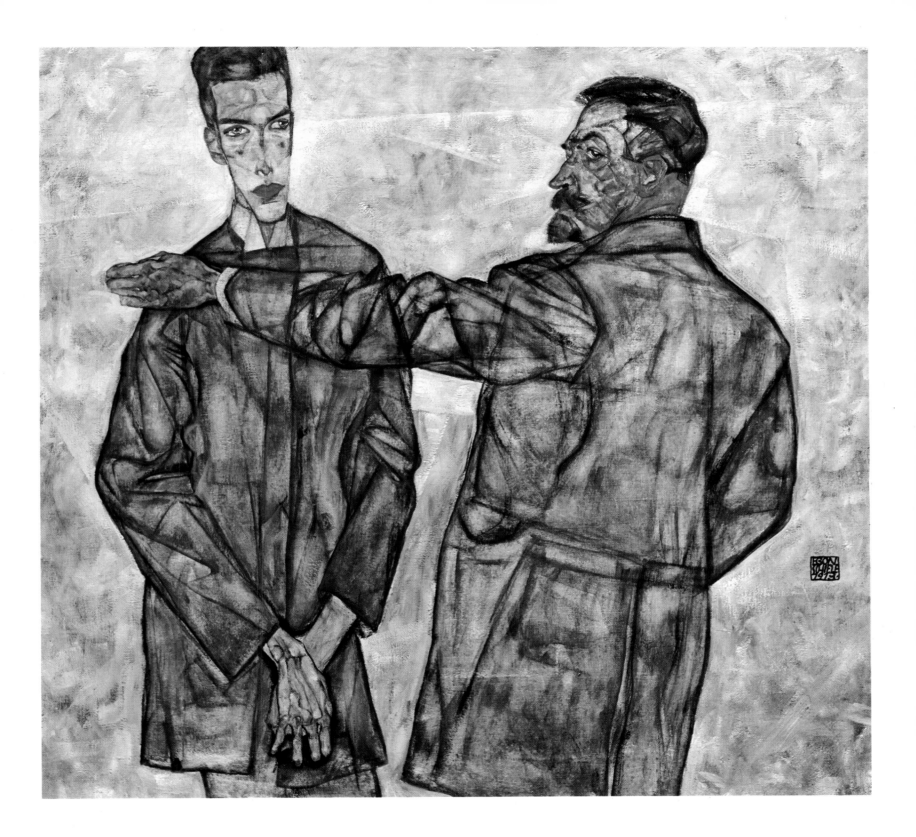

Plate 41

Woman in Green Blouse
1913

Plate 42
Two Kneeling Figures (Parallelogram)
1913

Plate 43

Stein on the Danube with Terraced Vineyards
(large version)
1913

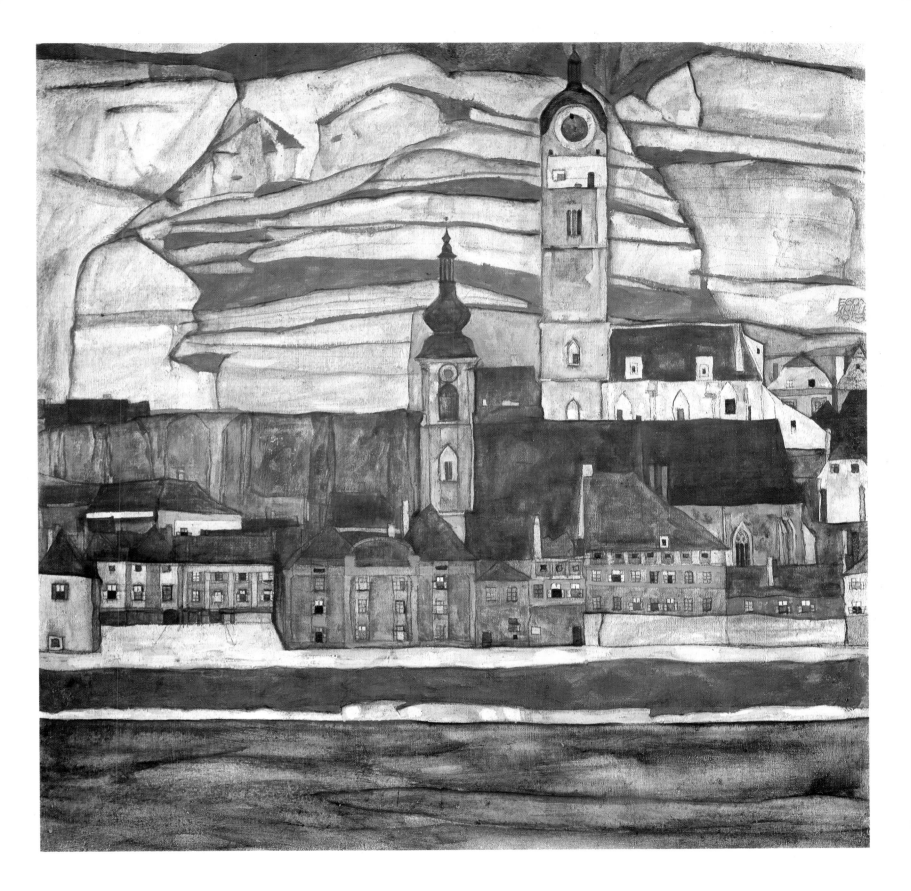

Plate 44

Peasant Homestead in a Landscape
1913

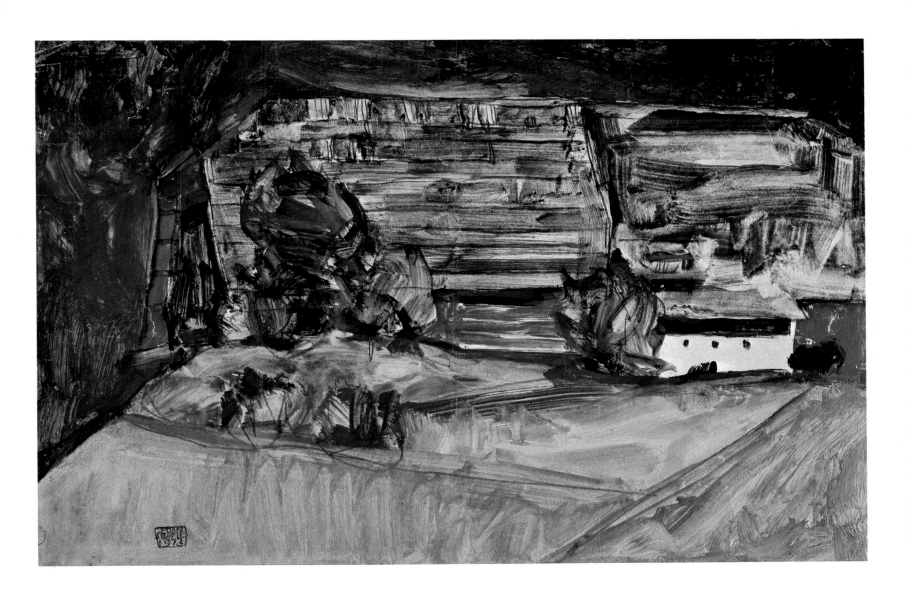

Plate 45

'The Truth was Revealed'
1913

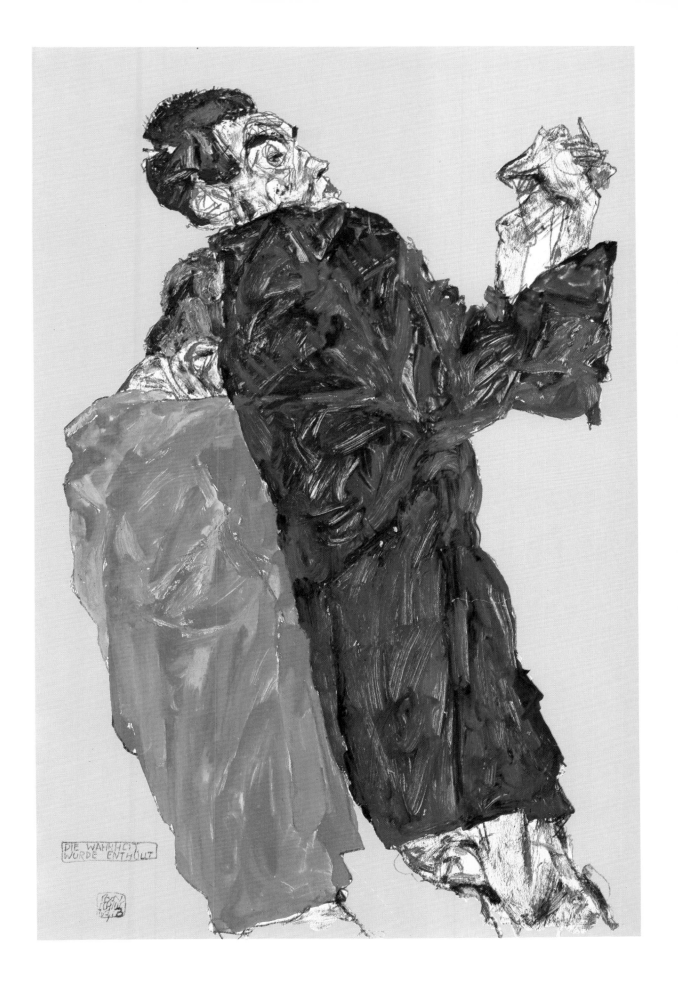

Plate 46
Fighter
1913

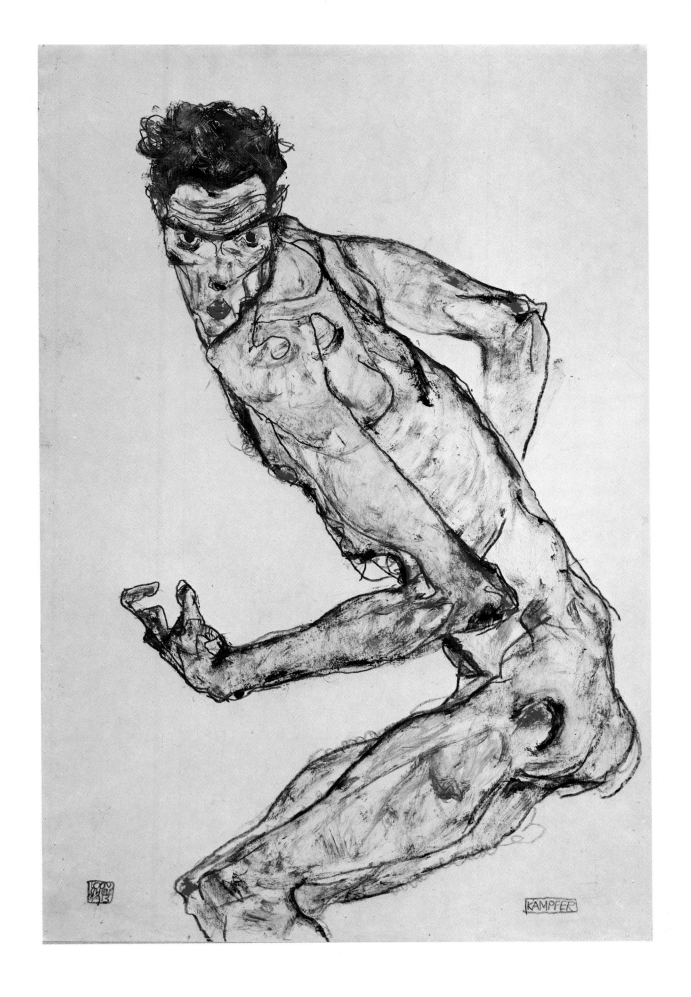

KÄMPFER

Plate 47
Recumbent Female Nude with Legs Apart
1914

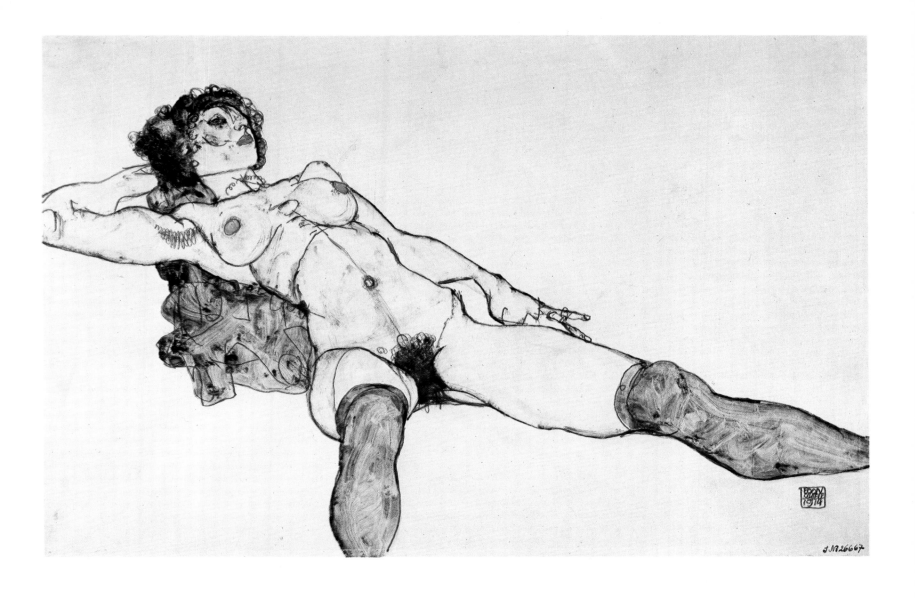

Plate 48
Male Nude with a Red Loincloth
1914

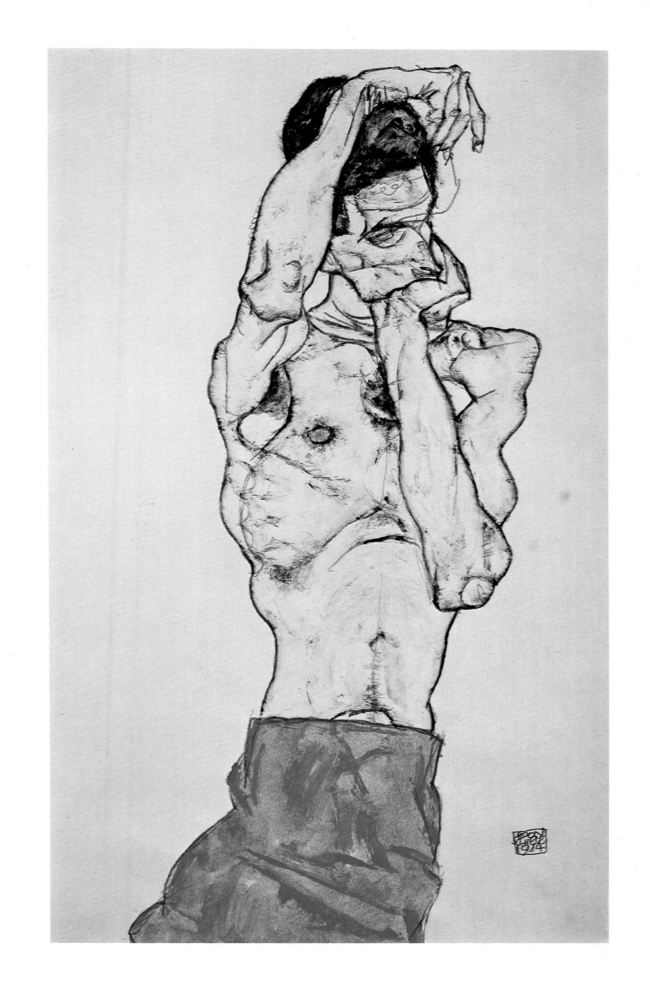

Plate 49

Mother and Child
1914

192

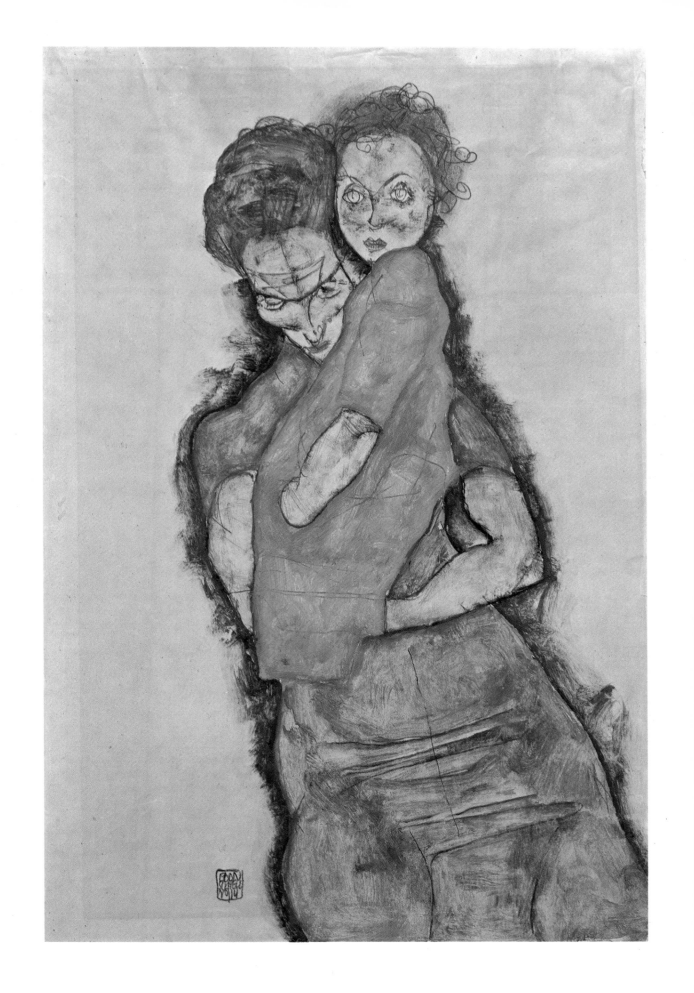

Plate 50
Blind Mother
1914

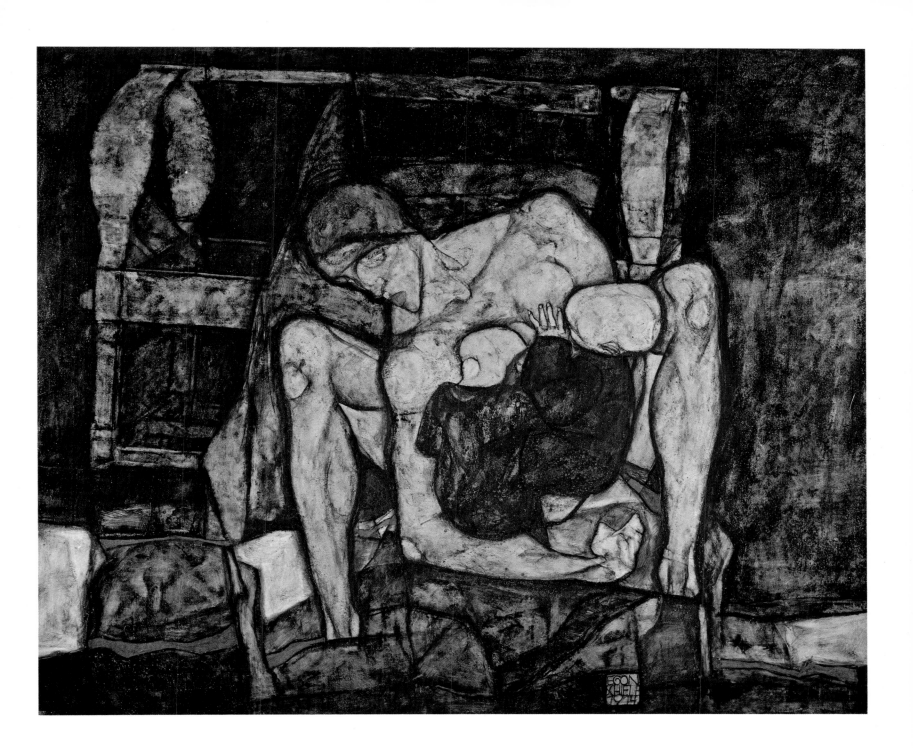

Plate 51

Old Houses in Krumau
1914

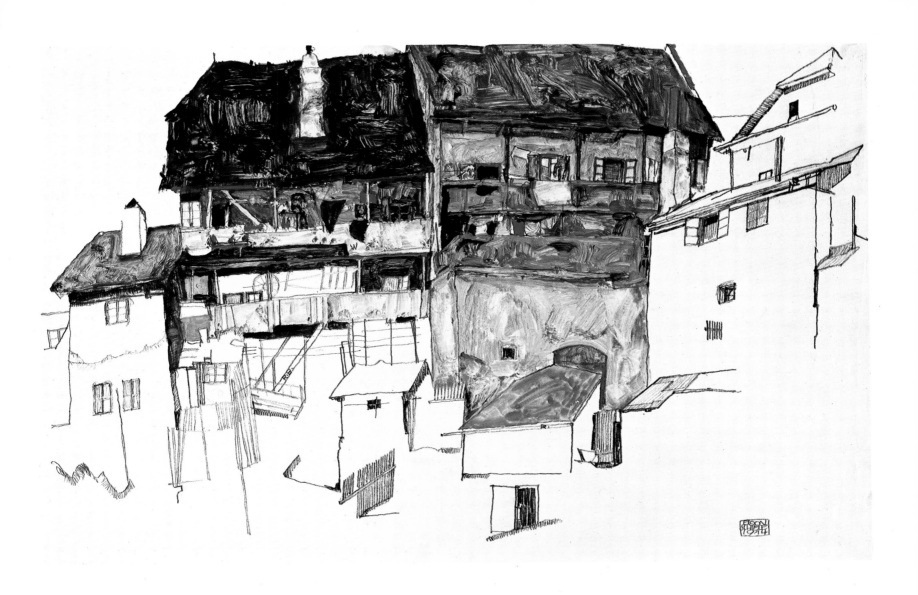

Plate 52
Windows
1914

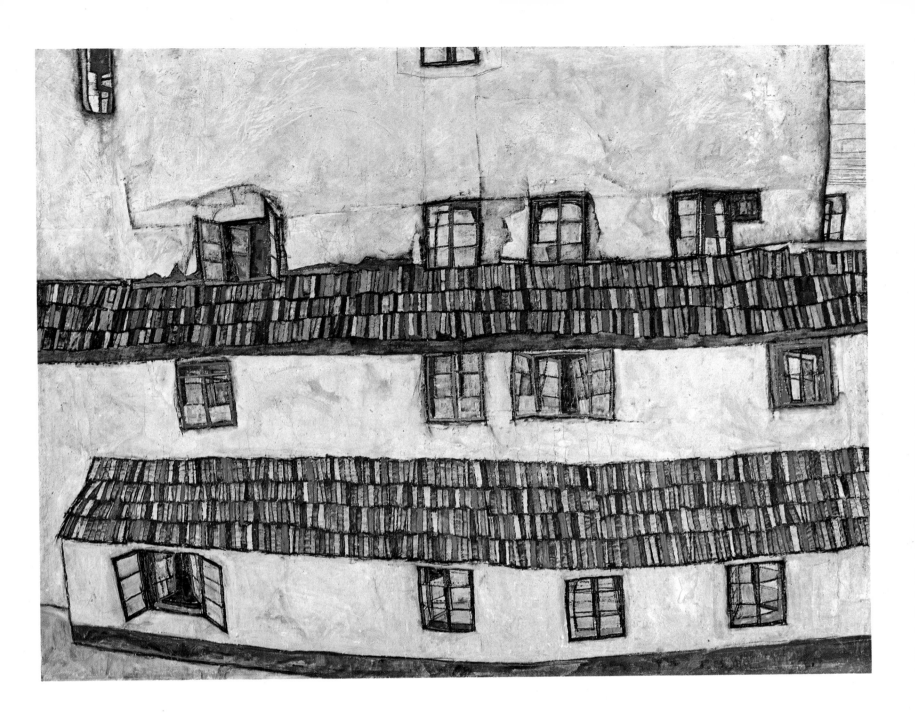

Plate 53

Standing Male Figure (Self-Portrait)
1914

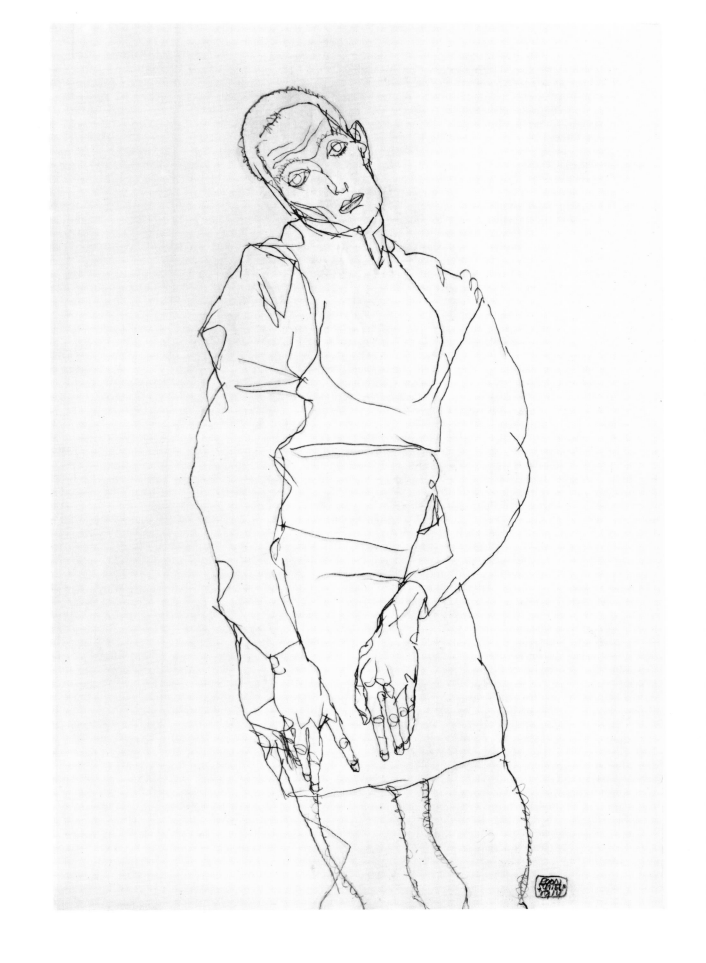

Plate 54

Female Nude to the Right
1914

202

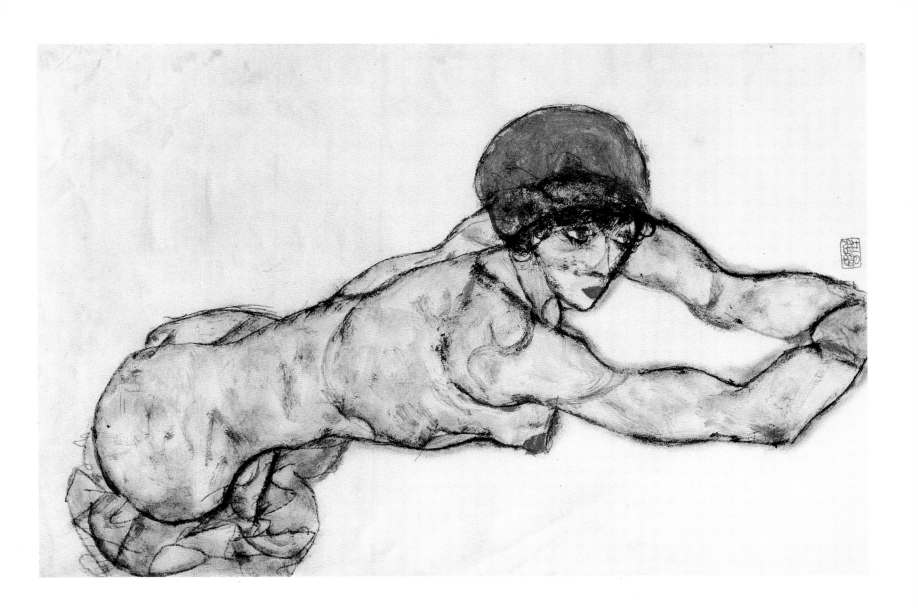

Plate 55

Seated Woman with her Left Hand
in her Hair
1914

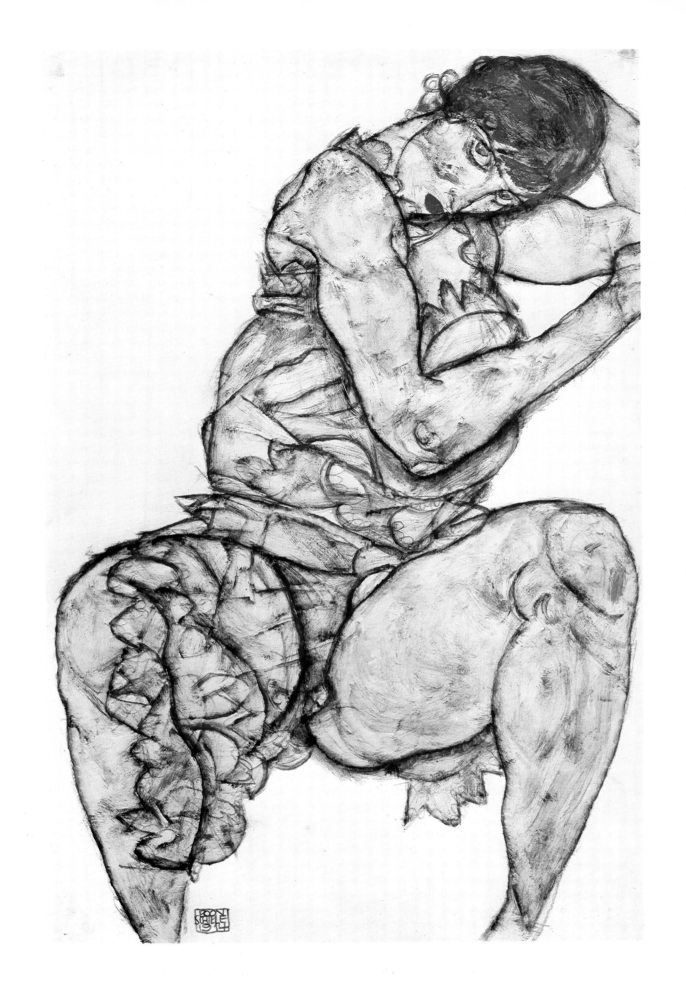

Plate 56
Two Girls Embracing Each Other
1915

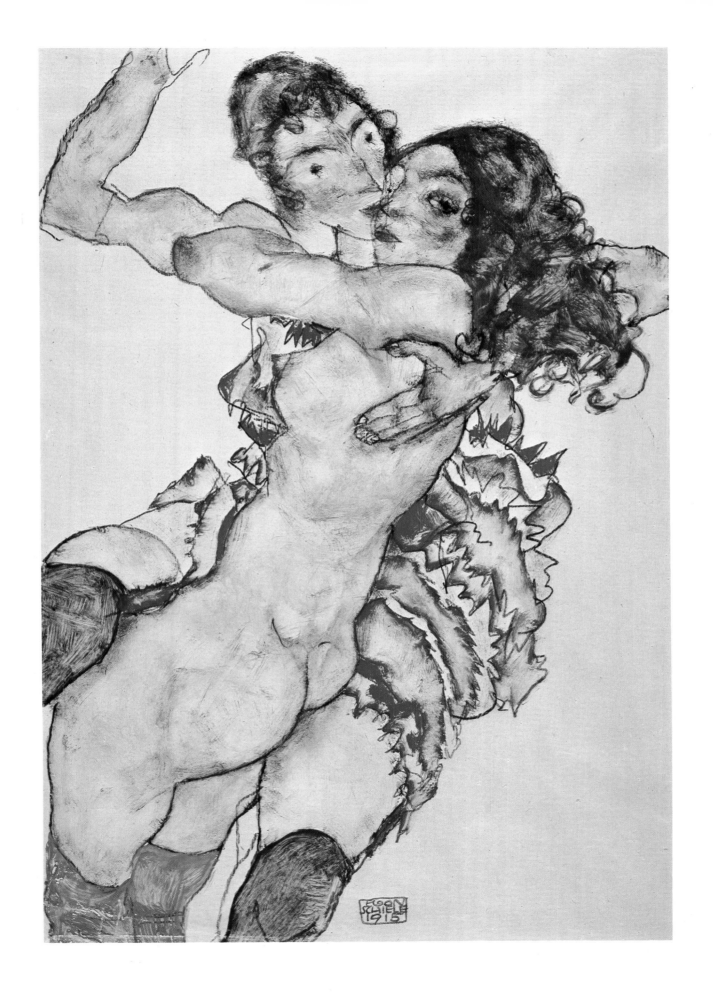

Plate 57

Woodland Prayer
1915

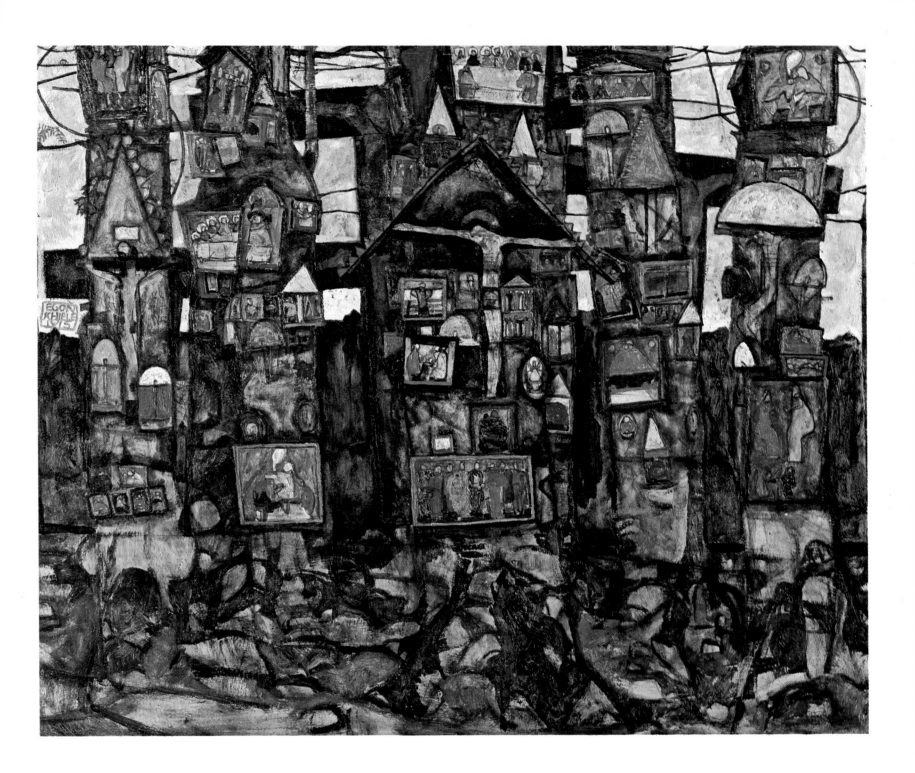

Plate 58
Levitation
1915

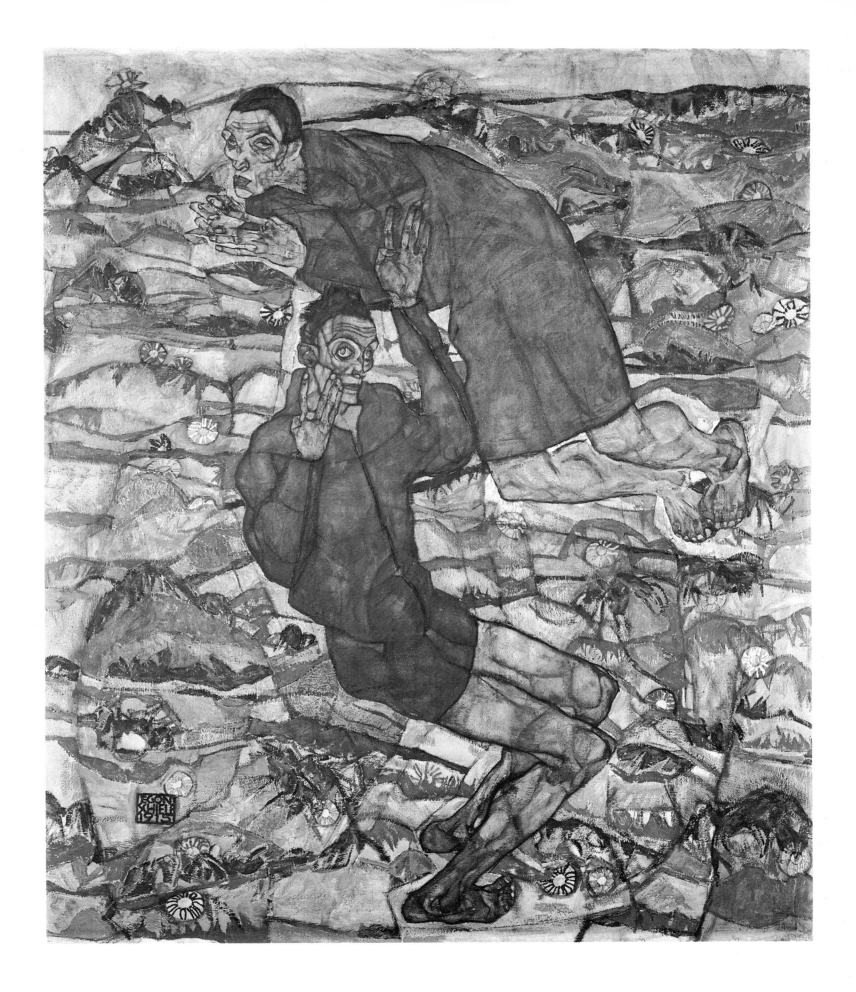

Plate 59
Death and Girl
1915

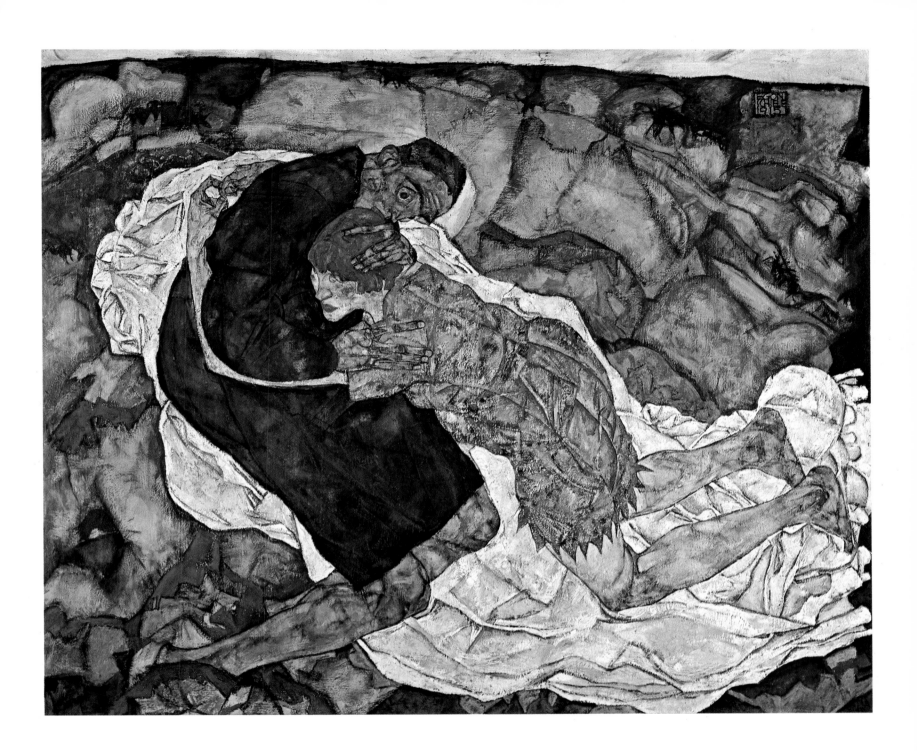

Plate 60
Portrait of Edith Schiele Standing
1915

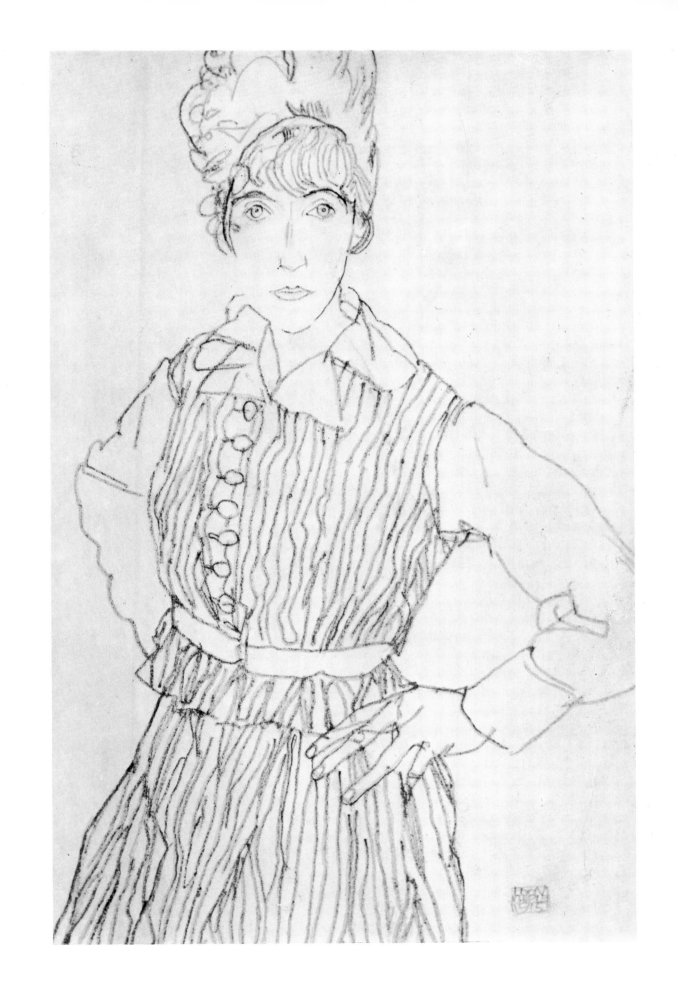

Plate 61

Portrait of Edith Schiele in a Striped Dress
1915

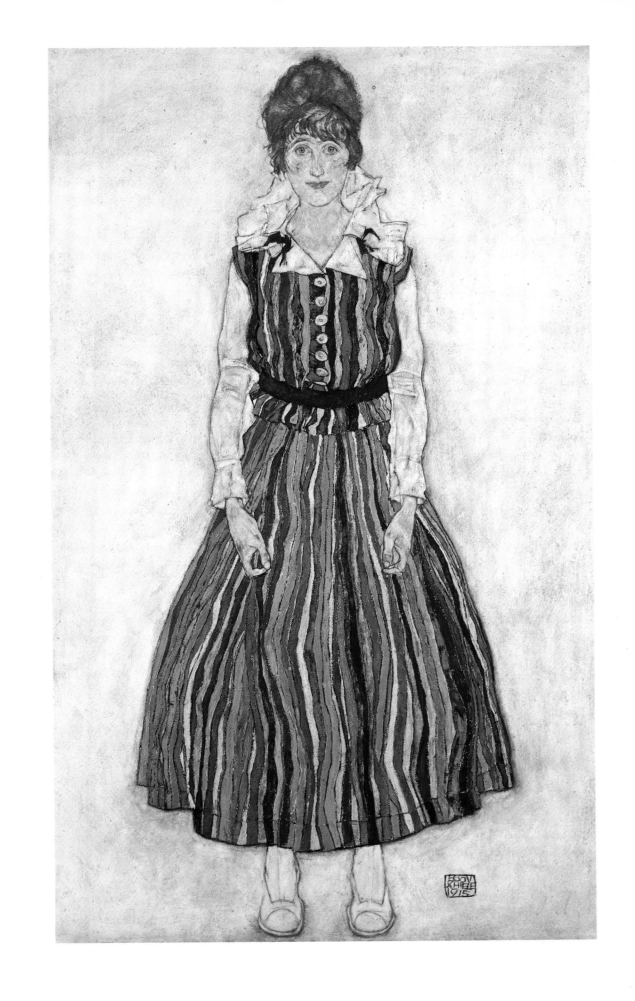

Plate 62

Aunt and Nephew
1915

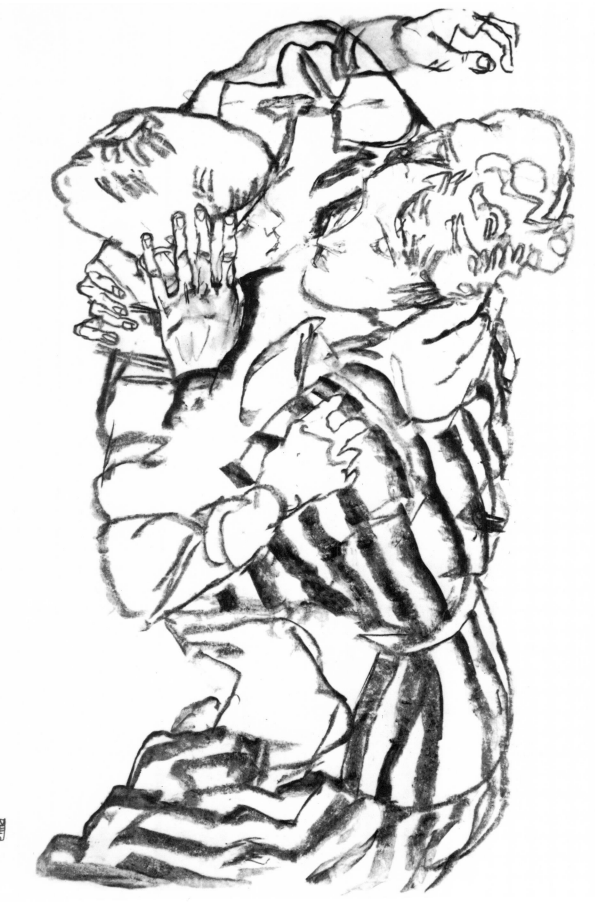

Plate 63

Landscape at Krumau
1916

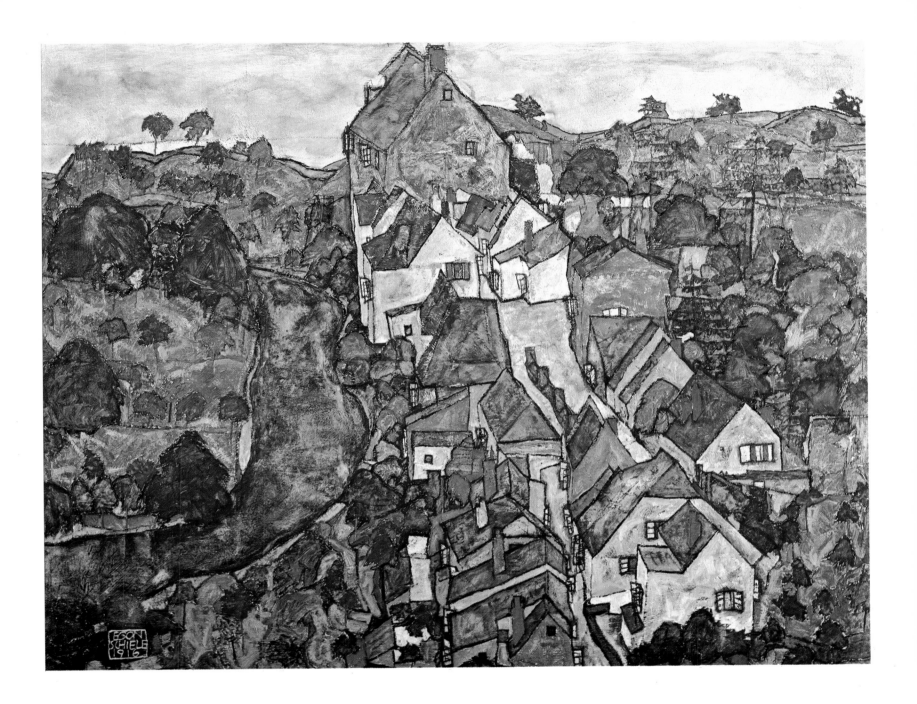

Plate 64
Portrait of Johann Harms
1916

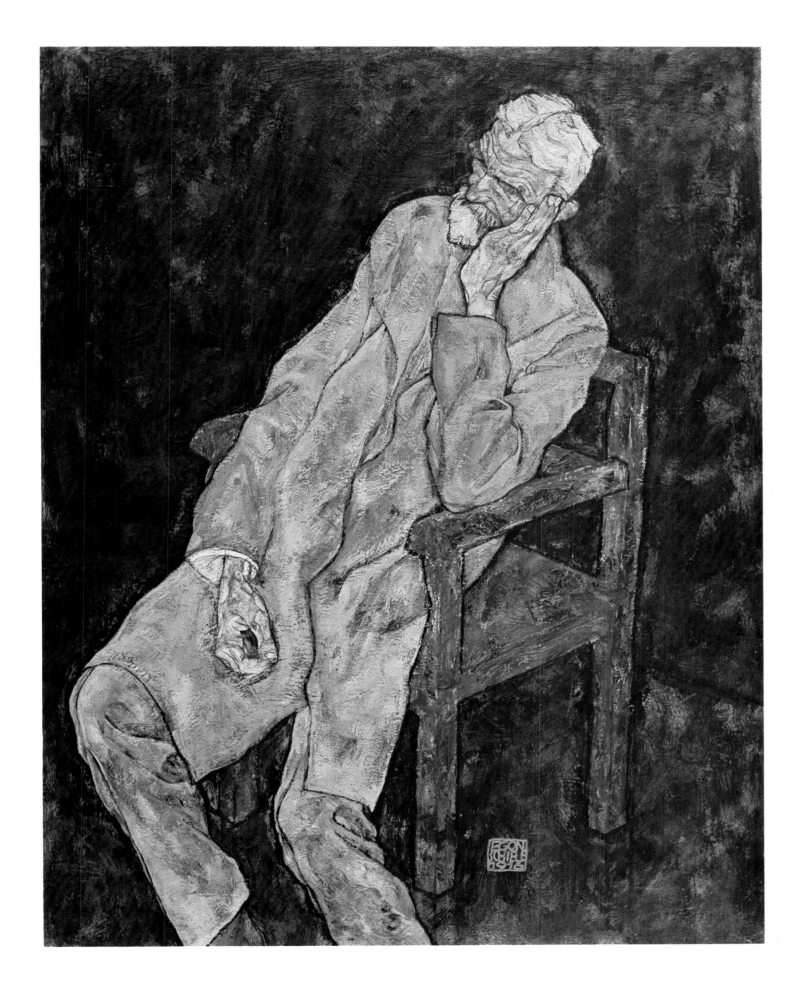

Plate 65
Office in the Prisoner-of-War Camp, Mühling
1916

Plate 66
The Mill
1916

226

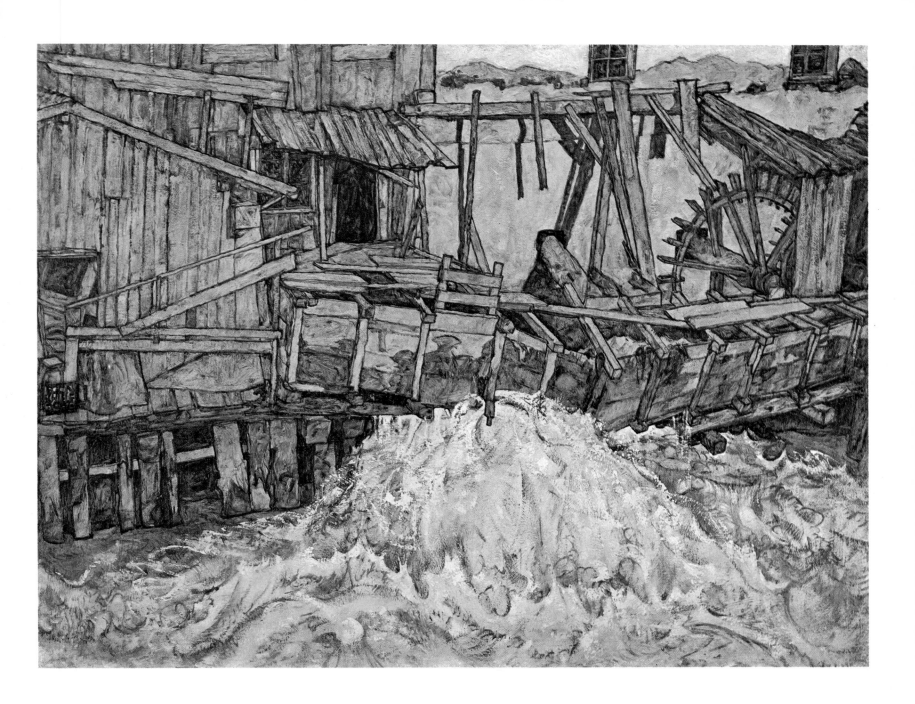

Plate 67

Mother with Two Children
1915/17

228

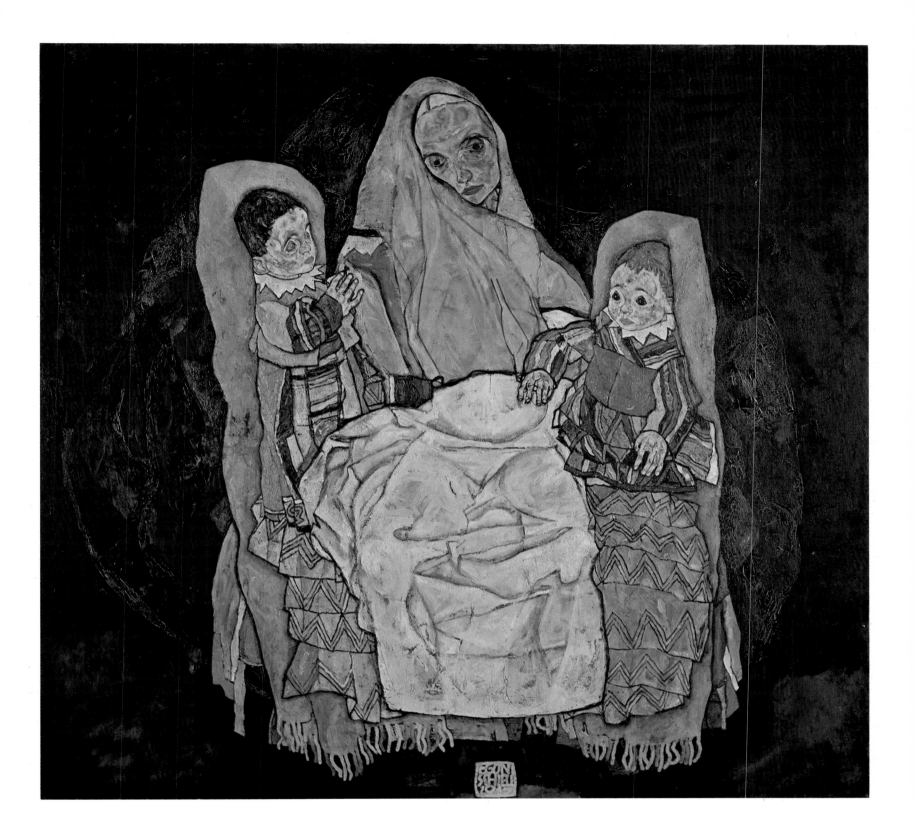

Plate 68
Four Trees
1917

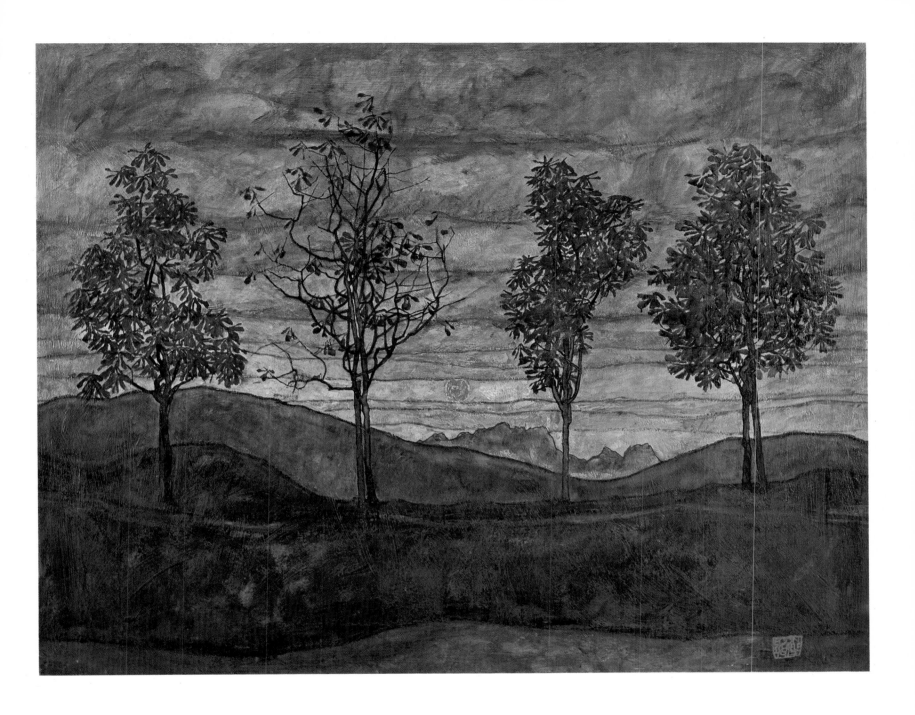

Plate 69

Portrait of Heinrich Benesch
1917

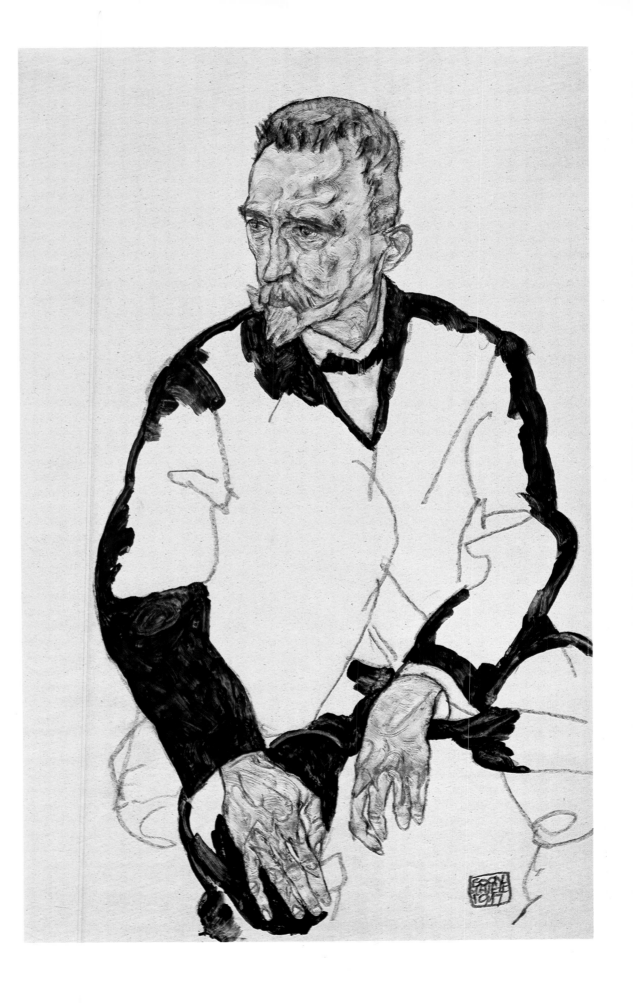

Plate 70
Old Gabled Houses in Krumau
1917

Plate 71
Street in Krumau
1917

Plate 72

Female Nude Lying on her Stomach
1917

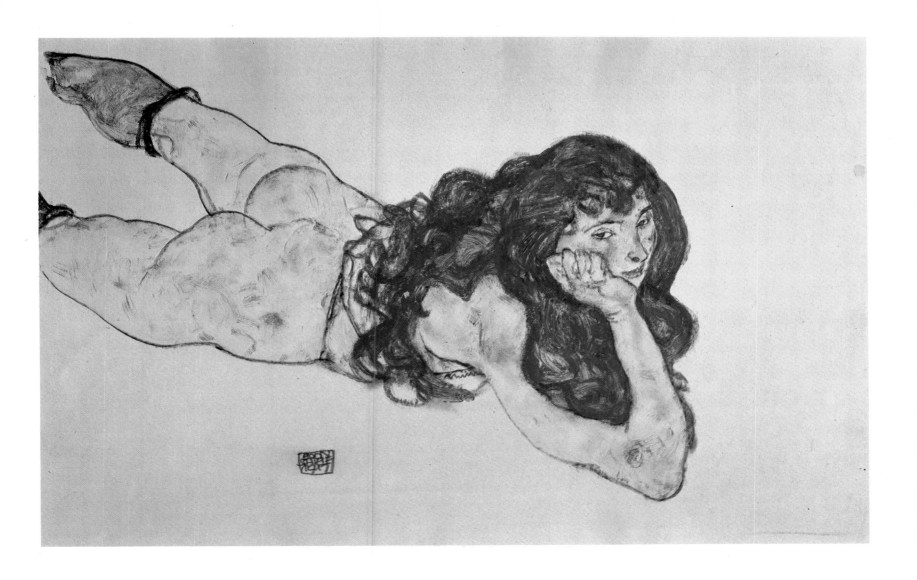

Plate 73
Seated Woman
1917

240

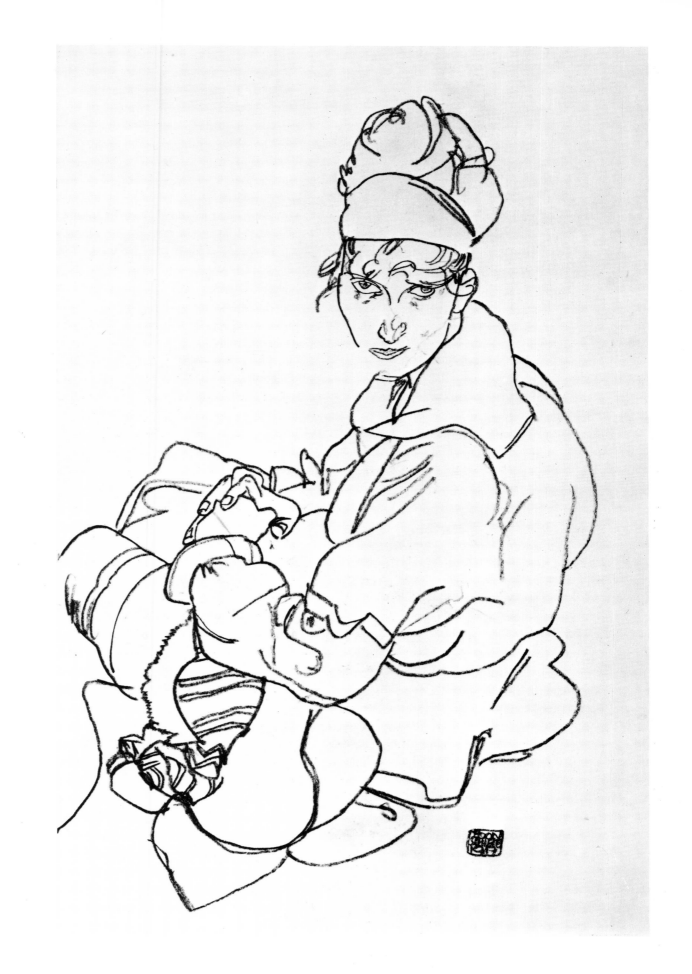

Plate 74
Embrace
1917

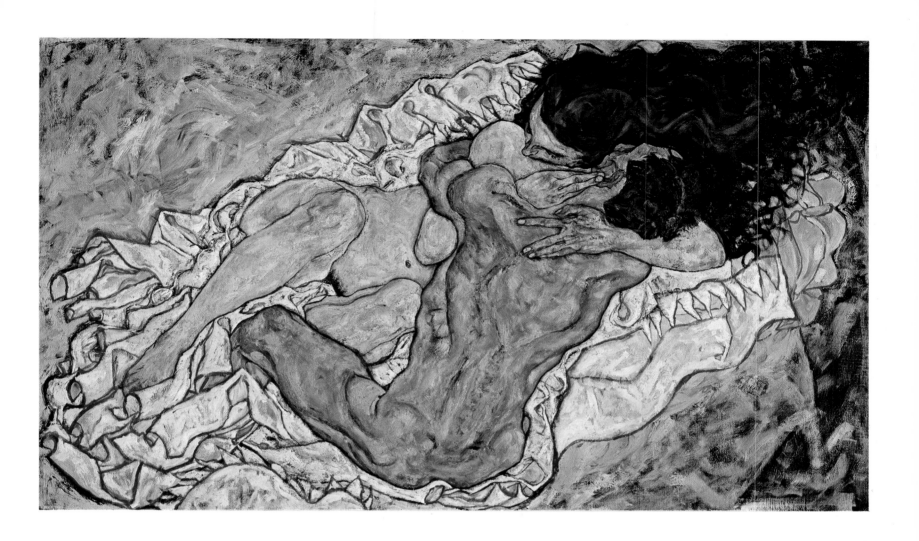

Plate 75
The Family
1918

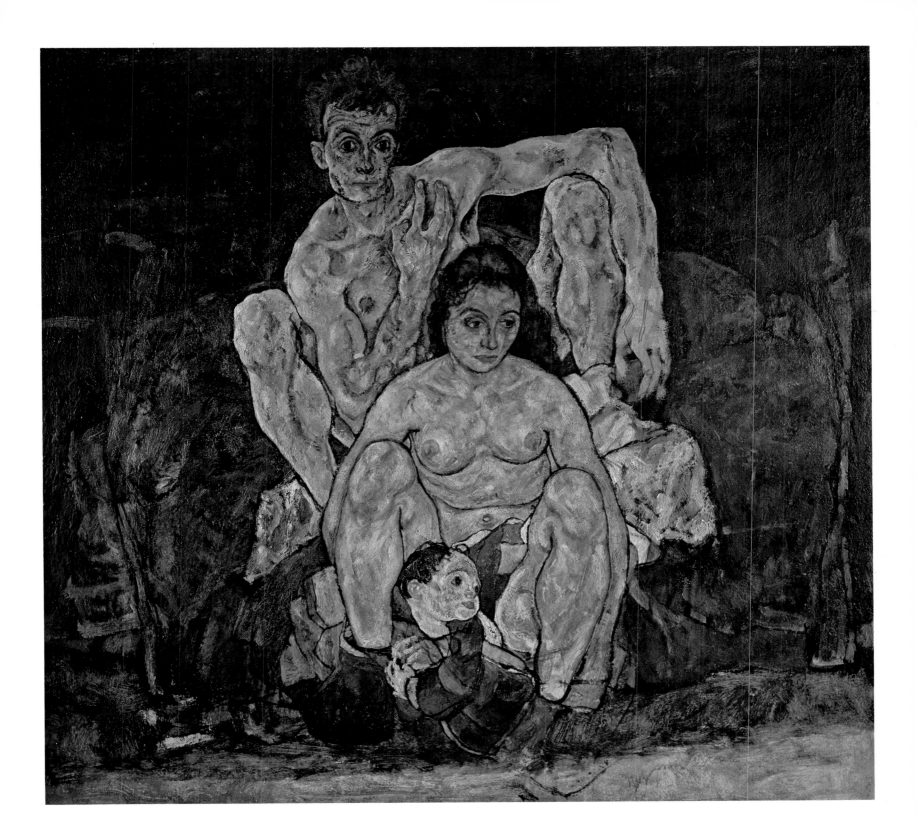

Plate 76

Portrait of Edith Schiele Seated
1917/18

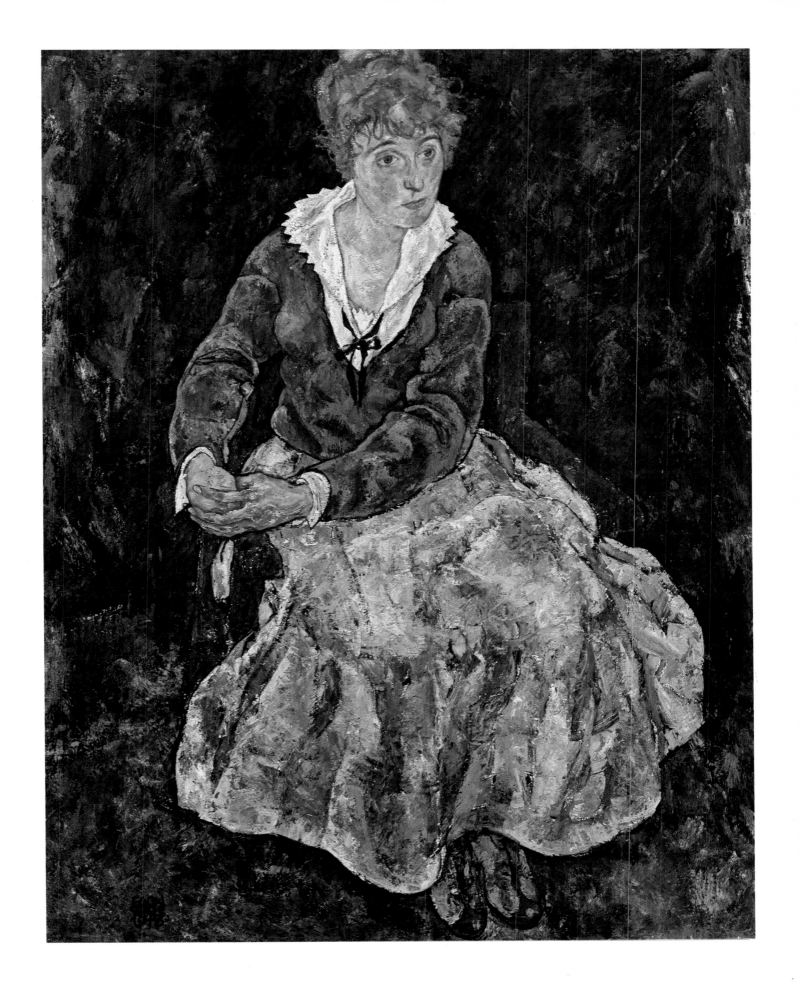

Plate 77

Portrait of Albert Paris von Gütersloh
1918

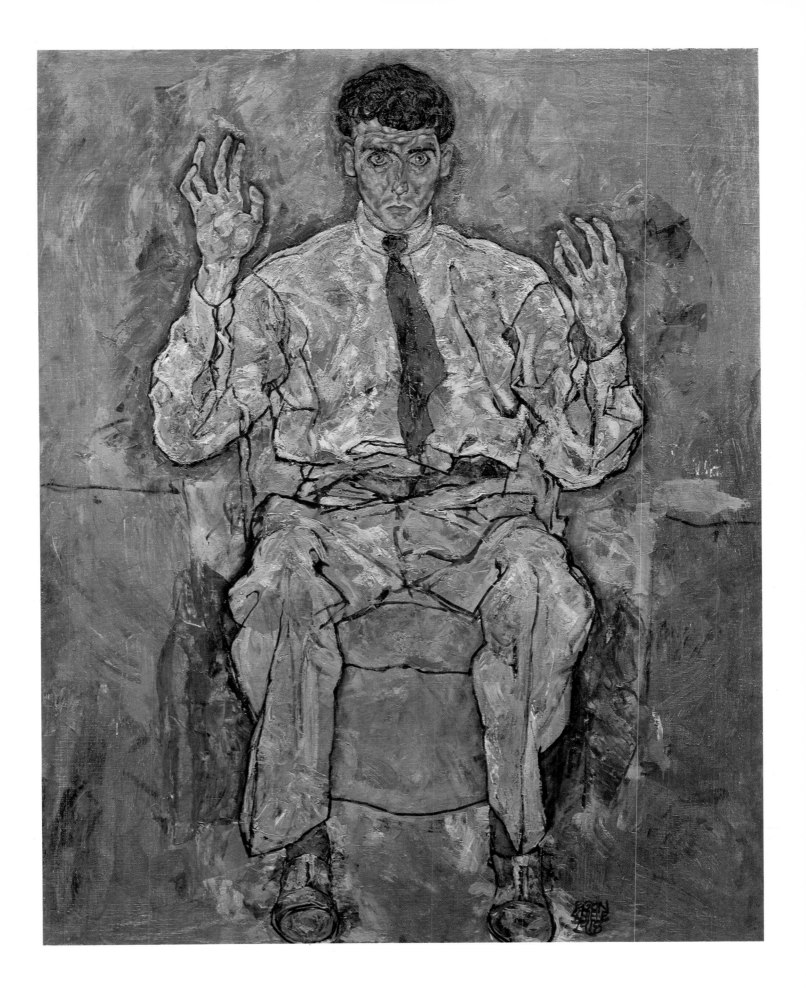

Plate 78

Squatting Woman
1918

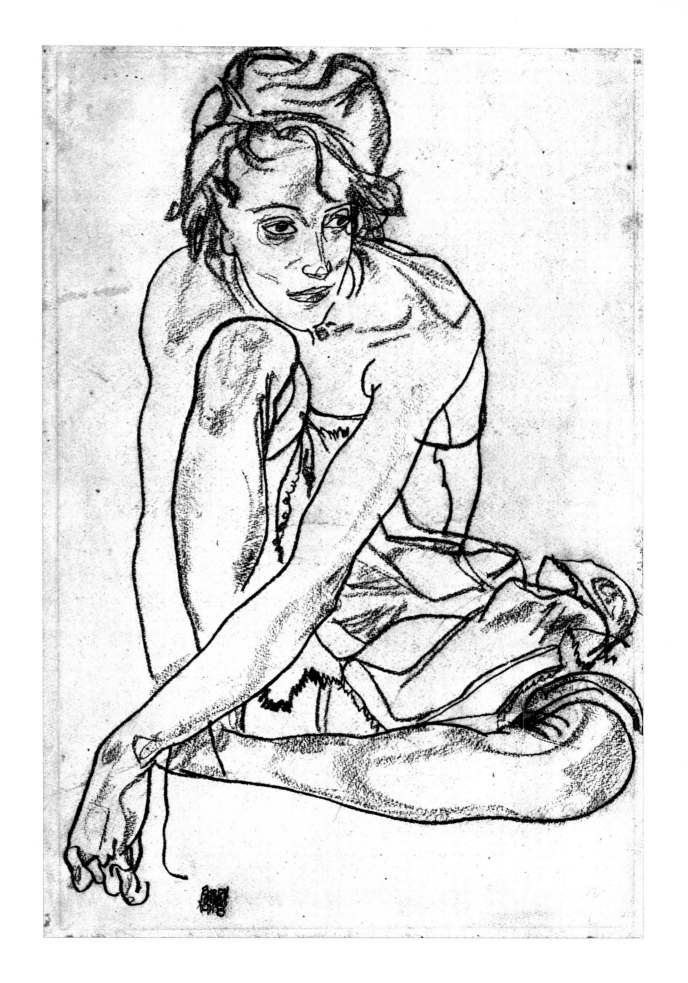

Plate 79

Peasants' Jugs
1918

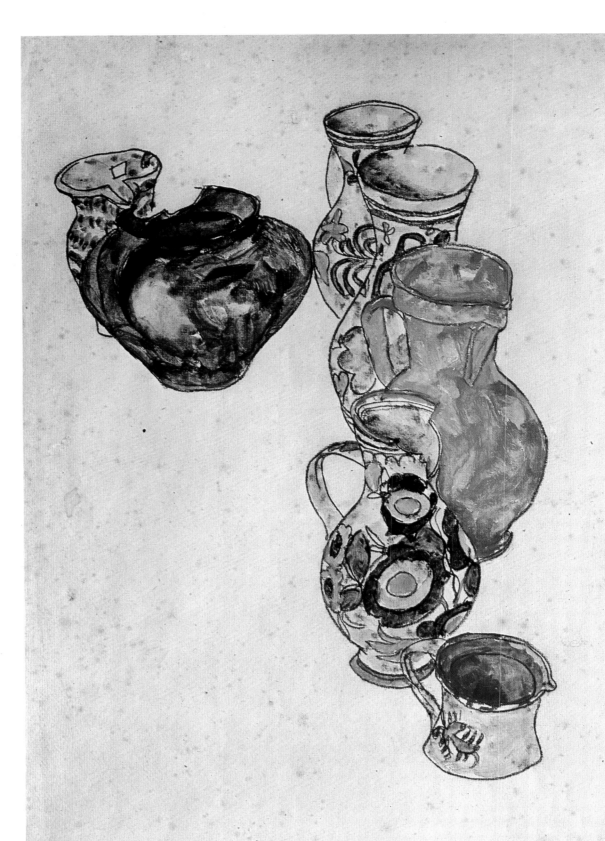

Plate 80

Portrait of the Artist's Mother
1918

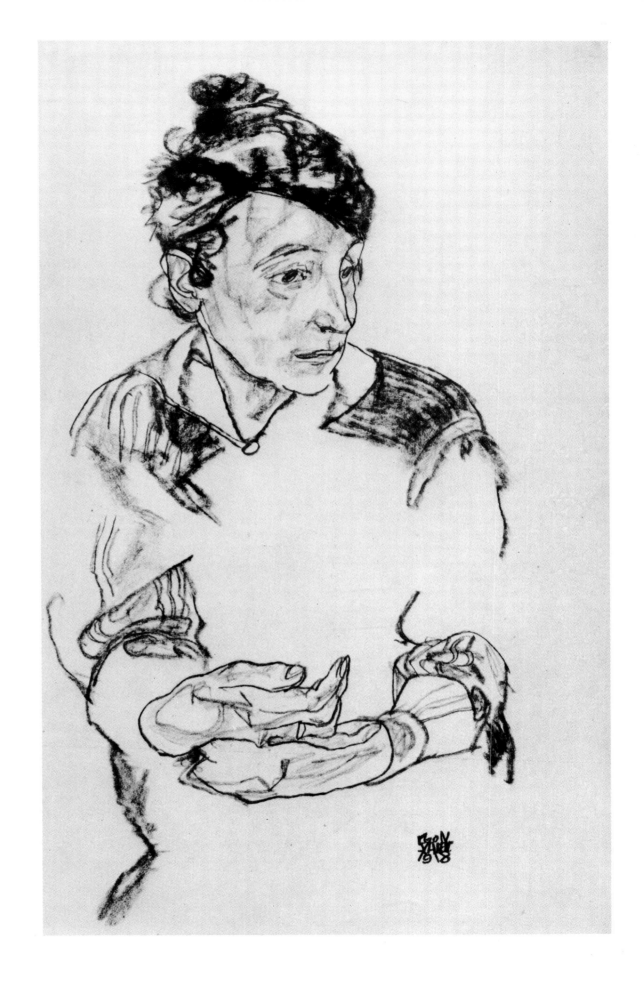

LIST OF PLATES

1

WATER SPRITES II 1908

Gouache, crayon, water-colour, white body-colour and gold paint on paper. 20.7 × 50.6 cm
Signed and dated: Schiele Egon 08
K. 65 ("Fairytale World"); L. 120
Private collection, Vienna

2

STANDING WOMAN IN A LONG CLOAK 1908

Pencil, coloured chalk, water-colour. 44.4 × 32 cm
Signed and dated: Schiele Egon 08. Inscribed on the reverse: "Veiled year"
Private collection

3

PORTRAIT OF THE COMPOSER LÖWENSTEIN 1909

Black chalk and crayon. 23.5 × 23.3 cm
Signed and dated: Schiele 1909. Inscribed: "Löwenstein"
Private collection

4

PORTRAIT OF GERTA SCHIELE 1909

Oil, silver and gold bronze paint on canvas, pencil.
139.5 × 140.5 cm
Dated in pencil: 1909
K. 89; L. 136
Private collection
The preliminary study immediately preceding the painting is reproduced in Leopold, p. 70.

5

SUNFLOWER 1909–10

Oil on canvas. 150 × 30 cm
Monogram: ES (interlaced)
K. 97; L. 139
Historisches Museum der Stadt Wien, Vienna

6

SEATED MALE NUDE 1910

Oil and body-colour on canvas. 152.5 × 150 cm
Not signed or dated
K. 112; L. 145
Collection of Dr. Rudolf Leopold, Vienna

7

FIELD OF FLOWERS 1910

Black chalk, gouache, gold bronze paint and white body-colour on paper. 44.5 × 30.8 cm
Monogrammed and dated: S. 10
On the back: pencil sketch of a railway-train
K. 122; L. 150
Private collection, Vienna

8

FEMALE NUDE 1910

Black chalk, water-colour and gouache, white body-colour.
44.3 × 30.6 cm
Monogrammed and dated: S. 10
On the back: a preparatory drawing for the painting "Danaë" of 1909 (K. 92; L. 130). Pencil and red crayon, squared for enlargement
Graphische Sammlung Albertina, Vienna. Inv. No. 30.996

9

NUDE SELF-PORTRAIT 1910

Black chalk, gouache, white body-colour. 44.9 × 31.3 cm
Monogrammed and dated: S. 10
On the back: Woman with a Black Ribbon, 1909
Private collection

10

THREE STREET URCHINS 1910

Pencil. 44.6 × 30.8 cm
Monogrammed and dated: S. 10
On the back: Lady with Hat, pencil, signed and dated 09
Graphische Sammlung Albertina, Vienna. Inv. No. 31.153

11

PORTRAIT OF THE ART CRITIC ARTHUR ROESSLER
1910

Oil on canvas. 100 × 100 cm
Monogrammed and dated: S. 10
K. 105; L. 153
Historisches Museum der Stadt Wien, Vienna

12

PORTRAIT OF THE PUBLISHER EDUARD KOSMACK
1910

Oil on canvas. 100 × 100 cm
Monogrammed and dated: S. 10
K. 103; L. 152
Österreichische Galerie, Vienna

13

STANDING MALE NUDE (SELF-PORTRAIT) 1910

Pencil, water-colour, gouache, "syndetikon" glue, white body-colour. 55.7 × 36.8 cm
Monogrammed and dated: S. 10
Graphische Sammlung Albertina, Vienna. Inv. No. 30.766

14

DEAD MOTHER 1910

Oil on wood. 32 × 25.7 cm
Monogrammed and dated: S. 10
K. 115; L. 167
Collection of Dr. Rudolf Leopold, Vienna

15

SCHIELE DRAWING A NUDE MODEL BEFORE A
MIRROR 1910

Pencil. 55.2 × 35.3 cm
Monogrammed and dated: S. 10
Graphische Sammlung Albertina, Vienna. Inv. No. 26.276

16

THE DANCER MOA 1911

Pencil. 48 × 31.8 cm
Signed and dated: Egon Schiele 1911. Inscribed: Moa
Graphische Sammlung Albertina, Vienna. Inv. No. 31.003
Other drawings inscribed "Moa" are in the Historisches Museum der Stadt Wien (Albertina exhibition catalogue, 1968, No. 182) and in a private collection in Vienna (Leopold, pl. 78 and Des Moines Art Center exhibition catalogue, 1971, No. 16).

17

GERTA SCHIELE WITH EYES CLOSED 1911

Pencil. 48 × 31.8 cm
Graphische Sammlung Albertina, Vienna. Inv. No. 31.248

18

COMPOSITION WITH THREE MALE FIGURES (SELF-PORTRAIT) 1911

Pencil, water-colour, gouache, white body-colour. 55 × 37 cm
Monogrammed and dated: S. 11
Private collection

19

DEAD CITY 1911

Oil on wood. 37.3 × 29.8 cm
Signed and dated: Egon Schiele 1911
K. 140 ("City on the Blue River I"); L. 182 (subject guide, p. 642)
Collection of Dr. Rudolf Leopold, Vienna
The same subject had already been treated by Schiele in 1910 (K. 117; L. 157); it also appears in the painting "World's Anguish" (K. 114; L. 165).

20

GIRL IN BLACK 1911

Pencil, water-colour. 45 × 31.6 cm
Signed and dated: Schiele Egon 11
Allen Memorial Art Museum, Oberlin, Ohio
The drawing immediately precedes the painting K. 125; L. 187

21

TWO LITTLE GIRLS 1911

Pencil, water-colour. 41 × 32 cm
Signed and dated: Egon Schiele 1911
Graphische Sammlung Albertina, Vienna. Inv. No. 27.945

22

SCHIELE'S ROOM IN NEULENGBACH 1911

Oil on wood. 40 × 31.6 cm
Signed and dated: Egon Schiele 1911 (three times)
K. 149; L. 193
Historisches Museum der Stadt Wien, Vienna

23

SELF-PORTRAIT WITH BLACK VASE 1911

Oil on wood. 27.5 × 34 cm
Signed and dated: Egon Schiele 1911
K. 124 ("Self-portrait with Spread-out Fingers"); L. 194
Historisches Museum der Stadt Wien, Vienna

24

TWO GIRLS 1911

Pencil, water-colour, gouache, white body-colour.
45.3 × 31.3 cm
Signed and dated: Egon Schiele 1911. Notation of colours
Private collection

25

THE BROTHER 1911

Pencil, gouache, white body-colour. 45 × 30.4 cm
Signed and dated: Egon Schiele 1911. Inscribed "Der Bruder"
Private collection

26

THE ARTIST'S MOTHER SLEEPING 1911

Pencil, water-colour, white body-colour. 31.6 × 45 cm
Signed and dated: Egon Schiele 1911
Graphische Sammlung Albertina, Vienna. Inv. No. 31.020

27

PREGNANT WOMAN AND DEATH 1911

Oil on canvas. 100.5 × 100.5 cm
Signed and dated: Egon Schiele 1911 (three times)
K. 135 ("Mother and Death"); L. 198
National Gallery, Prague

28

NUDE SELF-PORTRAIT 1912

Indian ink. 46.9 × 30.1 cm
Signed and dated: Egon Schiele 1912
Private collection
The drawing is very closely related to Schiele's lithograph for the "Sema" portfolio published by the Delphin Verlag. Schiele had submitted two drawings on transfer-paper, and their receipt was acknowledged in a letter of January 23, 1912 (Kallir, "Druckgraphik", p. 13, Nos. 1 and 2. A study for the second lithograph, hitherto known only as a print, is in the Galerie M. Scheer, Vienna). The motif of the horizontally outspread arms and the spread legs already appears in a self-portrait of 1911 in the Albertina (Inv. No. 31.156). For the position of the arms, cf. also a nude self-portrait of 1910, which appears on a photograph together with Schiele's painting "Half-nude of a Youth" (L. 149). The negative is in the Schiele archive in the Albertina.

29

HERMITS 1912

Oil on canvas. 181 × 181 cm
Signed and dated: Egon Schiele 1912 (three times)
K. 159; L. 203
Collection of Dr. Rudolf Leopold, Vienna

30

CARDINAL AND NUN 1912

Oil on canvas. 70 × 80.5 cm
Signed and dated: Egon Schiele 1912
K. 156; L. 210
Collection of Dr. Rudolf Leopold, Vienna
The picture also has the title "Caress".

31

FEMALE NUDE WITH BLUE STOCKINGS 1912

Pencil, water-colour, gouache. 48 × 31.5 cm
Signed and dated: Egon Schiele 1912
Collection of Kammersänger Prof. Anton Dermota, Vienna

32

WINTER TREES 1912

Oil on canvas. 80.5 × 80.5 cm
Signed and dated: Egon Schiele 1912
K. 160; L. 216
Private collection, Vienna

33

AUTUMN TREE IN MOVEMENT 1912

Oil on canvas. 80 × 80.5 cm
Signed and dated: Egon Schiele 1912
On the back, on the stretcher, inscribed in another hand:
Schiele: "Winterbaum"
K. 166 ("Autumn Tree in Movement" ["Winter Tree"]);
L. 221
Collection of Dr. Rudolf Leopold, Vienna

34

SHIPS AT TRIESTE 1912

Pencil, water-colour, gouache. 44 × 31.8 cm
Signed and dated: Egon Schiele 1912
Private collection

35

SELF-PORTRAIT 1912

Pencil, water-colour, gouache. 46.5 × 31.5 cm
Signed and dated: Egon Schiele 1912
Private collection

36

PORTRAIT OF ERICH LEDERER 1912-13

Oil on canvas. 139 × 55 cm
Signed and dated: Egon Schiele 1912
K. 174; L. 223
Private collection
As Leopold notes, the final sketch, squared in pencil for
transfer to canvas, has the date 1913.

37

HOLY FAMILY 1913

Pencil and gouache on transparent paper. 47 × 36.5 cm
Signed and dated: Egon Schiele 1913
K. —; L. 224
Private collection
The identification of this drawing with the work which
Schiele called the "Holy Family" was made by Leopold. For
the preliminary drawing of the female figure in the Albertina
cf. fig. 40.

38

THE BRIDGE 1913

Oil on canvas. 89.7 × 90 cm
Signed and dated: Egon Schiele 1913
K. 181; L. 229
Estate of Otto Kallir, New York

39

SELF-PORTRAIT 1913

Pencil. 48 × 32 cm
Signed and dated: Egon Schiele 1913
Private collection
Detail. The complete drawing is reproduced in: Benesch, O.,
"Egon Schiele als Zeichner", Vienna, n. d., pl. 14.

40

DOUBLE PORTRAIT (HEINRICH AND OTTO BENESCH)
1913

Oil on canvas. 121 × 131 cm
Signed and dated: Egon Schiele 1913
K. 175; L. 234
Neue Galerie der Stadt Linz, Wolfgang Gurlitt Museum
Two sketches for the composition in a sketch-book in the
Schiele archive of the Albertina collection already show
Heinrich Benesch's left arm stretched out horizontally
(Leopold, repr. p. 270). Cf. also fig. 49.

41

WOMAN IN A GREEN BLOUSE 1913

Pencil, gouache. 45.7 × 28 cm
Signed and dated: Egon Schiele 1913
Fischer Fine Art Ltd., London

42

TWO KNEELING FIGURES (PARALLELOGRAM) 1913

Pencil, Indian ink. 48.5×32 cm
Signed and dated: Egon Schiele 1913
Private collection

43

STEIN ON THE DANUBE WITH TERRACED
VINEYARDS (large version) 1913

Oil on canvas. 90×89.5 cm
Signed and dated: Egon Schiele 1913
K. 187 ("Stein on the Danube II"); L. 239 (subject guide
p. 652)
Private collection, U.S.A.

44

PEASANT HOMESTEAD IN A LANDSCAPE 1913

Pencil, water-colour and gouache on paper. 30.5×46.2 cm
Signed and dated: Egon Schiele 1913
K. —; L. 241
Private collection
Made, according to Leopold, during Schiele's summer holiday
in Carinthia.

45

"THE TRUTH WAS REVEALED" 1913

Pencil, water-colour and gouache. 48.2×32 cm
Signed and dated: Egon Schiele 1913. Inscribed
"Die Wahrheit wurde enthüllt"
On the reverse: a seated female nude, in pencil
Private collection

46

FIGHTER 1913

Pencil, gouache. 48.7×32.1 cm
Signed and dated: Egon Schiele 1913. Inscribed "Kämpfer"
On the reverse: a seated girl (Wally), in pencil
Private collection

47

RECUMBENT FEMALE NUDE WITH LEGS APART
1914

Pencil, gouache. 30.4×47.1 cm
Signed and dated: Egon Schiele 1914
Graphische Sammlung Albertina, Vienna. Inv. No. 26.667
Schiele drew this model several times. Cf. also the drawing
in the Albertina, Inv. No. 31.632.

48

MALE NUDE WITH A RED LOINCLOTH 1914

Pencil, water-colour, gouache. 48×32 cm
Signed and dated: Egon Schiele 1914
Graphische Sammlung Albertina, Vienna. Inv. No. 31.103

49

MOTHER AND CHILD 1914

Pencil, gouache. 48.1×31.9 cm
Signed and dated: Egon Schiele 1914
Collection of Dr. Rudolf Leopold, Vienna

50

BLIND MOTHER 1914

Oil on canvas. 99×120 cm
Signed and dated: Egon Schiele 1914
K. 193; L. 247
Collection of Dr. Rudolf Leopold, Vienna

51

OLD HOUSES IN KRUMAU 1914

Pencil, gouache. 32.5×48.5 cm
Signed and dated: Egon Schiele 1914. Notation of colours
L. repr. p. 655
Graphische Sammlung Albertina, Vienna. Inv. No. 31.158
A pencil drawing in the Niederösterreichisches Landes-
museum, Vienna (Inv. No. 1810), shows a similar view of the
same subject.

52

WINDOWS 1914

Oil on canvas. 110×141 cm
Not dated or signed
K. 201 ("Wall with Windows"); L. 252
Österreichische Galerie, Vienna

53
STANDING MALE FIGURE (SELF-PORTRAIT) 1914
Pencil. 48.2×31.5 cm
Signed and dated: Egon Schiele 1914
Nationalmuseum, Stockholm, NMH 95/1952

54
FEMALE NUDE TO THE RIGHT
Pencil, gouache. 32×48.5 cm
Signed and dated: Egon Schiele 1914
Graphische Sammlung Albertina, Vienna. Inv. No. 31.118

55
SEATED WOMAN WITH HER LEFT HAND IN HER
HAIR 1914
Pencil, gouache. 48.5×31.4 cm
Signed and dated: Egon Schiele 1914
Graphische Sammlung Albertina, Vienna. Inv. No. 31.119

56
TWO GIRLS EMBRACING EACH OTHER 1915
Pencil, gouache. 48×32.7 cm
Signed and dated: Egon Schiele 1915
Museum of Fine Arts, Budapest. Inv. No. 1915-933

57
WOODLAND PRAYER 1915
Oil on canvas. 100×120.5 cm
Signed and dated: Egon Schiele 1915
K. 210; L. 264
Private collection, Switzerland
For the preliminary study in one of Schiele's sketch-books
in the Schiele archive in the Albertina, of. fig. 60.

58
LEVITATION 1915
Oil on canvas. 200×172 cm
Signed and dated: Egon Schiele 1915
K. 206; L. 265
Collection of Dr. Rudolf Leopold, Vienna

59
DEATH AND GIRL 1915
Oil on canvas. 150.5×180 cm
Signed and dated: Egon Schiele 1915
K. 207; L. 266
Osterreichische Galerie, Vienna

60
PORTRAIT OF EDITH SCHIELE STANDING 1915
Charcoal. 46×28.5 cm
Signed and dated: Egon Schiele 1915
Private collection, New York (Photo: Galerie St Etienne
New York)
Preliminary study for the painting pl. 61
Schiele drew his wife in this striped dress several times
Cf. the drawing in the collection of Viktor Fogarassy, Graz
(Albertina exhibition catalogue, 1968, No. 252), and the
drawing reproduced in: Karpfen, F., "Das Egon Schiele
Buch", Vienna, 1921, No. 46.

61
PORTRAIT OF EDITH SCHIELE IN A STRIPED DRESS
1915
Oil on canvas. 180×110.5 cm
Signed and dated: Egon Schiele 1915
On the back of the canvas, there are fragments of a male
nude with raised arms and of two seated women
K. 205 ("Portrait of the Artist's Wife Standing"); L. 267
Haags Gemeentemuseum, The Hague
Apart from the portrait-study in the Albertina, Vienna,
Inv. No. 24.483 (Österreichische Galerie exhibition catalogue,
1968, No. 73), of. also the reproduction in the exhibition
catalogue of Gutekunst & Klipstein, 1956, No. 36.

62

AUNT AND NEPHEW 1915

Charcoal. 48.5 × 33.5 cm

Signed and dated: Egon Schiele 1915

Private collection

A portrait of Adele Harms, Schiele's sister-in-law, with her nephew Paul Erdmann. Cf. the drawings of the same subject in the Albertina, Vienna, Inv. No. 24.299 (Albertina exhibition catalogue, 1968, No. 254), in the Ala Story collection, Santa Barbara, California (Des Moines Art Center exhibition catalogue, 1971, No. 49), and also the illustrations in the La Boetie exhibition catalogue, New York, 1971, No. 26, and Benesch, Otto, "Egon Schiele", in "Art International II", 9/10, 1958/59.

63

LANDSCAPE AT KRUMAU 1916

Oil on canvas. 110 × 140.5 cm

Signed and dated: Egon Schiele 1916

K. 216; L. 268 ("Town and River", subject guide, p. 660)

Neue Galerie der Stadt Linz, Wolfgang Gurlitt Museum

64

PORTRAIT OF JOHANN HARMS 1916

Oil on canvas. 140 × 110.5 cm

Signed and dated: Egon Schiele 1916

K. 213 ("Portrait of an Old Man" [Johann Harms]); L. 270

The Solomon R. Guggenheim Museum, New York

65

OFFICE IN THE PRISONER-OF-WAR CAMP, MÜHLING 1916

Black and red chalk. 43.8 × 28.6 cm

Signed and dated: Egon Schiele 1916

Private collection, New York

66

THE MILL 1916

Oil on canvas. 110 × 140 cm

Signed and dated: Egon Schiele 1916

K. 217; L. 271 ("Decaying Mill", subject guide, p. 662)

Niederösterreichisches Landesmuseum, Vienna

67

MOTHER WITH TWO CHILDREN 1915-17

Oil on canvas. 150 × 159 cm

Signed and dated: Egon Schiele 1917

K. 223; L. 273

Österreichische Galerie, Vienna

The picture was already substantially completed in 1915, but was re-worked by the artist and signed in 1917, of. fig. 57.

68

FOUR TREES 1917

Oil on canvas. 110 × 140.5 cm

Signed and dated: Egon Schiele 1917

K. 225; L. 274

Österreichische Galerie, Vienna

69

PORTRAIT OF HEINRICH BENESCH 1917

Pencil, water-colour, gouache. 45.8 × 28.5 cm

Signed and dated: Egon Schiele 1917

Graphische Sammlung Albertina, Vienna. Inv. No. 31.261

70

OLD GABLED HOUSES IN KRUMAU 1917

Black chalk. 45.8 × 28.8 cm

Signed and dated: Egon Schiele 1917

L. repr. p. 664

Graphische Sammlung Albertina, Vienna. Inv. No. 31.172

71

STREET IN KRUMAU 1917

Black chalk, gouache. 47 × 29.9 cm

Signed and dated: Egon Schiele 1917. Inscribed on the reverse: Krummau a. d. M. vom Schlossturm Anfang Juni 1917

Private collection

Figures are very infrequent in Schiele's townscapes, but cf. the painting "Town's End", K. 231; L. 284.

72

FEMALE NUDE LYING ON HER STOMACH 1917

Black chalk, gouache. 29.8 × 46.1 cm

Signed and dated: Egon Schiele 1917

Graphische Sammlung Albertina, Vienna. Inv. No. 31.452

73
SEATED WOMAN 1917
Black chalk. 46×29.5 cm
Signed and dated: Egon Schiele 1917
Private collection, Vienna

74
EMBRACE 1917
Oil on canvas. 100×170 cm
Not signed or dated
K. 224; L. 276
Österreichische Galerie, Vienna

75
THE FAMILY 1918
Oil on canvas. 152.5×162.5 cm
Not signed or dated
K. 240; L. 289
Österreichische Galerie, Vienna

76
PORTRAIT OF EDITH SCHIELE SEATED 1917–18
Oil on canvas. 140×110.5 cm
Signed and dated: Egon Schiele 1918
K. 232; L. 285
Österreichische Galerie, Vienna
The picture was finished in 1917, but in 1918 Schiele reworked
several parts of it and added the date and the signature.

77
PORTRAIT OF ALBERT PARIS VON GÜTERSLOH
1918
Oil on canvas. 140.5×110 cm
Signed and dated: Egon Schiele 1918
K. 234; L. 294
The Minneapolis Institute of Arts, Minneapolis
A study for this picture is in the Albertina, cf. fig. 75.

78
SQUATTING WOMAN 1918
Black chalk. 45×29.5 cm
Signed and dated: Egon Schiele 1918
Graphische Sammlung Albertina, Vienna. Inv. No. 23.526

79
PEASANTS' JUGS 1918
Black chalk, water-colour. 46×30 cm
Signed and dated: Egon Schiele 1918
Private collection
Schiele made several drawings of peasant pottery. The initials
"O. W." on one of them stand for Ober-Waltersdorf, the
country-seat of Dr. Hugo Koller (colour plate in the Galerie
St Etienne exhibition catalogue, New York, 1968, No. 70).
Other drawings of peasant pottery are in the Österreichisches
Museum für angewandte Kunst, Vienna, and in a private
collection in Vienna.

80
PORTRAIT OF THE ARTIST'S MOTHER 1918
Black chalk. 45.7×29 cm
Signed and dated: Egon Schiele 1918
Graphische Sammlung Albertina, Vienna. Inv. No. 23.527

BIBLIOGRAPHY

Ankwicz v. Kleehoven, Hans, "Egon Schiele", in "Das Kunstwerk", Baden-Baden, V, 1951, No. 3

Arrold, Matthias, "Egon Schiele, Leben und Werk", Stuttgart–Zürich, 1984

Benesch, Heinrich, "Mein Weg mit Egon Schiele", edited and arranged by Eva Benesch, New York, 1965

Benesch, Otto, "Egon Schiele als Zeichner", portfolio of the Österreichische Staatsdruckerei, Vienna, n. d. (1950)

Benesch, Otto, "Egon Schiele und die Graphik des Expressionismus", in "Continuum, Zur Kunst Österreichs in der Mitte des 20. Jahrhunderts", pub. by: Institut zur Förderung der Künste in Österreich, Vienna, n. d. (1958), pp. 19 ff.

Benesch, Otto, "Egon Schiele", in "Art International II", No. 9/10, 1958-59, pp. 37 f., 75 f.

Born, Wolfgang, "Egon Schieles Zeichnungen", in "Deutsche Kunst und Dekoration", LXIII, 1928-29, pp. 115 ff.

Comini, Alessandra, "Egon Schiele in Prison", in "Albertina-Studien II", 1964, vol. 4, pp. 123 ff.

Comini, Alessandra, "Egon Schieles Tagebuch 1916", in "Albertina-Studien IV", 1966, vol. 2, pp. 86 ff.

Comini, Alessandra, "Schiele in Prison", New York Graphic Society Ltd., Greenwich, Connecticut, 1973

Comini, Alessandra, "Egon Schiele's Portraits", Berkeley–Los Angeles–London, 1974

Comini, Alessandra, "Egon Schiele", New York, 1976

Davis, Richard, "Portrait of Paris von Gütersloh by Egon Schiele in the Minneapolis Institute of Arts", in "Art Quarterly", Detroit, XIX, No. 1, 1956, p. 93

Dobai, Johannes, "Egon Schieles 'Jüngling vor Gottvater kniend'", in· "Jahrbuch 1968-69" of the Schweizerisches Institut für Kunstwissenschaft

Feuchtmüller, Rupert, "Egon Schieles Städtebilder von Stein an der Donau", in "Alte und moderne Kunst", vol. 103, Vienna, 1969, pp. 29 ff.

Fischer, Wolfgang, "Unbekannte Tagebuchblätter und Briefe von Egon Schiele und Erinnerungen einer Wiener Emigrantin in London", in "Albertina-Studien IV", 1964, vol. 4, pp. 172 ff.

Fischer, Wolfgang, "Egon Schiele als 'Militärzeichner'", in "Albertina-Studien IV", 1966, pp. 70 ff.

Grohmann, Will, "Schiele, Egon", in "Allgemeines Lexikon der bildenden Künstler", vol. XXX, 1936, p. 59

Gütersloh, Paris von, "Egon Schiele, Versuch einer Vorrede", Verlag Brüder Rosenbaum, Vienna, n.d. (1911)

Hertlein, Edgar, "Frühe Zeichnungen von Egon Schiele", in "Alte und moderne Kunst", vol. 95, Vienna, 1967, pp. 32 ff.

Hofmann, Werner, "Egon Schiele, Die Familie", Stuttgart, 1968 (Reclams Werkmonographien zur bildenden Kunst, No. 132)

Kallir, Otto, "Egon Schiele, Œuvrekatalog der Gemälde", with contributions by O. Benesch and Thomas H. Messer, Vienna, 1966 (bilingual edition, German and English)

Kallir, Otto (commentary), "A Sketchbook by Egon Schiele", New York, 1967 (bilingual edition, German and English)

Kallir, Otto, "Egon Schiele, Das druckgraphische Werk", Vienna, 1970 (bilingual edition, German and English)

Karpfen, Fritz (ed.), "Das Egon Schiele Buch", Vienna, 1921

Koschatzky, Walter, "Aus einem Briefwechsel Egon Schieles", in "Albertina-Studien II", 1964, vol. 4, pp. 170 ff.

Künstler, Gustav, "Egon Schiele als Graphiker", Vienna, 1946

Leopold, Rudolf, "Egon Schiele, ein Genie aus Österreich", in "B. P.—Querschnitt", vol. 1, 1959

Leopold, Rudolf, "Egon Schiele, Gemälde, Aquarelle, Zeichnungen", Salzburg, 1972. English edition, Phaidon, 1973

Liegler, Leopold, "Egon Schiele", in "Die graphischen Künste", No. XXXIX, 1916, pp. 70 ff.

Malafarina, Gianfranco, "L'opera di Schiele", Milan, 1982

Mitsch, Erwin, "Egon Schiele, Zeichnungen und Aquarelle", Salzburg, 1961 (first edition)

Mitsch, Erwin, "Egon Schiele, Selbstbildnis (1911)", in „Schätze aus Museen Österreichs", Notringjahrbuch, 1967, p. 39

Mitsch, Erwin (selector and editor), "Egon Schiele, Aquarelle

und Zeichnungen, 64 Lichtdrucke", Salzburg, 1968, publication No. 4 of the Albertina, ed. Walter Koschatzky

Nebehay, Christian M., "Egon Schiele 1890–1918. Leben, Briefe, Gedichte", Salzburg, 1979

Nebehay, Christian M., "Egon Schiele, Leben und Werk", Salzburg, 1980

Nebehay, Christian M., "Gustav Klimt – Egon Schiele und die Familie Lederer", Berne, 1987

Nirenstein, Otto, "Egon Schiele, Persönlichkeit und Werk", Berlin, Vienna, Leipzig, 1930

Portfolio: "Zeichnungen Egon Schiele. 12 Schwarzweisslichtdrucke in Originalgrösse", Richard Lanyi, Vienna, 1917 (limited edition of 400 copies)

Portfolio: "Egon Schiele, Handzeichnungen. 15 Lichtdrucke in Originalgrösse", Verlag Ed. Strache, Vienna, Prague, Leipzig, 1920 (limited edition of 510 copies)

Powell, Nicolas, "The Sacred Spring. The Arts in Vienna 1898–1918", London, 1974

Roden, Max, "Tage und Jahre um Egon Schiele", in "Kunst ins Volk", Vienna, 1950, vol. 11/12, pp. 496 ff.

Roessler, Arthur, "Egon Schiele", in "Bildende Künstler, Monatsschrift für Künstler und Kunstfreunde", vol. 3, Vienna, Leipzig, 1911 (Verlag Brüder Rosenbaum)

Roessler, Arthur, "Kritische Fragmente, Aufsätze über österreichische Neukünstler", Vienna, 1918

Roessler, Arthur (ed.), "In memoriam Egon Schiele", Vienna, 1921

Roessler, Arthur (ed.), "Briefe und Prosa von Egon Schiele", Vienna, 1921

Roessler, Arthur (ed.), "Egon Schiele im Gefängnis", Vienna, Leipzig, 1922

Roessler, Arthur, "Erinnerungen an Egon Schiele", Vienna, Leipzig, 1922 (second edition, Vienna, 1948)

Roessler, Arthur (ed.), "Das graphische Werk von Egon Schiele", portfolio with two lithographs and six etchings, Rikola Verlag, Vienna, Berlin, Leipzig, Munich, 1922 (limited edition of 80 numbered copies)

Roessler, Arthur, "Zu Egon Schieles Städtebildern", in "Österreichische Bau- und Werkkunst", Vienna, 1925-26, vol. II

Sabarsky, Serge, "Disegni erotici, Egon Schiele", Milan, 1981

Sabarsky, Serge, "Egon Schiele, vom Schüler zum Meister", Milan, 1984

Sabarsky, Serge, "Gustav Klimt, Oskar Kokoschka, Egon Schiele", Milan, 1984

Schöny, Heinz, "Die Vorfahren des Malers Egon Schiele", in "Adler, Zeitschrift für Genealogie und Heraldik", Vienna, 1968, 1, pp. 1 ff.

Schwarz, Heinrich, "Die graphischen Werke von Egon Schiele", in "Philobiblon", 1961, V, 1

Schwarz, Heinrich, "Nachtrag zu 'Die graphischen Werke von Egon Schiele'", in "Philobiblon", 1962, VI, 2

Schwarz, Heinrich, "Schiele, Dürer and the Mirror", in "The Art Quarterly", vol. XXX, Nos. 3-4, 1967, pp. 210 ff.

Selz, Peter, "Egon Schiele", in "Art International IV", No. 10, 1960, pp. 39 ff.

Tietze, Hans, "Egon Schiele", in "Die bildenden Künste, Wiener Monatshefte", II, 1919, pp. 99 ff.

Vergo, Peter, "Art in Vienna 1898–1918. Klimt, Kokoschka, Schiele and their Contemporaries", London, 1975. Second edition, Oxford, 1981

Vollmer, Hans, "Schiele, Egon", in "Allgemeines Lexikon der bildenden Künstler des XX. Jahrhunderts", vol. 6, section H-Z, Leipzig, 1962, p. 398

Weiermair, Peter, "Egon Schiele, Schriften und Zeichnungen", Innsbruck, 1968 (fourth publication of the Allerheiligenpresse)

Werner, Alfred, "Schiele and Austrian Expressionism", in "Arts", New York, vol. 35, No. 1, Oct. 1960, pp. 46 ff.

Zahn, Leopold, "Gustav Klimt und Egon Schiele", in "Das Kunstwerk", Baden-Baden XI, 1958, No. 9

SELECT LIST OF EXHIBITIONS

The name of the author of the introductory text is given in brackets.

1909
"Internationale Kunstschau", Vienna

1913
"Egon Schiele", Galerie Neue Kunst Hans Goltz, Munich (A. Roessler and E. Schiele, "Entwurf zu einem geschriebenen Selbstbildnis")

1914-15
"Kollektivausstellung Egon Schiele", Galerie Arnot, Vienna (O. Benesch)

1918
"XLIX. Ausstellung der Secession", Vienna, March 1918

1919
"Egon Schiele", Gustav Nebehay Kunsthandlung, Vienna ("Die Zeichnung", vol. I, April 1919)

1923
"Egon Schiele, Gemälde und Handzeichnungen", Neue Galerie, Vienna (K. Rathe)

1925-26
"Egon Schiele", Galerie Würthle, Vienna (A. Roessler)

1928
"Egon Schiele, Gedächtnisausstellung zum 10. Todestag des Künstlers", Hagenbund - Neue Galerie, Vienna (B. Grimschitz)

1948
"Egon Schiele, Gedächtnisausstellung", Albertina, Vienna (O. Benesch, A. P. Gütersloh, B. Fleischmann). No printed catalogue

1948
"Egon Schiele, Gedächtnisausstellung", Neue Galerie, Vienna (O. Kallir - Nirenstein)

1948
"Egon Schiele, Paintings, Water-colours, Drawings", Galerie St Etienne, New York (J. v. Sternberg)

1949
"Egon Schiele", Neue Galerie der Stadt Linz (E. Köller)

1949
"Gustav Klimt - Egon Schiele", Graphische Sammlung der Eidgenössischen Technischen Hochschule, Zurich (E. Gradmann)

1956
"Kunst aus Österreich", Stedelijk Museum, Amsterdam (W. Hofmann)

1956
"Egon Schiele, Bilder, Aquarelle, Zeichnungen, Graphik", Gutekunst & Klipstein, Berne, stock- and exhibition-catalogue No. 57 (O. Benesch, with a list of the graphic works compiled by E. W. Kornfeld and H. Bolliger)

1957
"Kunst aus Österreich", Kunsthalle, Berne (K. Demus)

1958
"Graphik des Expressionismus aus der Sammlung der Albertina in Wien und aus österreichischem Privatbesitz", Kunsthaus, Zurich (O. Benesch)

1960-61
"Egon Schiele", Institute of Contemporary Art, Boston (Thomas M. Messer, O. Kallir), travelling exhibition, U.S.A.

1961
"Egon Schiele", Galerie im Griechenbeisl, Vienna

1963
"Viennese Expressionism 1910-1926", University Art Gallery, Berkeley, California (Herschel B. Chipp)

1963
"Zeugnisse der Angst in der modernen Kunst", Darmstadt, Mathildenhöhe

1963
"Egon Schiele", Tiroler Landesmuseum Ferdinandeum, Innsbruck (E. Durig)

1964
"Wien um 1900", Secession und Künstlerhaus (F. Glück, F. Novotny)

1964
"L'Espressionismo", XXVII Maggio Musicale Fiorentino, Palazzo Strozzi, Florence

1964
"Egon Schiele, Paintings, Water-colours and Drawings", Marlborough Fine Art Ltd., London (W. Fischer, R. Leopold)

1965
"Egon Schiele, Aquarelle, Zeichnungen", Galerie Haemmerle, Götzis, Vorarlberg (O. Oberhuber)

1965
"Gustav Klimt and Egon Schiele", The Solomon R. Guggenheim Museum, New York (on Schiele: Thomas M. Messer, J. T. Demetrion, A. Comini)

1965
"Egon Schiele, Water-colours and Drawings from American

Collections", The Galerie St Etienne, New York (Thomas M. Messer)

1967

"Egon Schiele, Paintings, Water-colours and Drawings", Felix Landau Gallery, Los Angeles, California (F. Landau)

1967

"2. Internationale der Zeichnung", Darmstadt, Mathildenhöhe, "Sonderausstellung Egon Schiele" (W. Hofmann)

1968

"Gedächtnisausstellung Egon Schiele, Gemälde", Österreichische Galerie, Vienna (H. Bisanz; catalogue by E. Baum)

1968

"Egon Schiele, Leben und Werk", Historisches Museum der Stadt Wien, Vienna (H. Bisanz)

1968

"Gustav Klimt - Egon Schiele", Albertina, Vienna (on Schiele: A. P. Gütersloh, O. Benesch, E. Mitsch)

1968

"Egon Schiele, Eine Ausstellung des Kulturamtes und des Museums Carolino Augusteum Salzburg" (R. Leopold)

1968

"Egon Schiele, Frühe Werke und Dokumentation", Galerie Christian M. Nebehay, Vienna (Christian M. Nebehay)

1968

"Egon Schiele, Water-colours and Drawings", The Galerie St Etienne, New York (O. Benesch, O. Kallir)

1969

"Egon Schiele", Marlborough Fine Arts Ltd., London (W. Fischer, H. Rosé)

1971

"Vienna Secession, Art nouveau to 1970", Royal Academy of Arts, London

1971

"Egon Schiele and the Human Form, Drawings and Water-colours", Des Moines Art Center (James T. Demetrion)

1971

"Egon Schiele and his Circle", La Boetie, New York

1972

"Egon Schiele, Oils, Water-colours, Drawings and Graphic Work", Fischer Fine Art Ltd., London (W. Fischer)

1973

"Gustav Klimt - Egon Schiele, Zeichnungen und Aquarelle", Galerie im Taxispalais, Innsbruck (O. Breicha)

1973

"Det moderne Gennembrud i Østrigsk Kunst", Statens Museum for Kunst, Copenhagen (E. Fischer, E. Mitsch)

1977

"Egon Schiele 1890–1918", Galerie Annasäule, Innsbruck (P. Weiermair)

1980

"Gustav Klimt – Egon Schiele", Galerie St. Etienne, New York (J. Kallir)

1981

"Austria's Expressionism", Galerie St. Etienne/Rizzoli New York (J. Kallir)

1981

"Experiment Weltuntergang – Wien um 1900", Kunsthalle Hamburg (W. Hoffmann)

1984

"Le Arti a Vienna. Dalla Secessione alla Caduta dell'Impero Asburgico", Venice Palazzo Grassi (R. Leopold)

1984

"Egon Schiele", Milan – Rome – Venice (S. Sabarsky)

1984

"Egon Schiele, Vom Schüler zum Meister, Zeichnungen und Aquarelle, 1906–1918", Akademie der bildenden Künste, Vienna (S. Sabarsky)

1985

"Gustav Klimt und Egon Schiele, mit Werken von Alfred Kubin", Künstler der Jahrhundertwende, Tokyo

1986

"Vienne 1880–1938, L'Apocalypse joyeuse", Certre Georges Pompidou, Paris

1986

"Vienna 1900; Art, Architecture and Design", Museum of Modern Art, New York

1986

"Egon Schiele und Wien zur Jahrhundertwende", Tokyo (R. Leopold)

The researches for this book began in 1968, when I was entrusted with the organization of the great Schiele exhibition in the Albertina, Vienna. My text rests on the solid foundations of the critical catalogues of the artist's work compiled by O. Kallir and R. Leopold, which are indispensable for the close study of Schiele's art. My notes to the plates and the text illustrations are therefore confined to the essential data and some supplementary suggestions.

I wish to thank the public collections and the private owners of works by Schiele, many of whom wish to remain anonymous, for their generous cooperation and for their ready help in supplying photographs.

Erwin Mitsch

Photographic Credits:
F. Bertrand, Geneva; Corvina Verlag, Budapest; Hinz SWB, Basle; Lichtbildwerkstätte Alpenland, Vienna; E. Lünemann, Graphische Sammlung Albertina, Vienna; Photostudio Otto, Vienna; J. Scherb, Vienna; Schiele Archive, Graphische Sammlung Albertina, Vienna.
Other reproductions are based on photographs kindly put at the author's and publishers' disposal by private owners and public collections.